BROOKLYN
THEN & NOW

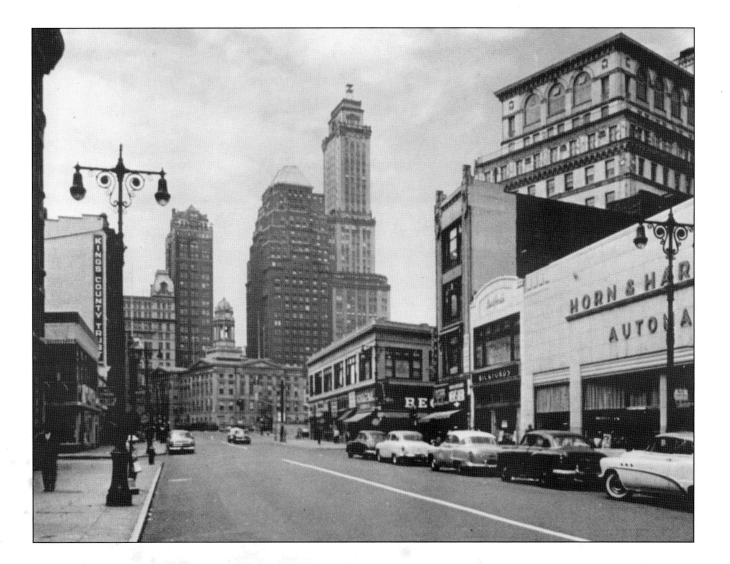

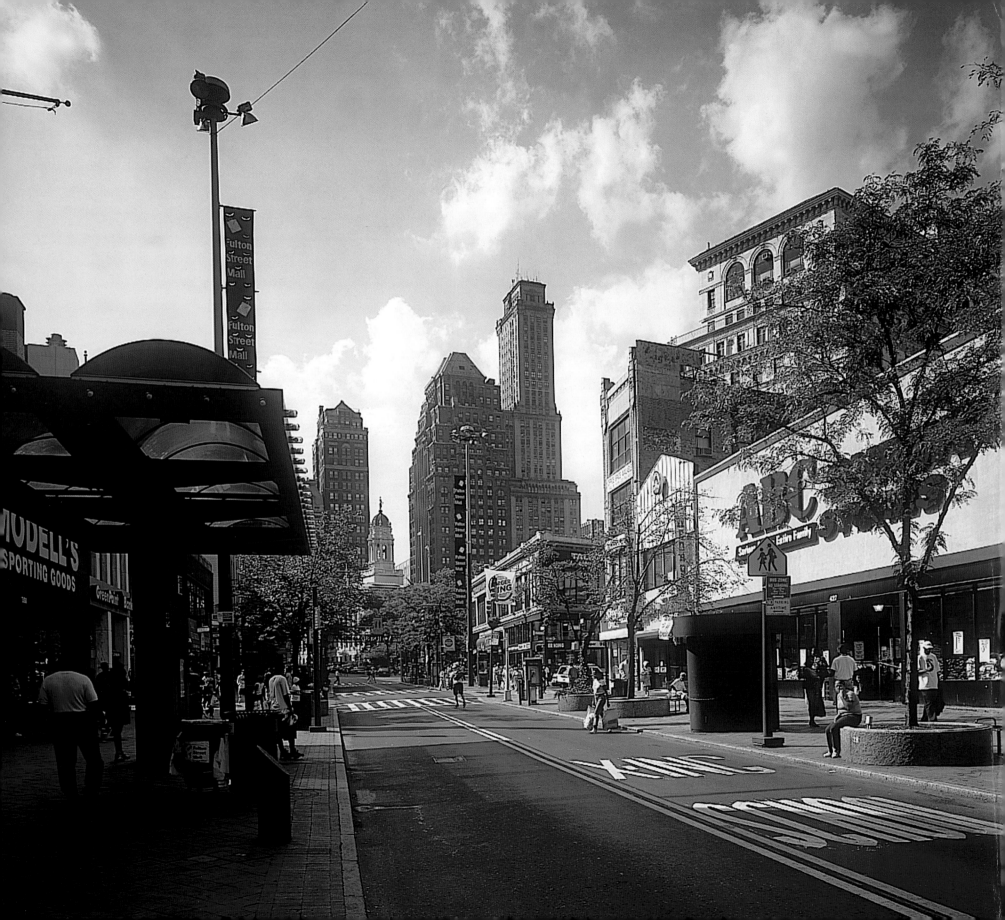

BROOKLYN THEN & NOW

MARCIA REISS

THUNDER BAY
P·R·E·S·S

San Diego, California

Thunder Bay Press
An imprint of the Advantage Publishers Group
5880 Oberlin Drive, San Diego, CA 92121-4794
www.advantagebooksonline.com

Produced by PRC Publishing Ltd,
64 Brewery Road, London N7 9NT, England
A member of the Chrysalis Group plc.

ISBN 1-57145-792-5

Library of Congress Cataloging-in-Publication Data available upon request.

Printed in China

1 2 3 4 5 06 05 04 03 02

ACKNOWLEDGMENTS
Thanks to the Brooklyn Historical Society, the venerable institution in Brooklyn
that made this book possible. To Sean Ashby for conscientious work in compiling the
historic photos, and to Wendy Aibel-Weiss for support along every step of the way.
Thanks also to Thomas Gilcoyne of the National Museum of Racing; David Sharps of
the Waterfront Museum in Red Hook; Lucy Gentile, Mary Fox, and Julie Moffat of the
Prospect Park Alliance; Scott Sendrow of New York City Parks and Recreation; Josie
Phelps and Mae Pan of the Brooklyn Botanic Garden; and Richard Drucker of the
Brooklyn Navy Yard Development Corporation.

To my husband, Charles Reiss, who introduced me to Brooklyn and inspired my love
of urban history.

BIBLIOGRAPHICAL REFERENCES:

Jackson, Kenneth T., editor, *The Encyclopedia of New York City*. New Haven:
 Yale University Press, 1995.
Snyder-Grenier, Ellen M., *Brooklyn! An Illustrated History*. Philadelphia:
 Temple University Press, 1996.
Stern, Robert A.M. and others, *New York (1880, 1900, and 1930)*. New York:
 Rizzoli International Publications, 1987.

PHOTO CREDITS:

The publisher wishes to thank Simon Clay for taking all the contemporary
photography in this book, and the Brooklyn Historical Society for kindly supplying
all the archival photography. Exceptions to this are noted under the captions.

The front cover shows Brooklyn Bridge over the East River © CORBIS.

The front flap photographs show Nathan's Famous Hot Dog Stand, Coney Island,
then (top, see page 124 inside, photo courtesy of Brooklyn Historical Society) and
now (bottom, see page 125 inside, photo by Simon Clay)

The back cover shows Brooklyn Bridge today, photo by Simon Clay.

The back flap photographs show the Brooklyn Academy of Music then (left, see page
36 inside, photo courtesy of Brooklyn Historical Society) and now (right, see page 37
inside, photo by Simon Clay).

The photographs on pages 1 and 2 show Fulton Street looking west, circa 1958, then
(see page 26) and now (see page 27).

INTRODUCTION

Brooklyn is the quintessential "old neighborhood." It's the place where Walt Whitman and Mae West walked cobblestone streets and rode trolley cars, where Woody Allen and Barbra Streisand ate hot dogs at Coney Island and cheered for the Brooklyn Dodgers at Ebbets Field.

Brooklyn's history is centuries old, older than the Dutch who settled there in the 1630s. It is as old as the Native Americans who lived there for thousands of years and whose language, mixed with Dutch and English, lives on in the names of Brooklyn neighborhoods, buildings, and streets. In the relatively modern images of nineteenth-century photography, however, Brooklyn is not as old as it would seem. *Brooklyn Then and Now* reveals some unexpected impressions of this dynamic era. One of the most surprising is how very new Brooklyn looks in its first century as a city.

Chartered in 1834, the City of Brooklyn was originally one of six towns established by Dutch and British settlers in the seventeenth century. The new city expanded by taking over the five more rural towns one by one. The march of development unfolds on the pages of this book in photos of mansions, grand hotels, and suburbs that rose on farmland and the oceanfront.

Photographed in their first years of development, these "old" neighborhoods and even their parks are starkly new. Not surprisingly, tall buildings and cars line many of these streets in the contemporary photos. Yet, contrary to the usual image of urbanization, Brooklyn's streetscape, even downtown, now shows a softer edge of full-grown trees.

The photos of Brooklyn as a young city reveal its climb toward civic recognition. City Hall (1848), the first Academy of Music (1861), Prospect Park (1873), and the greatest achievement of all—the Brooklyn Bridge (1883)—established Brooklyn's reputation and power. Brooklyn was a city with a keen sense of itself. Among the four boroughs that consolidated with Manhattan to form New York City in 1898, it was the only one with its own history as an independent city. It seems that it never got used to the idea of being part of something bigger than itself. Even after consolidation, Brooklyn kept building grand places and institutions, including the Brooklyn Museum of Art, the Brooklyn Public Library, and the Brooklyn Botanic Garden, imbuing them with its own identity and civic pride.

The city grew, fueled by shipping and industry. With enough room on its waterfront to rival crowded Manhattan, Brooklyn built miles of warehouses and piers, and became the heart of the Port of New York, handling more than half of the port's cargo. Linked to Manhattan by dozens of ferry lines, and by 1909, by three East River bridges, Brooklyn became a transportation hub and one of the nation's largest industrial centers.

When Walt Whitman wrote *Crossing Brooklyn Ferry* in 1856, he described the "wild red and yellow light" of industrial smokestacks on Brooklyn's waterfront. By 1875, Brooklyn had fifty oil refineries, including the huge facility operated by John D. Rockefeller's Standard Oil. By 1890, Brooklyn had the largest sugar refinery in the world, the parent company of today's Domino Sugar. By the turn of the century, forty-five breweries were producing beer in Brooklyn, more than in any other city in the country. Hundreds of factories produced paper cartons, paint, shoes, soap, coffee bags, tin cans, and nearly every other product of daily life. Thousands of workers lived in Brooklyn's burgeoning neighborhoods, in row houses and tenements. Many industrialists also made their homes here in magnificent mansions and country retreats. In the early 1920s, when Brooklyn led the nation in housing construction, middle-class families found affordable homes in new neighborhoods springing up in the farther reaches of the borough.

The archival photos record Brooklyn's great places, including many that were lost in the twentieth century. Fires destroyed the first Academy of Music and some of Coney Island's pleasure palaces. A sea change in industrial technology and the U.S. economy after World War II made the old shipping terminals and factories obsolete. The Brooklyn Navy Yard, after 165 years of operation, shut down in 1966. Even the Brooklyn Dodgers left. More recent events are also evident. Several photos taken from the Brooklyn waterfront, just two weeks before the attack on the World Trade Center, are now poignant reminders of a tragic change in the Manhattan skyline.

At the same time, this book presents a picture of lasting history and new growth. Community groups carrying on Brooklyn's civic spirit have saved many historic buildings, and even some of Coney Island's famous rides. In the 1960s, Brooklyn Heights became New York City's first landmark district, and Bedford-Stuyvesant, the largest African-American community in the country, also preserved block after block of its Victorian homes. New housing, modern office buildings, a new baseball stadium, and the reconstruction of bridges and roadways also demonstrate the never-ending process of a city rebuilding itself.

The City of Brooklyn began with fewer than 16,000 residents. When it merged with Manhattan in 1898, the number of people in Brooklyn alone was 1.2 million. Half a century later, Brooklyn's population was 2.7 million. Promoted as Manhattan's first suburb in the early 1800s, Brooklyn lost many residents to new suburbs built beyond New York City after World War II. At 2.3 million, it is still the fourth largest city in the U.S., more populous than Boston, San Francisco, Atlanta, and St. Louis combined. From the beginning, Brooklynites were a mix of nationalities whose numbers and diversity grew along with the new city. Today, multicultural communities of new immigrants and long-time residents are reinvigorating the old neighborhoods, increasing Brooklyn's population and vitality once again.

Brooklyn Bridge and waterfront, from Manhattan, 1904. The Brooklyn Bridge had opened more than twenty years before this photo was taken, yet ferries were still taking people across the East River and would continue to do so for another two decades. A ferryboat has just left Brooklyn's Fulton Ferry Terminal and another can be seen at the dock near the bridge tower (left). A wall of warehouses and piers stretches along the riverfront (right). Ships calling here unloaded cargo directly into the warehouses and avoided hauling crates through crowded streets. Brooklyn had so many of these warehouses that it was called "the walled city."

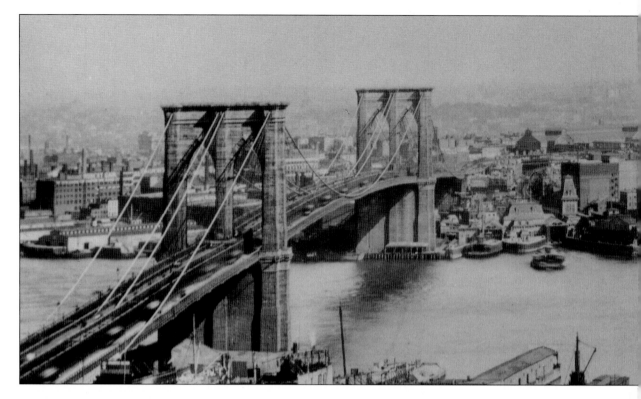

Brooklyn's role as a great port ended after World War II and only a few ships now bring cargo here. Today, this section of the waterfront is a place for recreation. A sightseeing cruiser streams past the old ferry landing near the bridge tower (left). The wall of nineteenth-century warehouses is gone, and above it, an elevated highway topped by a tree-lined promenade (right) runs above the old piers.

In the future, the Brooklyn Bridge Park, a grand public space, will extend for more than a mile along the water's edge.

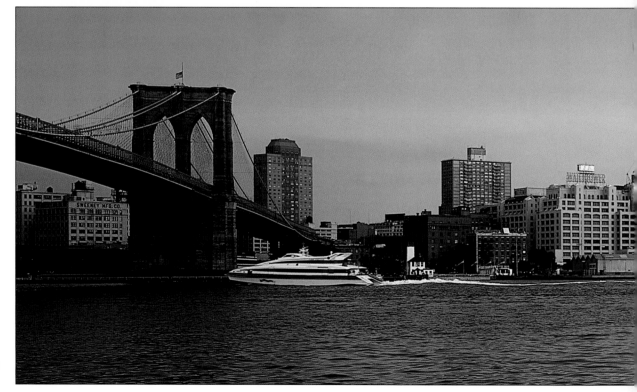

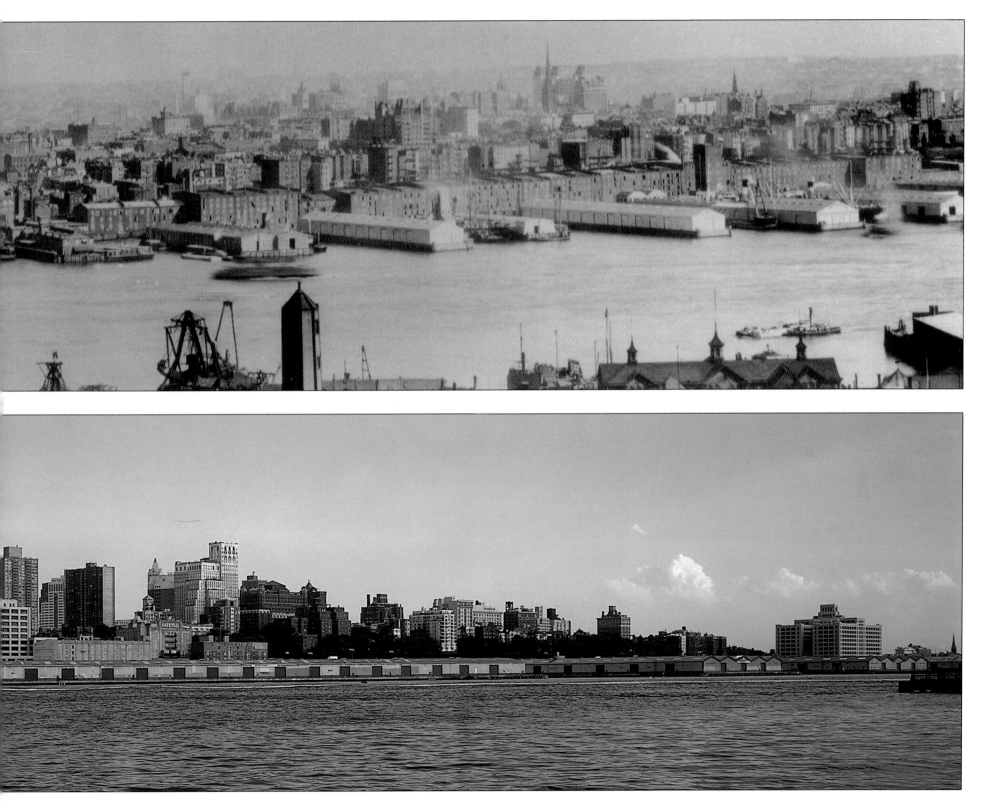

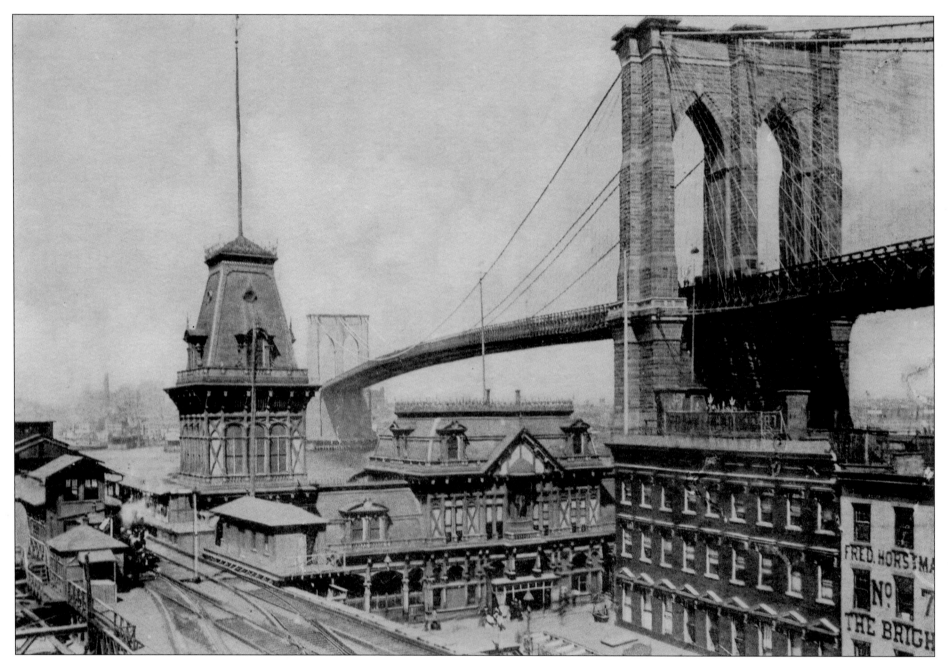

Foot of Old Fulton Street, 1904. With its pyramid roof tower and handsome facade, the Fulton Ferry Terminal looks almost as grand here as the Brooklyn Bridge. Built in 1865, the terminal was Brooklyn's gateway, the culmination of more than two centuries of ferry service to Manhattan. Yet, just a few years later, the bridge tower would rise next to the terminal. Although plans for the bridge were well known when the ferry operators began building the new terminal, they did not hesitate in going forward with an elaborate building.

They could not imagine Brooklyn without a ferry service, but the bridge, the first span over the East River, would change transportation beyond everyone's imagination. In the 1890s, an elevated train platform (far left) began bringing passengers to both the ferry terminal and the bridge. The ferry, subject to the vagaries of weather, was no match for the bridge. In 1924, ferries stopped running from Fulton Street. Two years later the grand terminal was demolished.

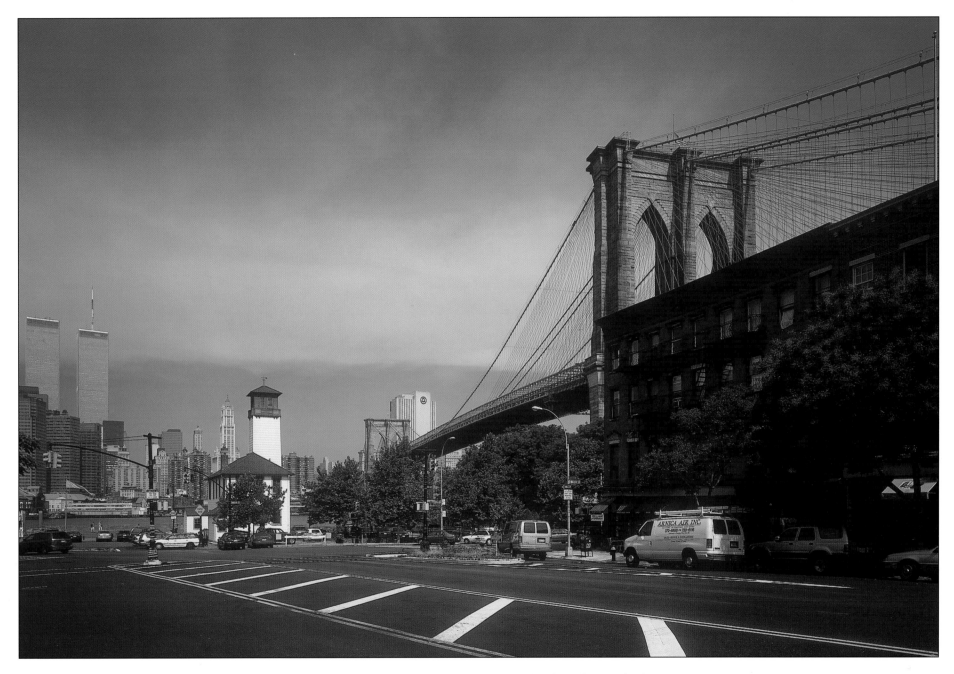

The little fireboat house at the end of Fulton Street replaced the ferry terminal in 1926. This broad street had been widened in 1835 to accommodate a dozen horsecar lines leading to the ferry. Once the ferries stopped running, the street became a backwater. Rediscovered in the 1970s, the area has become a sightseeing destination. The row of early nineteenth-century buildings (right), originally taverns and lodgings for ferry passengers, are now filled with popular restaurants. Without the large ferry terminal and the elevated trainline, the street is open to panoramic views of the East River and Manhattan skyline. This photo was taken just two weeks before the tragic attack on the World Trade Center towers (left) on September 11, 2001.

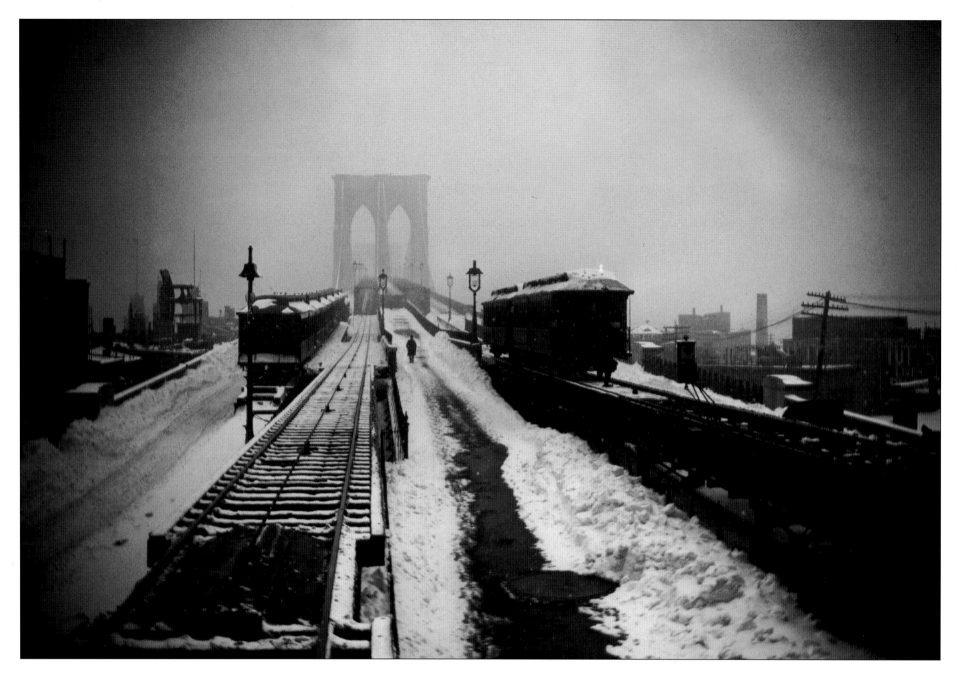

Brooklyn Bridge, 1888. Public demand for a bridge across the East River intensified during the winter of 1866–1867, when chunks of ice clogged the river and kept the ferries idle for weeks. Thousands of people, determined to get to the other side, walked across the frozen river. Construction of the bridge, a monumental undertaking, began in 1869 and took fourteen years to complete. Five years after it opened in 1883, the 1,595-foot-long span—the longest in the world at the time—was put to the test by the great blizzard of 1888. While the winds gusted up to eighty-four miles per hour, the span did not sway. The bridge cable cars, shown here, started running again a few days after the storm.

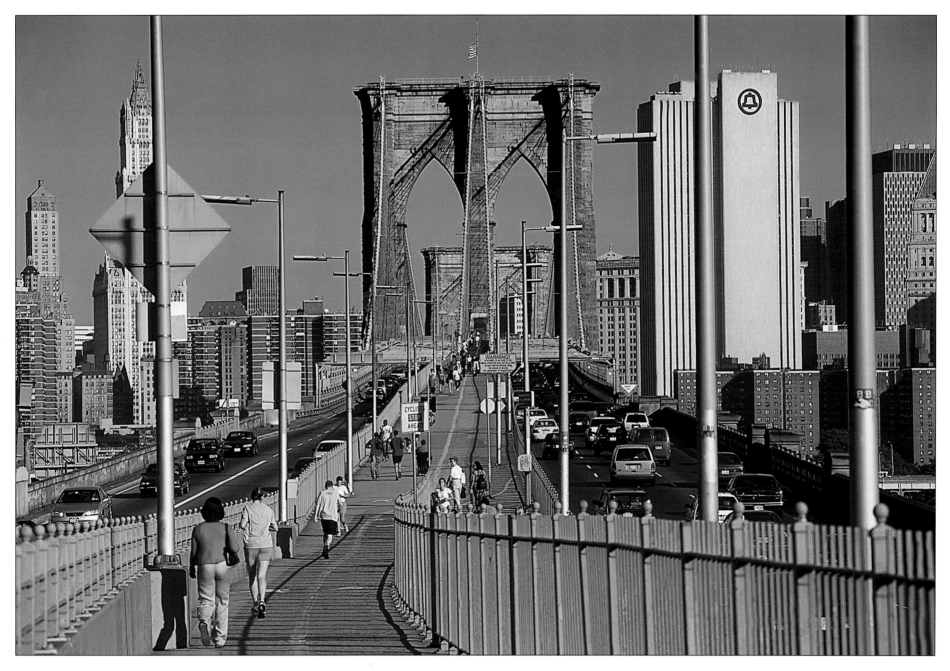

The cable cars are gone, replaced by auto traffic. People now walk over the bridge for the sheer pleasure of the view. The Manhattan backdrop is an eclectic mix of architecture, from the soaring Gothic spire of the Woolworth Building (left, behind bridge pole), completed in 1913, to the chunky functionalism of the Telephone Building (right), built in 1974.

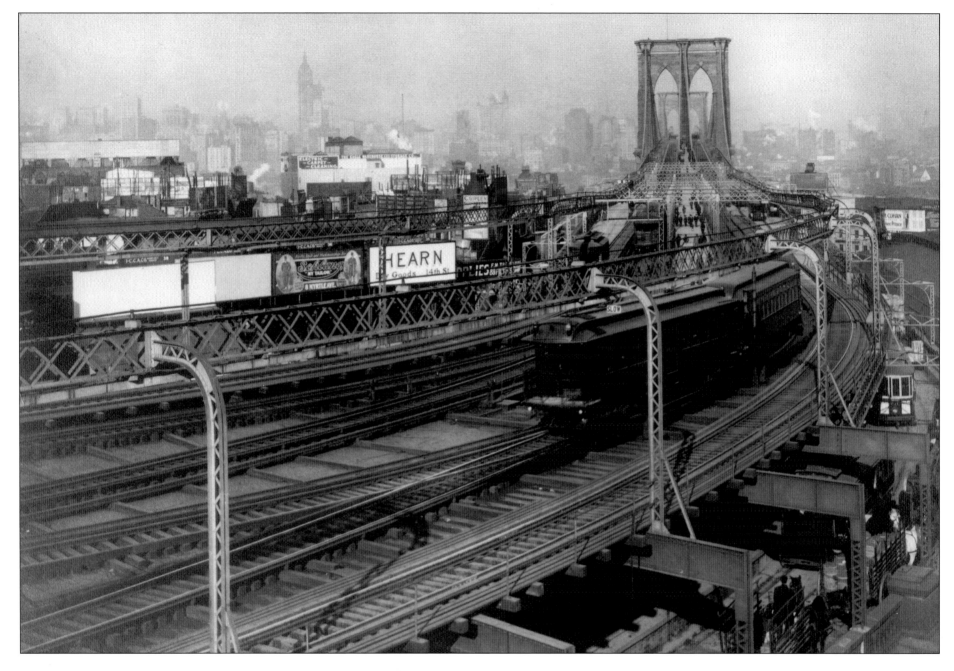

Brooklyn Bridge looking toward Manhattan, circa 1908. This was the year that trolleys replaced cable cars on the bridge. An endless wire cable had pulled the cars across the bridge, one car counterbalancing the other, as they climbed up and down the span. The trolleys in this photo are running on two levels, powered by electric wires carried in the overhead structures. The engines and furnaces generating the power were on the Brooklyn side. Horse-drawn wagons can still be seen on the lower level (right). Rising above the Manhattan skyline is the silhouette of the Singer Tower (left). Completed in 1908, the forty-seven-story building was the world's tallest at the time.

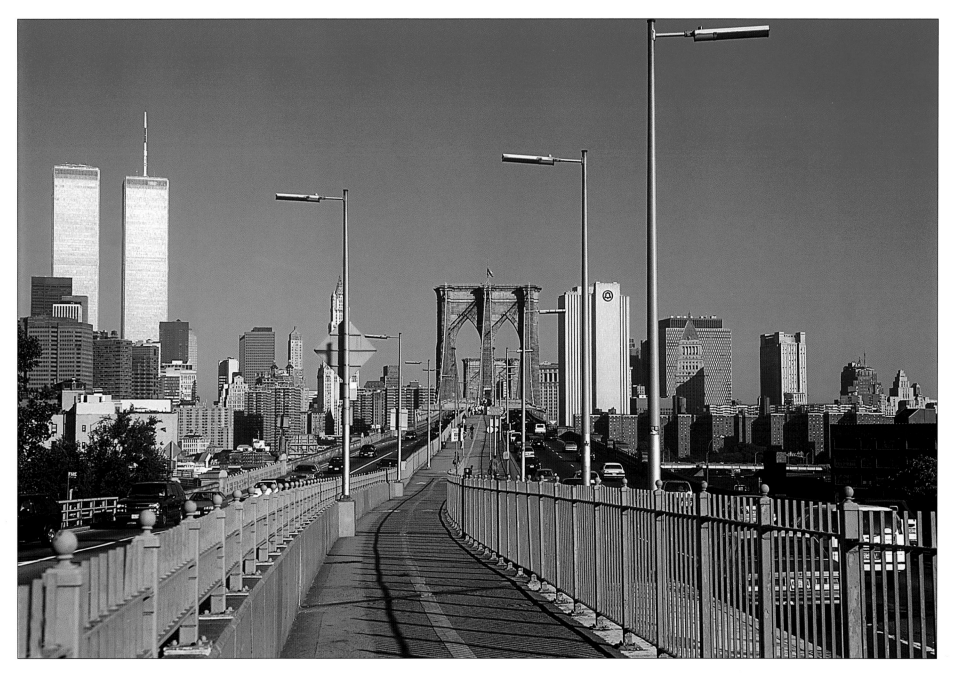

The approach to the bridge changed in the 1940s when construction of the Brooklyn-Queens Expressway replaced the trolley tracks and channeled cars directly onto the bridge. In Manhattan, near where the Singer Tower once rose, the World Trade Center towers still stand in this photo. The Singer Tower was torn down in the 1960s, at the same time that the World Trade towers were going up. After the catastrophic attack and collapse of the Trade Center, thousands of people fled Lower Manhattan, running across this bridge walkway.

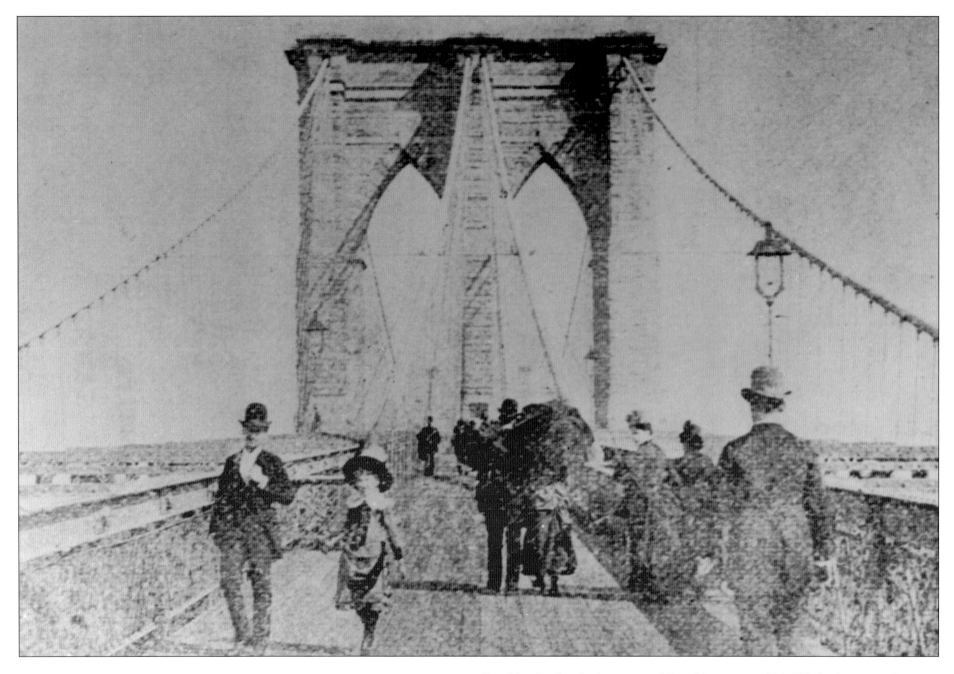

Brooklyn Bridge, looking toward Brooklyn, circa 1900. While these people seem to be enjoying their outing on the bridge, they may also be avoiding carfare. The price of a ride on the bridge cable car was five cents. To save money, many people walked instead, including thousands of workers who traveled each day between tenements in lower Manhattan and factories near the Brooklyn waterfront. Pedestrians paid a penny to cross the bridge, but they could buy books of twenty-five tickets for only a nickel each. By 1895, the walk was free.

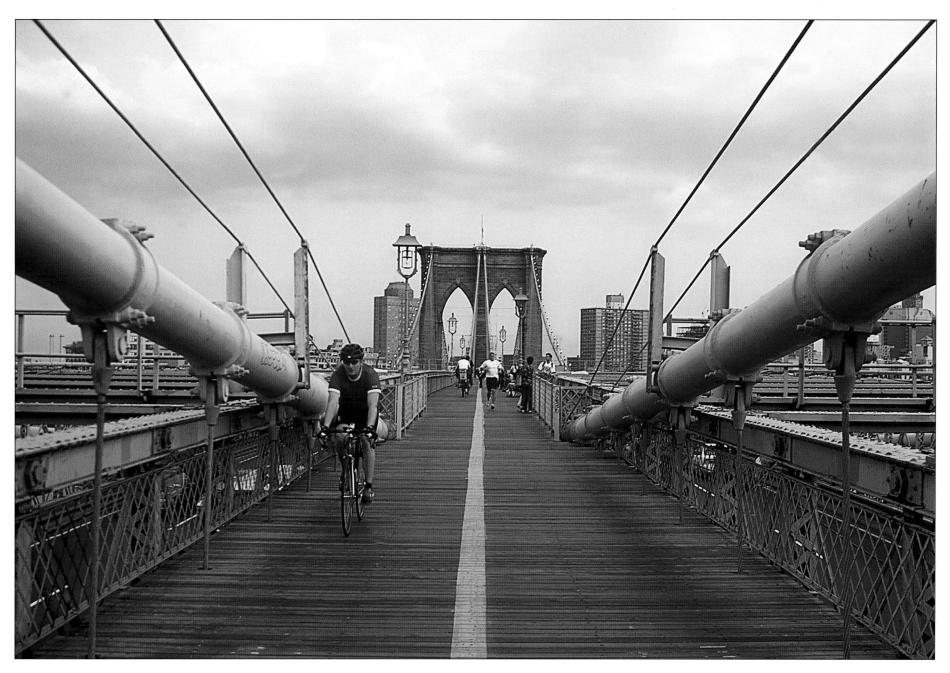

Staircases once interrupted the bridge walkway, creating a level path over the steep span of the bridge. Today, ramps make it easier for bicyclists to cross, but a painted line down the center of the walkway is needed to keep bike riders and walkers from bumping into each other. The lights on the walkway look just as they did when the Brooklyn Bridge opened and became the first bridge to have electric lights. The bridge towers were once the tallest structures in New York City. Now, tall buildings, even on the Brooklyn side, provide competition.

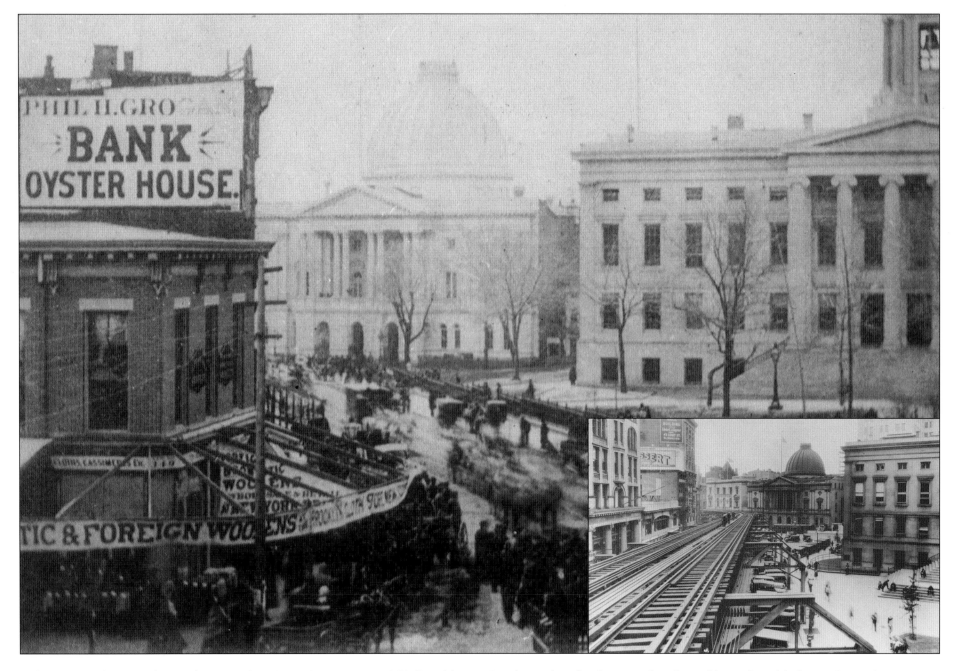

Fulton Street (now Cadman Plaza West) at Court Street, circa 1860. Brooklyn built its city hall (right) in 1848, turning this area into a busy government and court center. In this view, City Hall, topped by a cupola, dominates the street, as horse-drawn trolleys and pedestrians create a blur of traffic. The Kings County Courthouse (center), built in 1868, echoes City Hall's portico of Greek columns. The courthouse had a high Roman dome reminiscent of the Pantheon, but the feature is barely visible in this old photo. Oyster houses, like the one advertised on the side of a building (left), were a popular attraction at this time when fresh oysters were readily available from local waters. In the 1890s, an elevated rail line was built over Fulton Street, which intruded on the elegant architecture of City Hall and the courthouse (see inset).

In 1898, Brooklyn became part of Greater New York City and Brooklyn's City Hall became known as "Borough Hall." Over the next century, Borough Hall and its columned portico (far right) stayed much the same, while everything around the building completely changed. Fulton Street and the elevated no longer run through the area. The Kings County Courthouse and other nearby buildings are also gone, replaced in the 1940s by a complex of new court buildings and a plaza in front of Borough Hall. The cast-iron kiosk in the plaza (left of center) was added in 1990 as a wheelchair-accessible entrance to the subway station under the park.

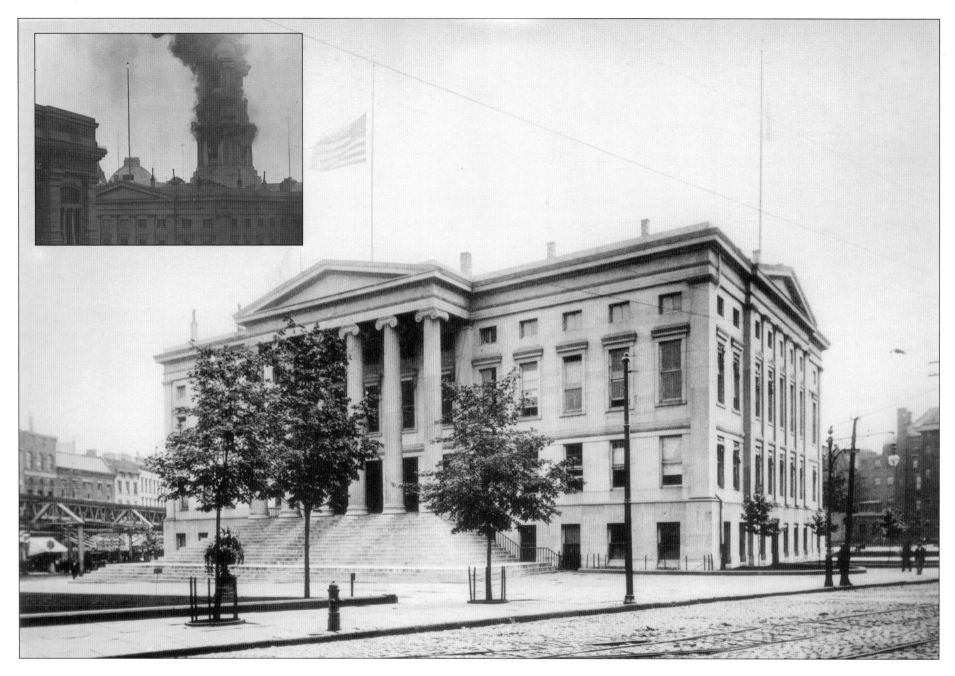

Court Street, circa 1896. A fire raged through the cupola on top of City Hall (Borough Hall) in 1895 (see inset). Although it looked like marble, the cupola was only wood, and its large bell, released by the fire, crashed through the roof and the two floors below to land in the entrance hall. After the fire, the top of the building was crowned only with a flag. Running past the building, Court Street is covered with cobblestones and trolley tracks. The newly constructed elevated on Fulton Street is also visible (far left).

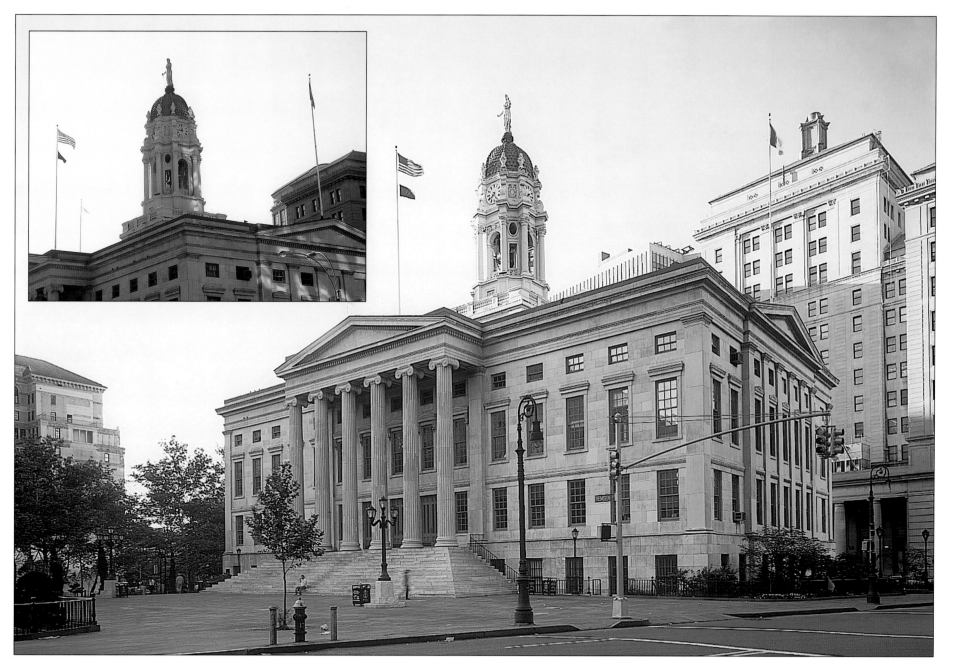

Borough Hall's new cupola, made of iron, has been in place since 1898. The entire building was restored in the 1980s. At that time, a crowning figure of justice, first planned in 1898, was finally placed on top of the cupola (see inset). Even though taller structures, like the Kings County Municipal Building, surround it, Borough Hall is once again a showcase in the downtown area.

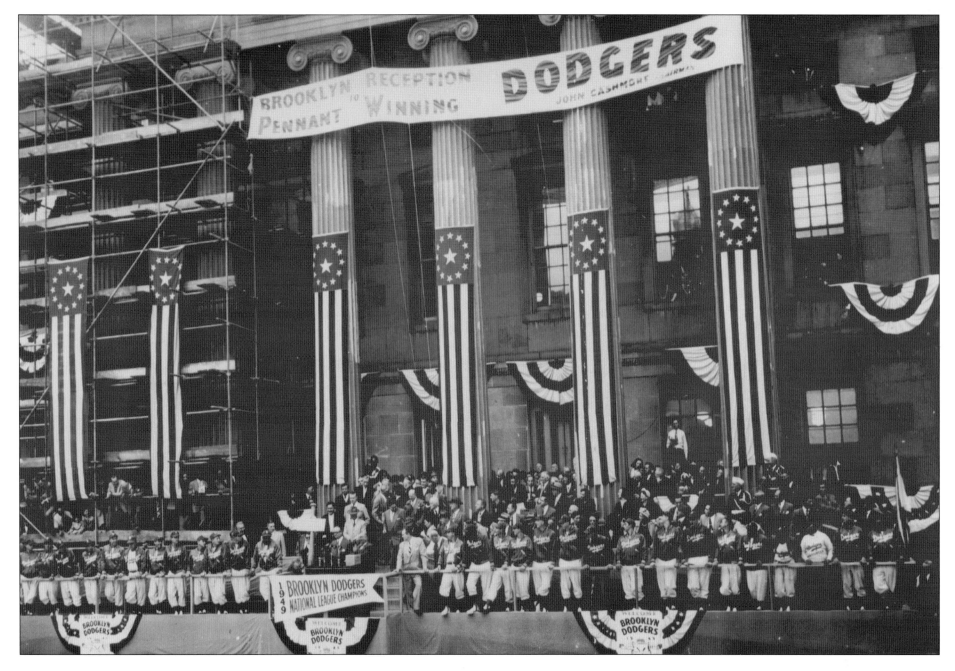

Borough Hall steps, 1949. In their golden years of the 1940s and 1950s, the Brooklyn Dodgers brought people together. Fans cheered for the team at Ebbets Field, cried together over losses, and turned out for celebrations like this one at Borough Hall. This gathering was just two years after Jackie Robinson joined the team, ending a ban against African-Americans that had been in effect in Major League Baseball for more than eighty years. Joining Robinson and the team at this celebration were two other African-American players who also became stars, Roy Campanella and Don Newcombe.

In 1957, the unthinkable happened—the Dodgers left Brooklyn for good. The team owner, Walter O'Malley, moved the club to Los Angeles. Since then, Borough Hall has never hosted another Major League Baseball celebration. The New York Yankees, of course, play in the Bronx, and while the New York Mets came on the scene in 1962, winning the hearts of many Brooklyn Dodgers fans, the Mets' home stadium is in Queens. Only time will tell if the Brooklyn Cyclones, the new minor league team that plays in Coney Island, will earn the right to celebrate on these steps.

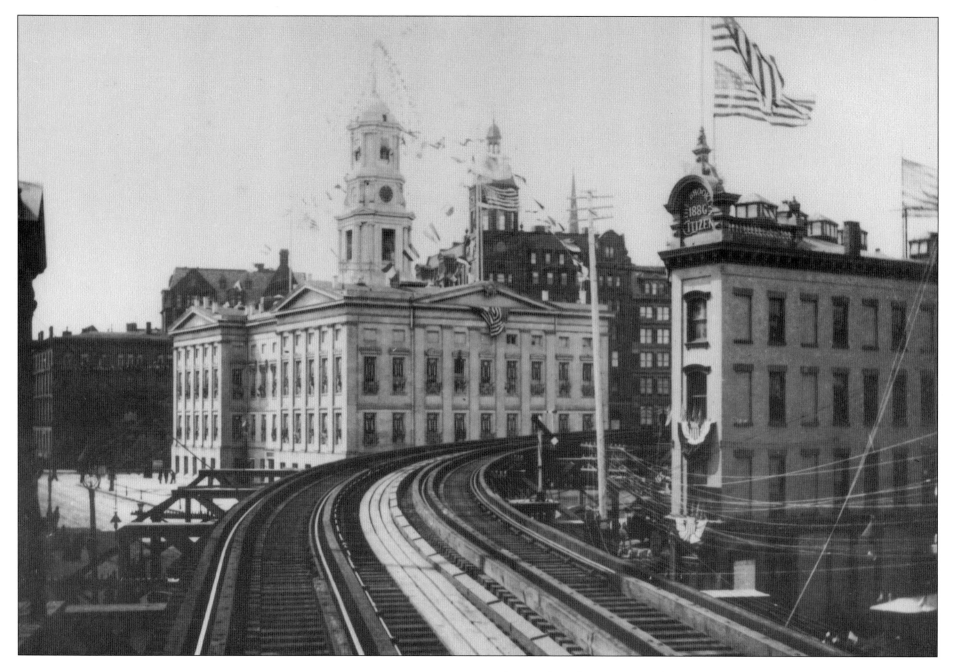

Fulton and Joralemon streets, looking toward Borough Hall, circa 1920. The elevated that wrapped itself around Borough Hall in the 1890s diminished the building's appearance but made the area a transportation hub. For the first time, people could travel by train without interruption from neighborhoods throughout Brooklyn to the government and commercial center at Borough Hall and on to the Brooklyn Bridge and Manhattan.

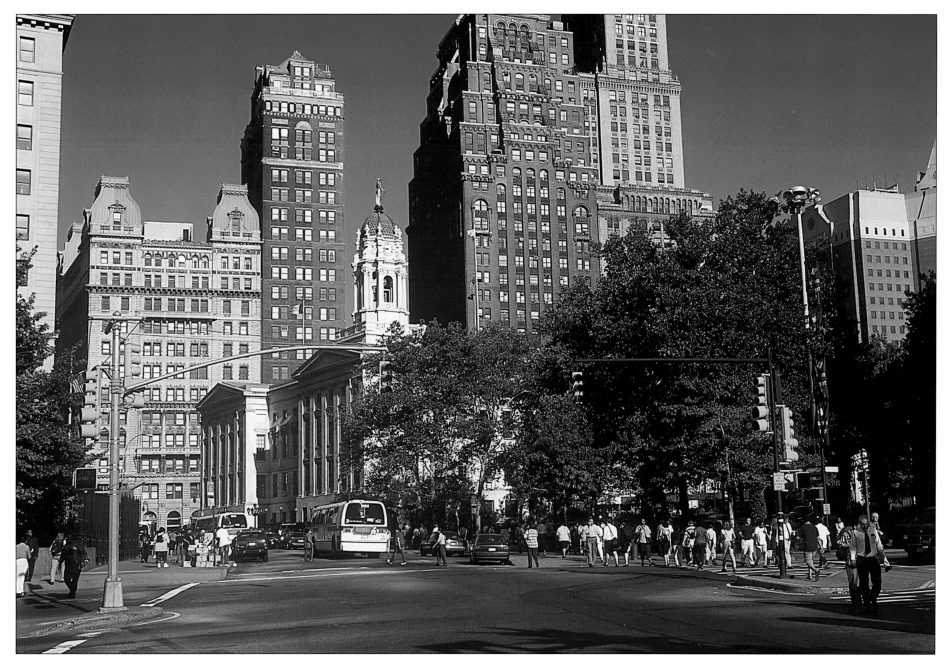

The elevated was a major presence in the downtown area for half a century, until it was replaced by the subway system and demolished in 1941. Today, office towers frame Borough Hall, and without the tracks overhead, light and trees fill the streets.

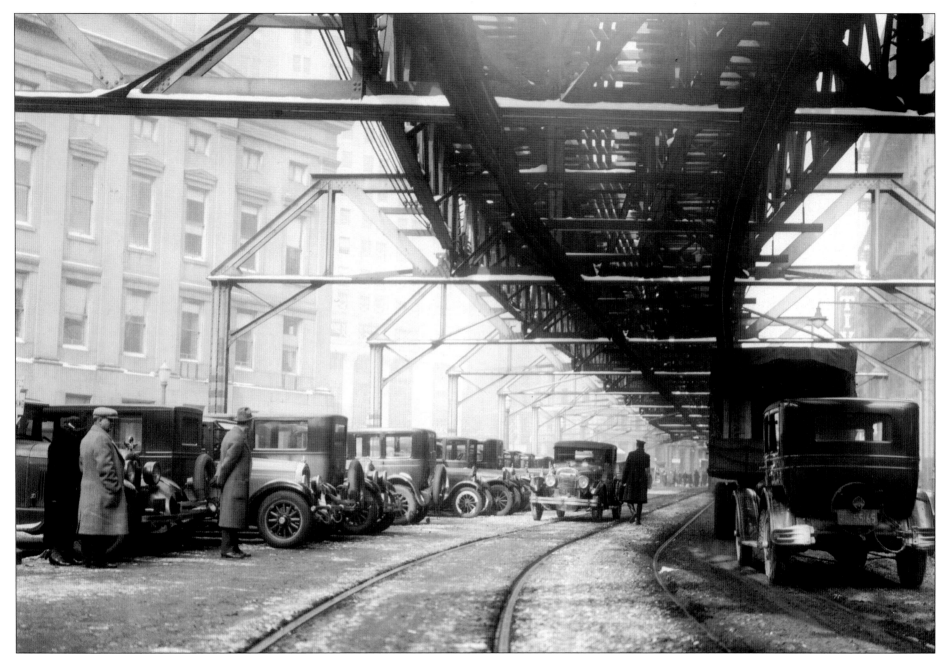

Fulton Street (Cadman Plaza West), near Joralemon Street, circa 1920. Under the shadows of the elevated, Fulton Street looks like a scene from a gangster film. But this section, which curved past Borough Hall (left), was simply a parking area. A policeman (center) seems to be directing a driver away from the path of the trolley tracks.

Without a trace of the elevated or the trolley, Cadman Plaza (off Joralemon Street) is a pleasant, tree-lined area. Borough Hall's restored facade is also much cleaner without the soot that once drifted down from the trains above.

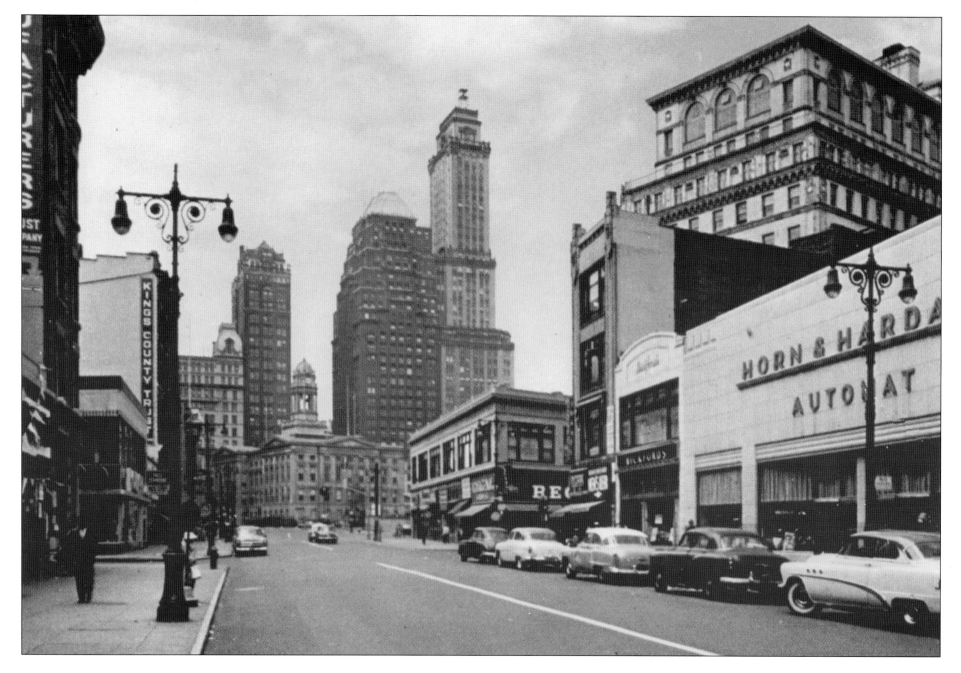

Fulton Street, looking west, circa 1958. The Horn & Hardardt Automat
(right) was a well-known chain of self-serve restaurants unique to New York
City at this time. The service was quick, but hardly automatic. Instead of
waiting on tables, the staff placed dishes of food into glass-door
compartments. Patrons put in the required coins to open the doors, much like
vending machines today.

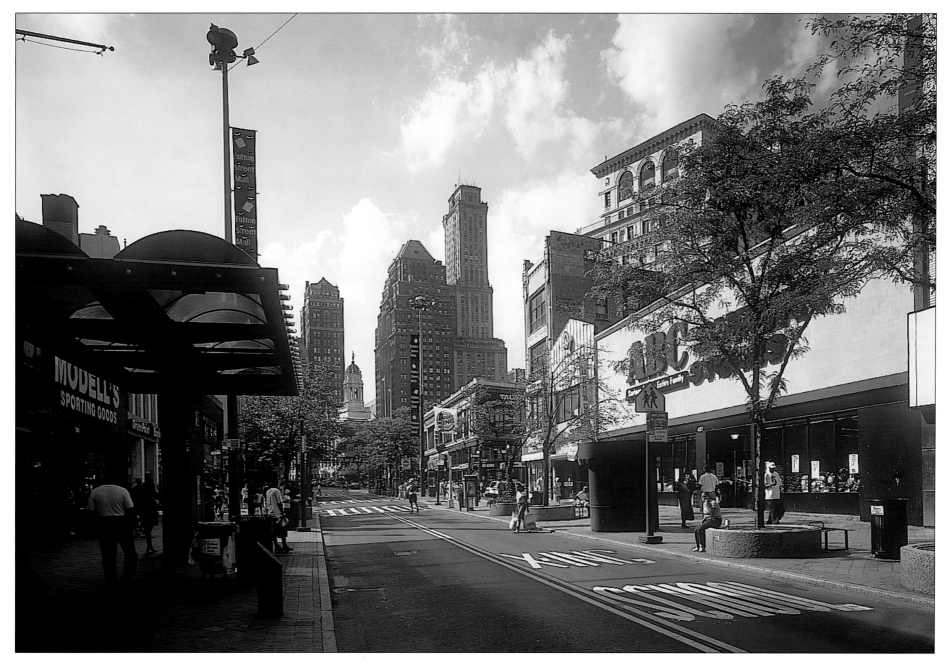

Nearly every building is the same in this current view. The former Horn & Hardart, which went out of business in the 1960s, has a new facade. The greater change is Fulton Street itself, now a pedestrian mall, closed to cars. The street is narrower and the sidewalks are wider, allowing more room for people and trees.

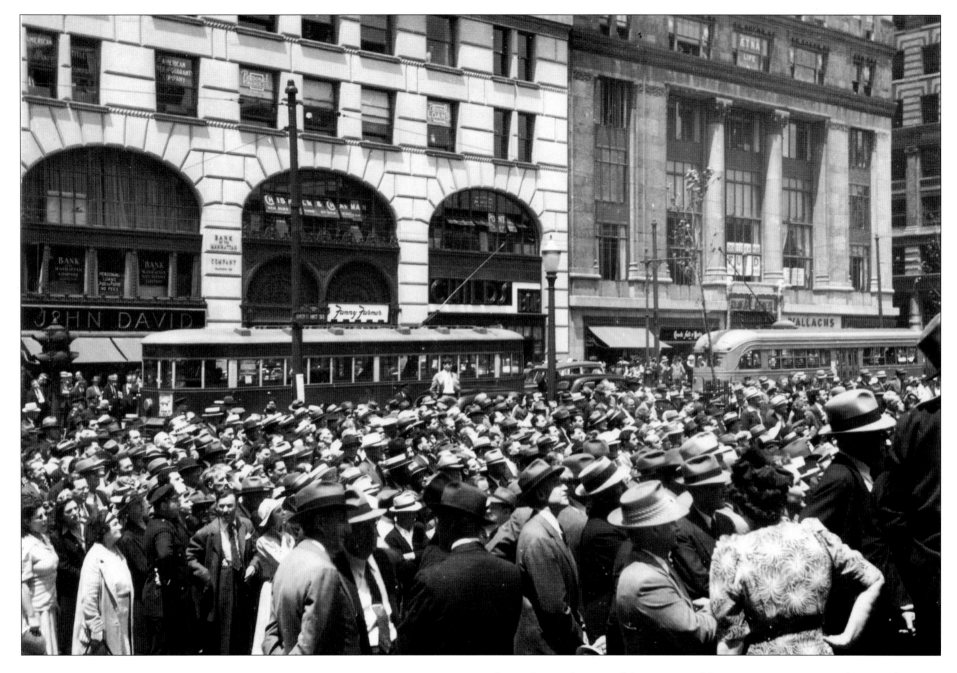

Court Street, between Montague and Remsen streets, 1941. The crowds are gathered here to celebrate the demolition of the elevated tracks on nearby Fulton Street. Typical of the times, everyone is properly attired in a business suit or dress.

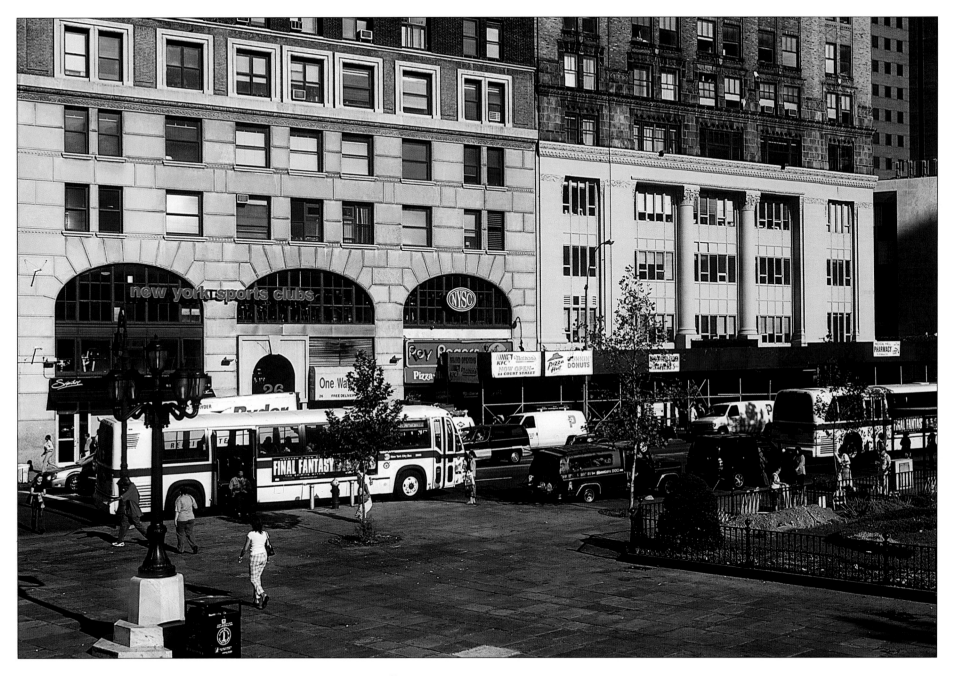

Sixty years later, the shops have changed, but the Court Street office buildings are just the same. Buses have replaced the trolleys, and in contrast to the earlier photo, no one wears a hat.

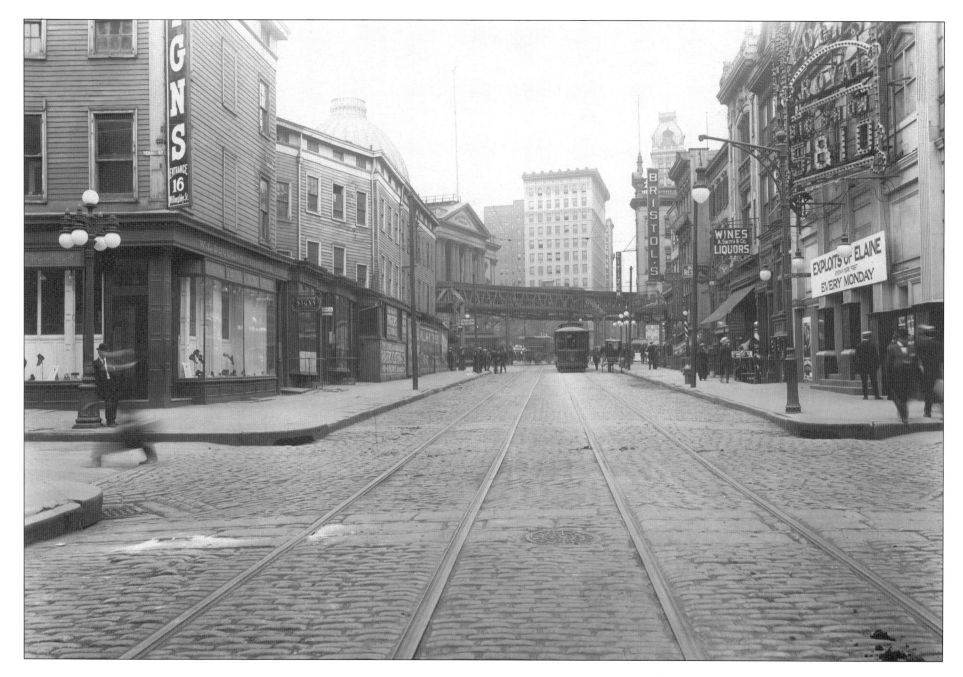

Willoughby Street, near Pearl Street, circa 1915. Cobblestone streets, trolley tracks, and wooden buildings characterized downtown Brooklyn in this era. At the end of the street, a trolley car moves along the tracks in front of the elevated trainline on Fulton Street. The dome and portico of the Kings County Courthouse (left) are visible just behind the elevated. Seemingly quiet, the street has signs of livelier activity. Under the Loews Royal Theater marquee (right), a sign advertises "Exploits of Elaine Every Monday."

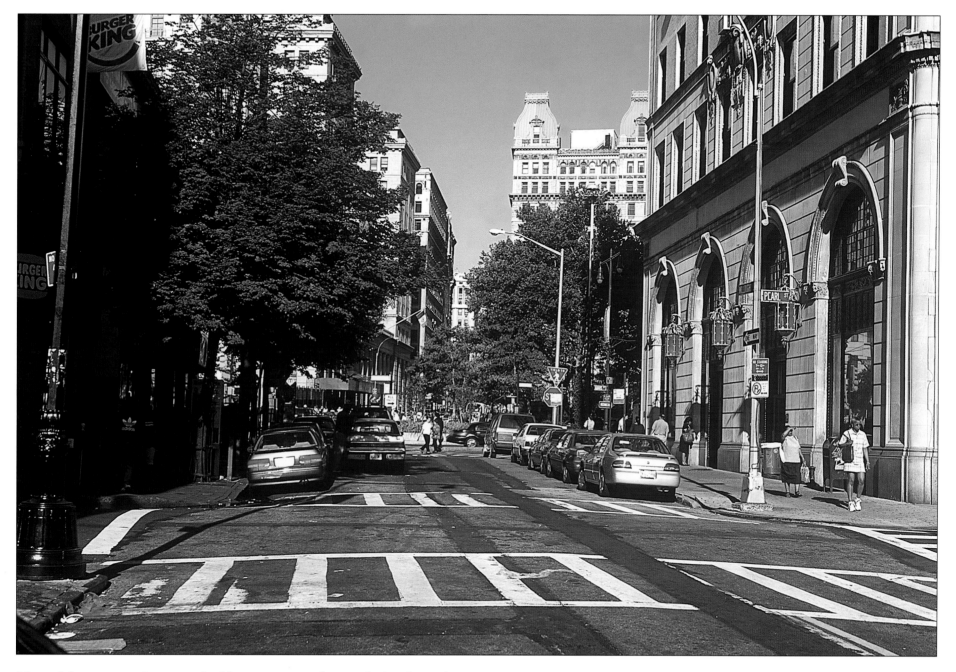

Most of the nineteenth-century buildings are gone, along with the elevated
and the trolley. Trees, rare on downtown streets a century ago, are now a
prominent feature.

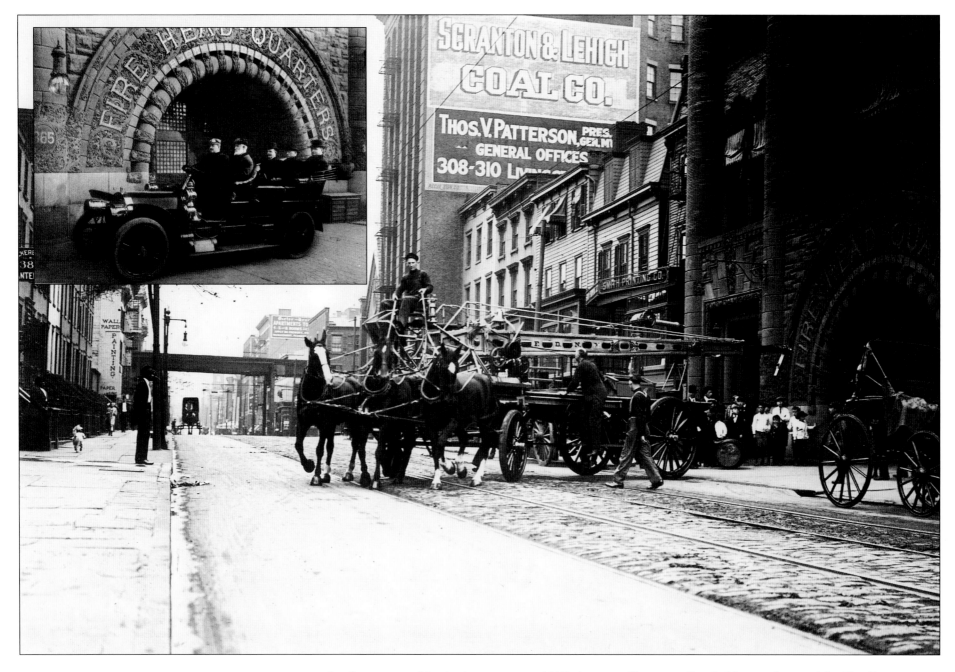

Jay Street, near Myrtle Avenue, circa 1915. A team of horses pulls a ladder truck out of the Fire Department Headquarters, as a group of local children watches from the street. While horses were used until 1922, fire department officials, like those photographed in front of the building's arched entrance in 1910 (see inset), traveled in the latest cars. For many years after it was built in 1892, the headquarters building was one of the tallest in the area and served as a watchtower for surrounding fires. The row houses on both sides of the street were built as homes, but they already show signs of transformation to commercial use. In the background, the elevated trainline runs along Myrtle Avenue. *From the Brian Merlis Collection (main image)*

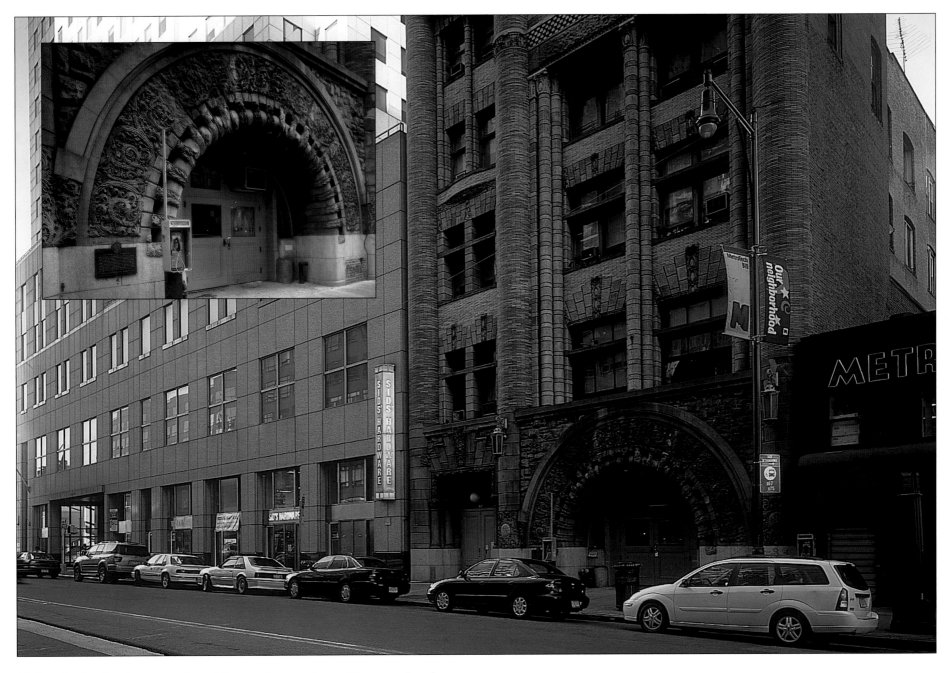

Today, the fire headquarters abuts Metrotech, a modern office complex that stretches across Myrtle Avenue. The rugged old building, no longer used by the fire department, is a city landmark, protected from demolition. The building is currently owned by the Black United Fund, a nonprofit organization that leases apartments in the upper floors and is creating a computer center in the ground floor space under the arch.

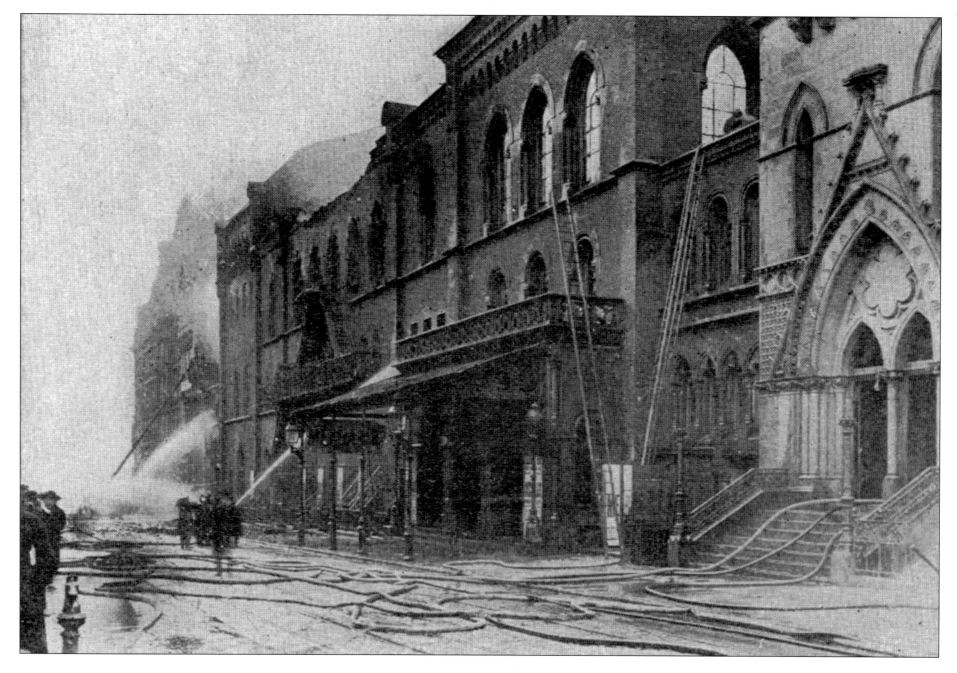

Montague Street, south side between Court and Clinton Streets, 1903. This devastating fire destroyed the Academy of Music (center building with marquee), which had been the focus of Brooklyn's cultural life. When it was built in 1861, the academy was hailed as a turning point in Brooklyn's civic reputation. Up until then, as the *New York Times* bluntly reported, "Brooklyn had been the worst appointed city in the North." Now it was no longer a provincial backwater. With the new academy, the *Times* proclaimed, "The tone of the entire city has been changed."

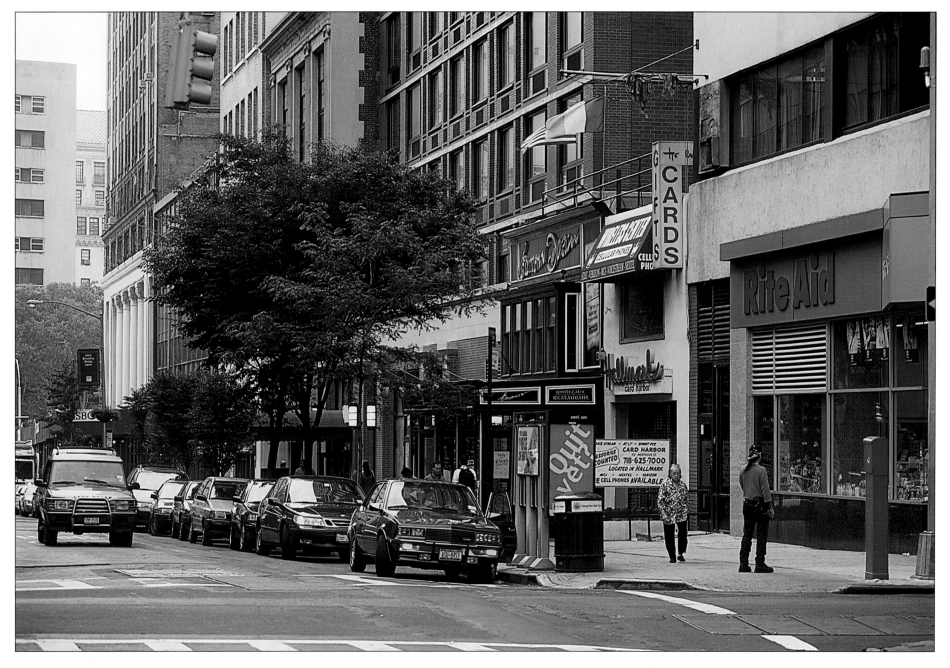

After the 1903 fire, a new Academy of Music was built about a mile away (see next page), and in time, all of the other institutions on this block also relocated. Although none of the buildings in the earlier photo exist today, Montague Street remains a busy commercial center of Brooklyn Heights, a landmark neighborhood that includes many other historic buildings.

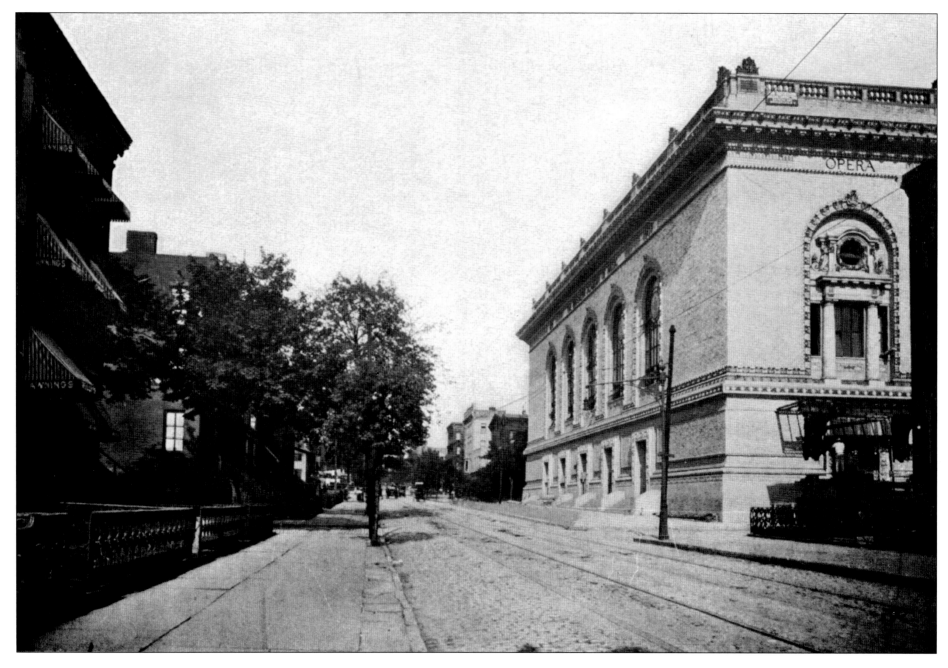

Lafayette Avenue, 1908. The loss of the original Academy of Music building in the fire of 1903 was a blow to Brooklyn's civic pride. Much larger than the first structure on Montague Street, this new building was designed to be more elaborate and complex. It contained an opera house, theater, lecture hall, and a large foyer used for balls and banquets. While Brooklyn civic leaders were trying to reestablish the city's cultural prominence, they revealed some provincial limitations. The new academy's richly ornamented interior included nude cherubs on the Opera House ceiling. The trustees asked the artist to add clothes, but when he protested, a compromise was reached and only the figures nearest the audience were changed.

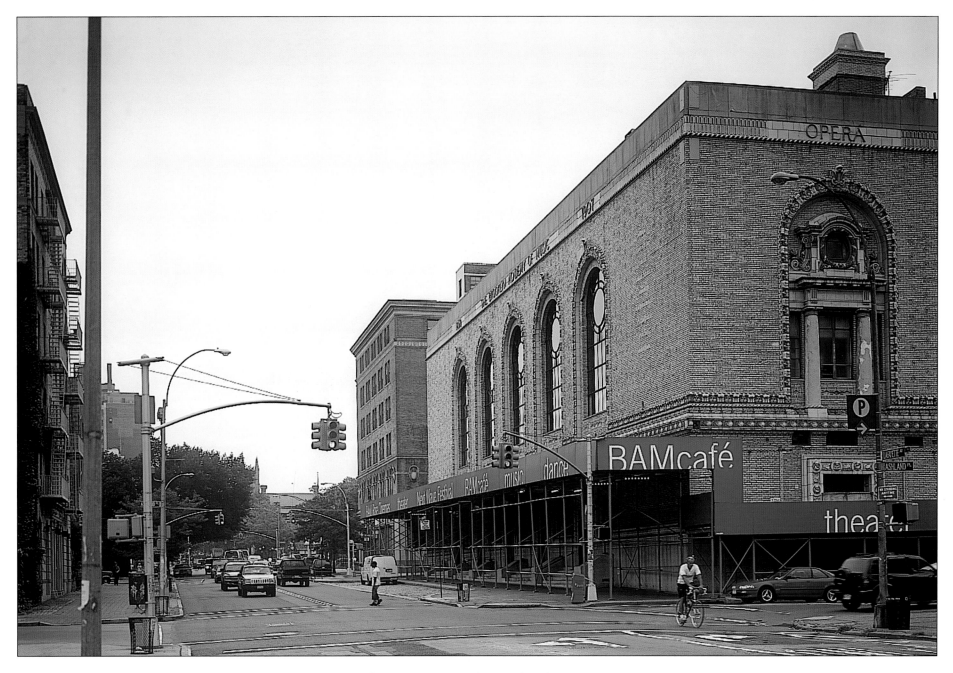

Over the past century, the Brooklyn Academy of Music, now known as "BAM," has made a few changes in its physical appearance. Without its former elaborate cornice, the building, according to the American Institute of Architects, "looks like the queen of England without a hat." But while BAM has lost a degree of architectural elegance, it has established a new reputation for the avant-garde. Once home to Sarah Bernhardt and Enrico Caruso, BAM is now a citywide center of new-wave dance, music, theater, and film. The exterior of the building is currently under restoration, and new studios and stages are in development in the surrounding area.

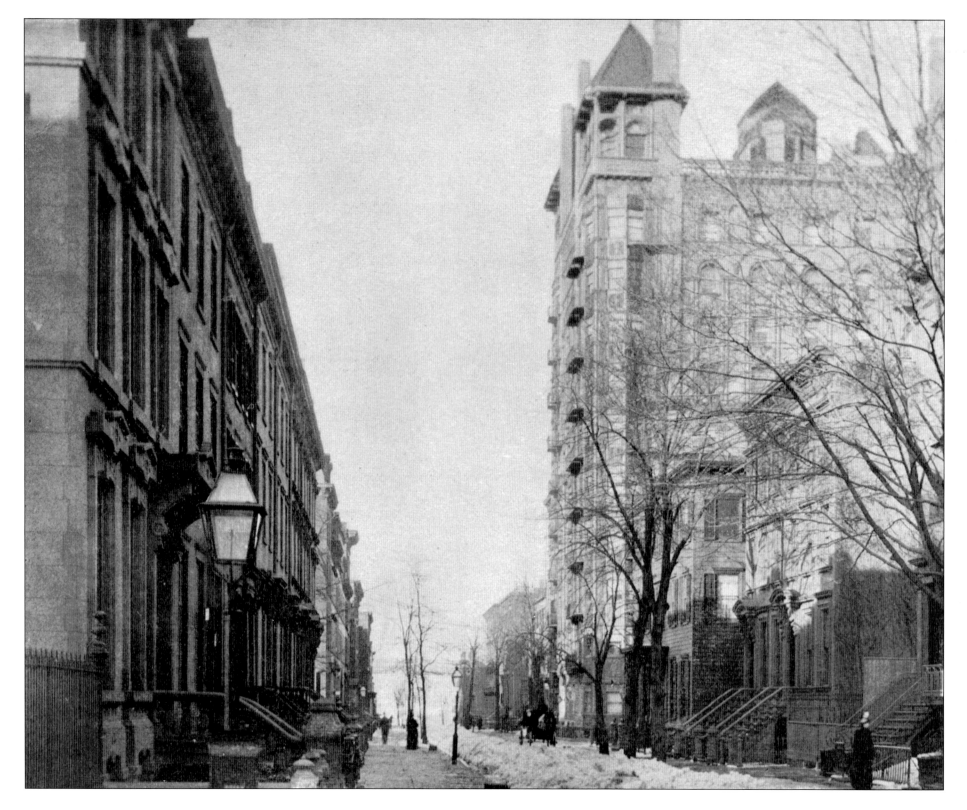

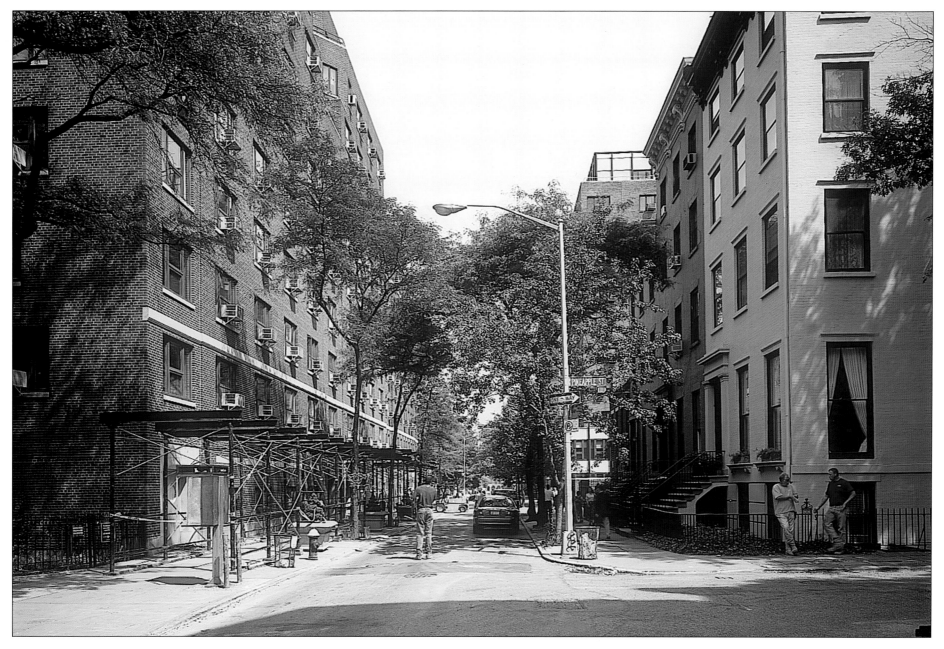

Left: Columbia Heights, between Pineapple and Orange streets, circa 1895. A premier street in Brooklyn Heights, Columbia Heights overlooked the East River. When the Hotel Margaret (right) was built there in 1889, it was one of Brooklyn's tallest structures, second only to the Brooklyn Bridge, and afforded the neighborhood's best waterfront views.

Above: The Hotel Margaret was being converted to apartments when it burned in 1980. The owner replaced it with a new apartment building,

obscured here by other modern buildings, which had already changed the character of this block. In the 1960s, many of the block's nineteenth-century row houses were replaced with architecturally undistinguished buildings. Community residents mounted a campaign to preserve the many other historic buildings in the neighborhood, and as a result, in 1965, Brooklyn Heights was designated New York City's first historic district. Today, dozens of these districts exist throughout the city, providing a legal barrier against the demolition of historic structures.

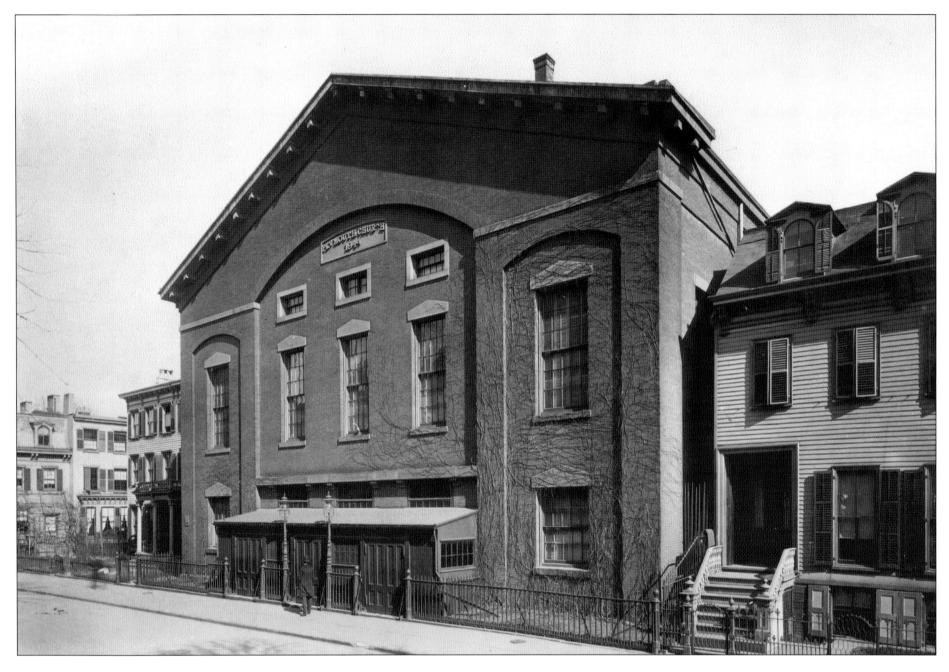

Orange Street, between Henry and Hicks streets, 1905. Before the Civil War, Plymouth Church was known as the "Grand Central Station of the Underground Railroad," a place where fugitive slaves were hidden and given support in their journey to freedom. The preacher, Henry Ward Beecher, was a dynamic abolitionist whose spellbinding sermons drew crowds to the church every Sunday, including notable figures such as Abraham Lincoln, Mark Twain, and Charles Dickens.

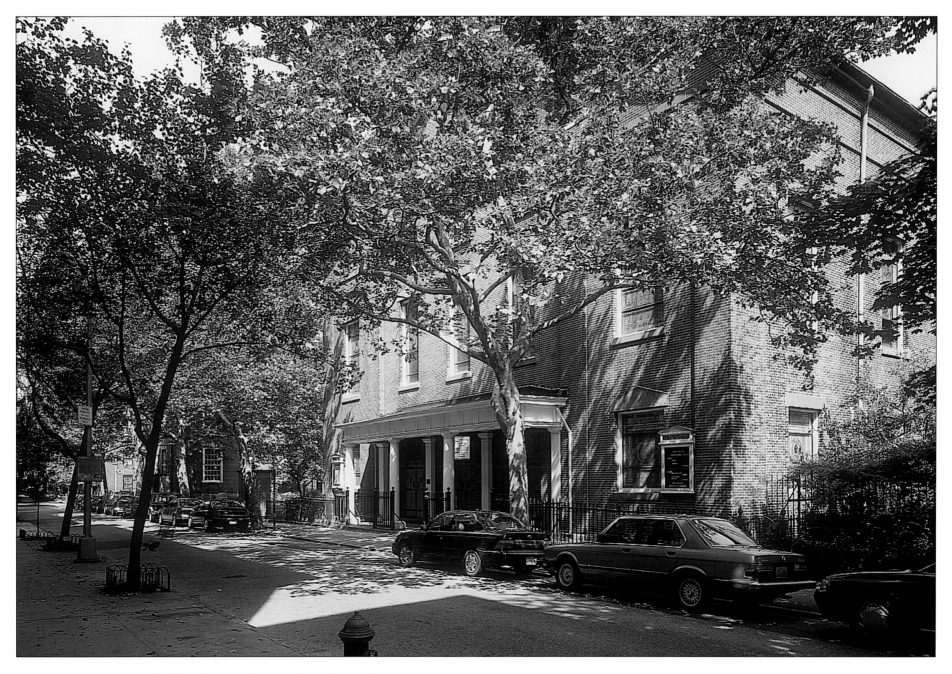

Like many celebrities, the church's preacher was the subject of controversy.
Accused of adultery with a member of his congregation, Henry Ward Beecher
endured a long, public trial after the Civil War. Although he was acquitted
of the charges, Beecher withdrew from public life. His sister, Harriet Beecher
Stowe, the author of *Uncle Tom's Cabin,* is much better known today. On
this quiet, tree-lined street, the simple church building belies Beecher's
stormy history.

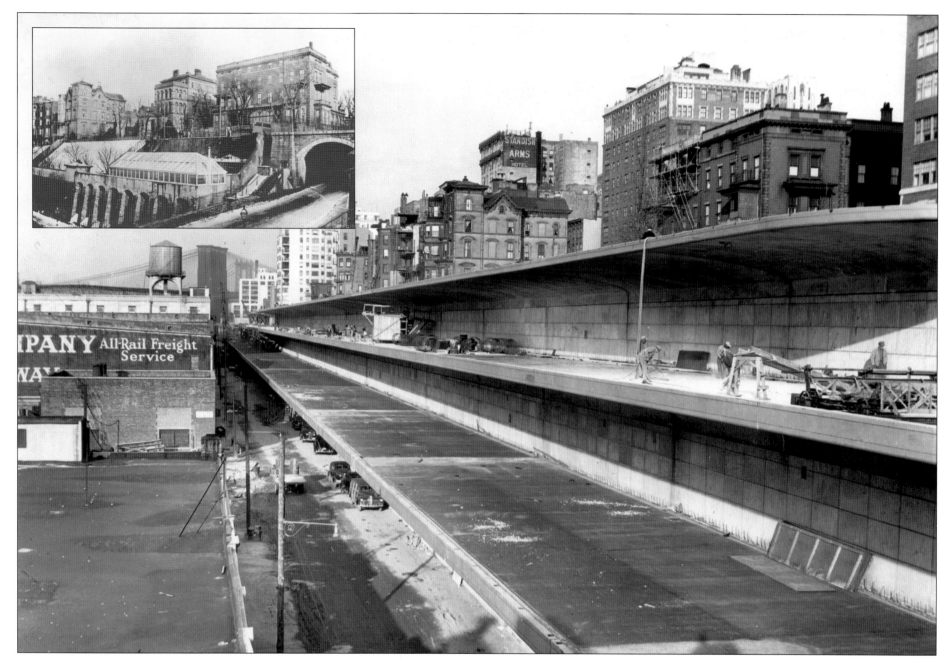

Montague Terrace, circa 1900 (see inset). Overlooking the East River and a short ferry ride from Manhattan, Brooklyn Heights became New York City's first suburb in the early 1800s. Its developer, Hezekiah Pierrepont, wanted to build a promenade along this bluff where people would be able to stroll and enjoy views of New York Harbor. But his affluent neighbors, afraid of losing their privacy, persuaded Pierrepont to give up the project. His son, Henry Pierrepont, who lived in a mansion here (inset, center), ran the powerful Union Ferry Company. It controlled all Brooklyn ferries to Manhattan and created a line to Wall Street that local residents reached by walking down Montague Street, through the arched viaduct (inset, right) to the waterfront. Less profitable than the one from Fulton Street, the ferry at Montague Street ran at a loss so that the Brooklyn Heights gentry could avoid the commoners. "All the gentlemen went to their business that way," a resident observed, and the boats "were as full of friends as a drawing-room at an afternoon tea."

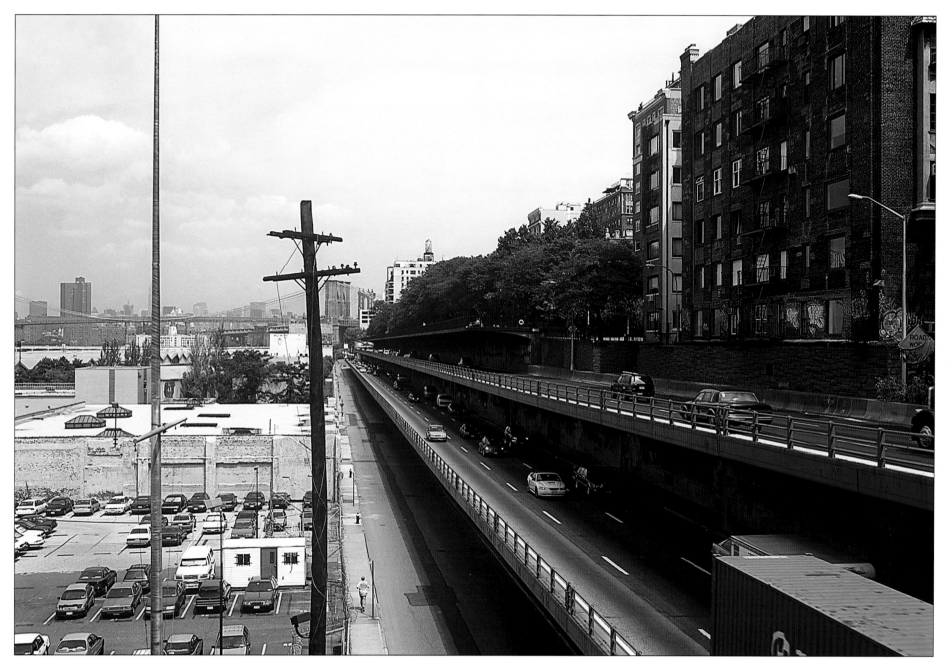

In the 1940s, Robert Moses, New York City's great builder of parks and highways, plowed expressways through many neighborhoods. But the citizens of Brooklyn Heights were influential enough to strike a better deal. They persuaded Moses to run the Brooklyn-Queens Expressway around, not through, the neighborhood with a double roadway extending off the edge of the Heights. At left is the roadway in construction in 1948. Moses carried out

Hezekiah Pierrepont's century-old plan when he topped off the roadway with a public promenade. This walkway begins under the thick line of trees above the upper roadway (center). The area below the roadway, once a shipping terminal and now filled with parked cars, will be incorporated in the Brooklyn Bridge Park as it is built along the riverfront. The bridge is visible in the distance (left).

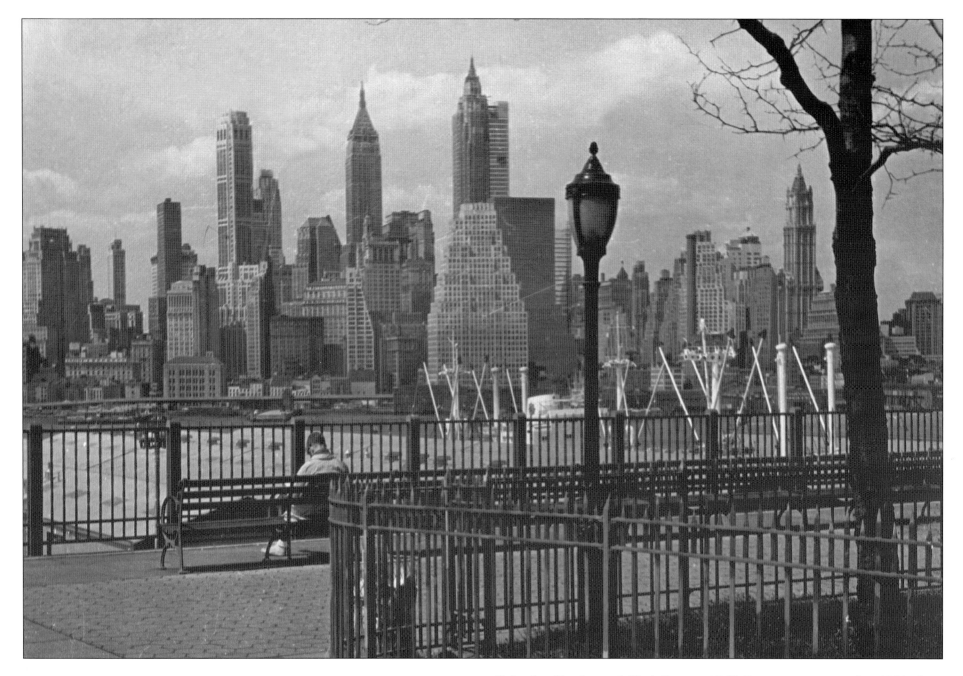

Columbia Heights and Clark Streets, 1965. Ever since it opened in 1951, the Brooklyn Heights Promenade has provided the city's best view of Lower Manhattan. At this time, the Singer Tower (center), built in 1908 by the Singer Sewing Machine Company, was still the tallest building in Lower Manhattan. Just a few years later, it would be remembered as one of the tallest buildings ever demolished, coming down to make way for even bigger skyscrapers.

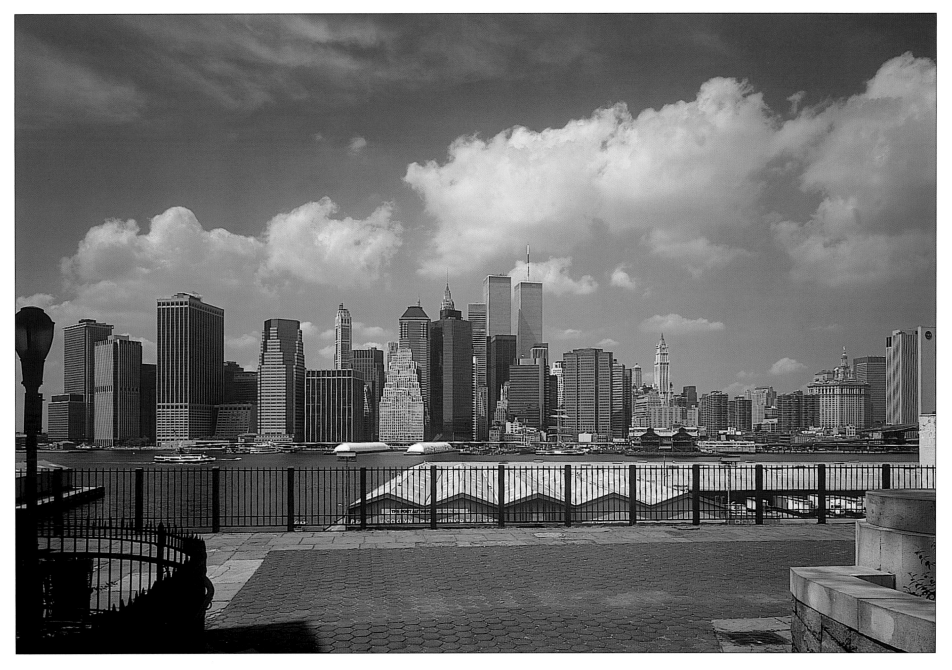

Buildings that towered above the skyline in 1965 are hemmed in here by newer, much bigger structures. But, on September 11, 2001, terrorists attacked the two tallest buildings on the skyline. Hundreds of people watched in horror from the promenade as the 110-story World Trade Center towers collapsed. In the days following the disaster, Brooklynites came here to stare at the gap in the skyline, leaving flowers, candles, and handwritten messages of grief and sympathy on the promenade fence and pavement.

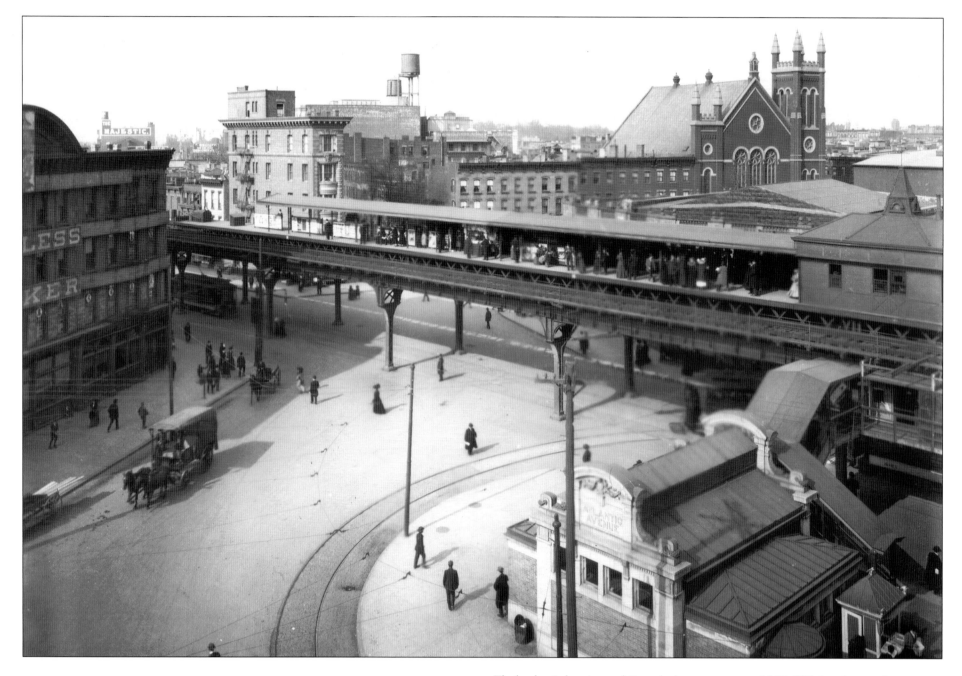

Flatbush, Atlantic, and Fourth Avenues, circa 1908. While a horse-drawn wagon moves down the street, this photo reveals the advent of more modern transportation facilities. The small Beaux Arts building (right) had just opened this year, marking the entrance to a new subway to Manhattan. The subway connected here with an elevated line that ran through Brooklyn and with the Long Island Railroad Terminal, the building behind the elevated platform (far right).

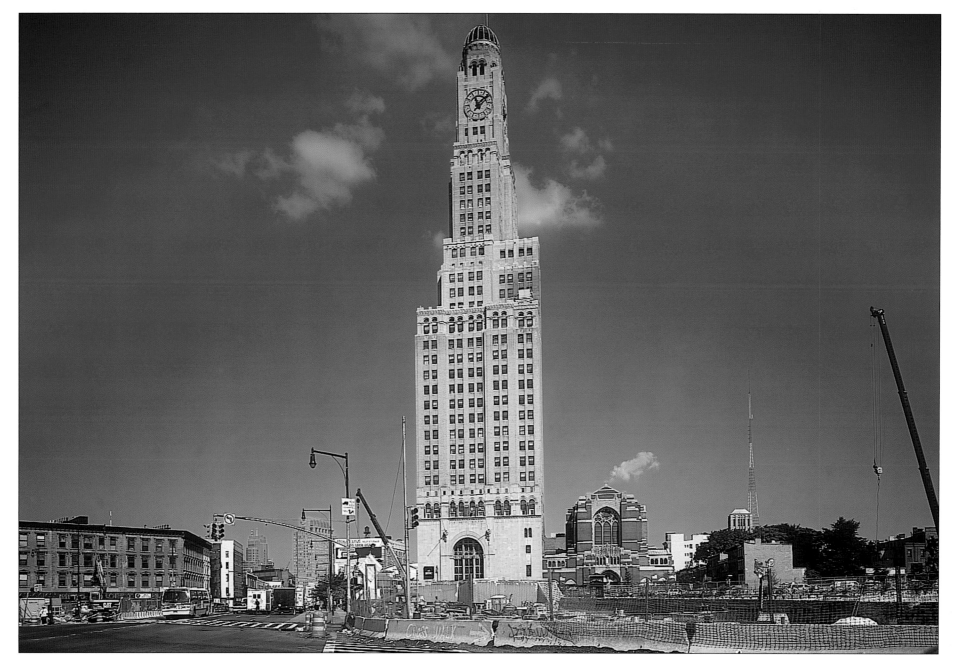

In 1929, the Williamsburgh Savings Bank Building rose above this intersection, dwarfing everything else around it. At 512 feet, the building is still Brooklyn's tallest and is also known for its monumental four-faced clock, visible from many parts of Brooklyn. While the Beaux Arts building is not in the photo, it still exists, but only as a newsstand. The subway and railroad connections still run underground, but the elevated and railroad terminal building are gone. A retail center is in construction on the old railroad terminal site.

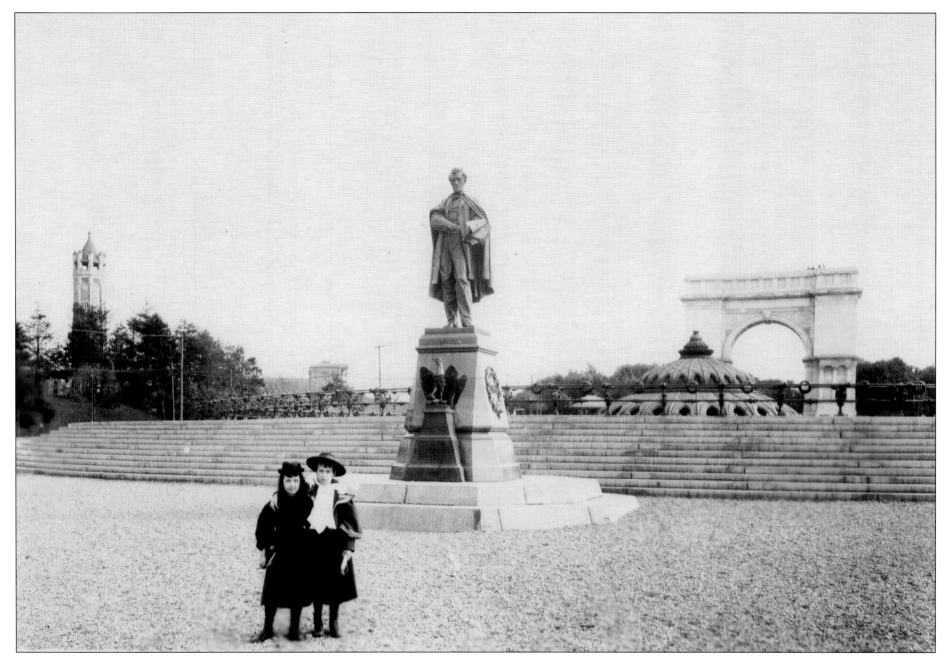

Eastern Parkway and Flatbush Avenue, circa 1892. The plaza was built in 1870 as the gateway to two other grand developments of that era, Prospect Park and Eastern Parkway. When this photo was taken, the arch in the background (right), the Soldiers and Sailors Monument, was brand new. The arch was built to honor Union forces that perished in the Civil War, and legendary Union General, William Tecumseh Sherman, laid the cornerstone in 1889. In this view, the arch does not have its crown of heroic sculpture, which would not be added until the end of the nineteenth century. The girls are posing in front of a statue of Abraham Lincoln. Between the statue and the arch is the cast-iron dome of a fountain that once spouted jets of water illuminated by colored lights. Three years later, the dome was razed for construction of an even more elaborate "electric fountain."

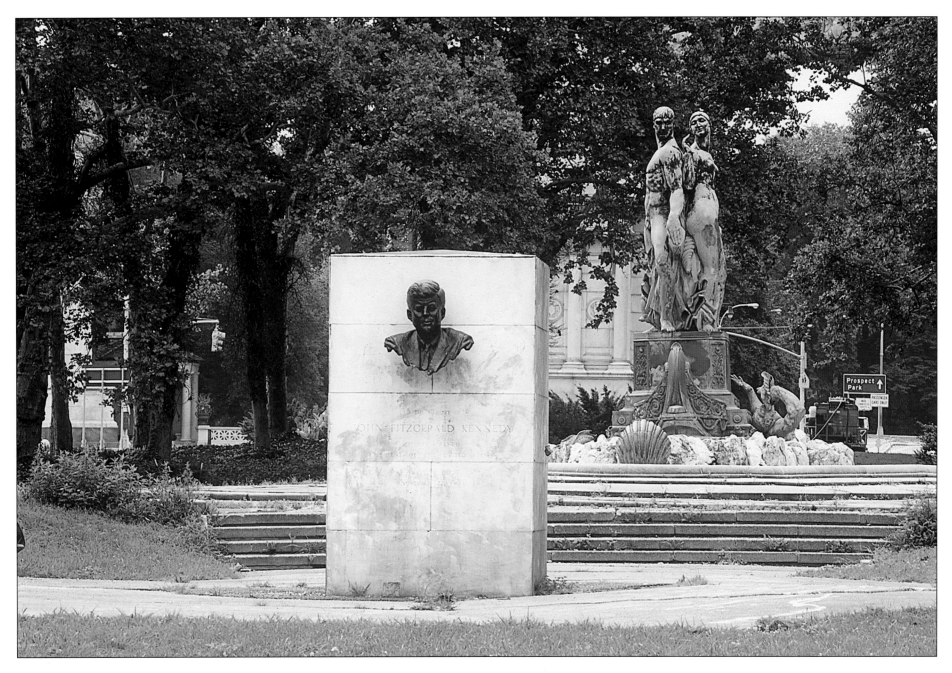

In the first decade of the twentieth century, subway construction under the plaza destroyed the plaza's electric fountain. Afterward, this space was simply a grass-filled oval until 1929, when the Bailey Fountain, this verdigris bronze group of Tritons and Neptunes, was built. The statue of Lincoln was moved to the park's concert grove in 1895; a monument honoring another assassinated president, John F. Kennedy, was installed in the plaza in 1965.

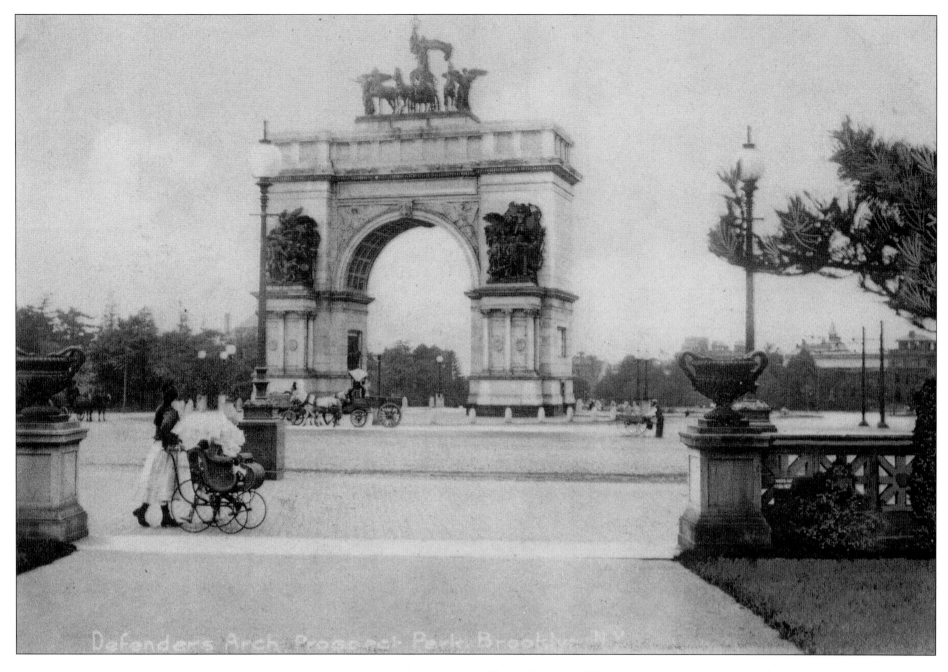

Union Street and Eastern Parkway, circa 1900. The woman pushing the baby carriage may be looking at the newly installed sculpture on the arch. On top is a chariot drawn by four horses, led by the allegorical figure of Victory raising her rod of triumph. Figures representing the Union Army and Navy stand on pedestals on the sides of the arch.

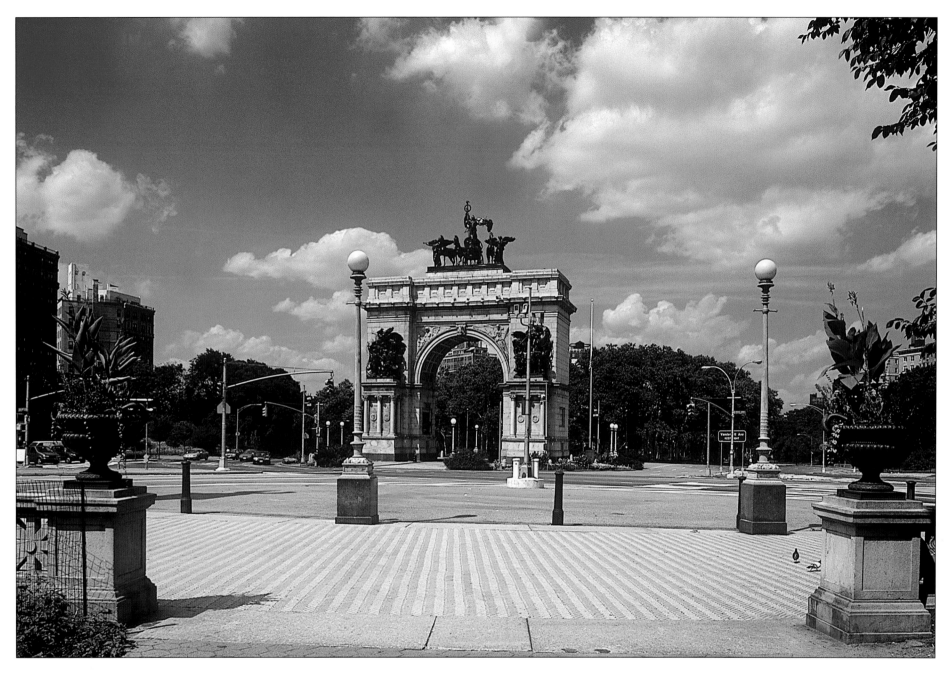

Corroded by pollution and pigeons over the years, the sculpture on top of the arch was taken down and restored in the 1980s. Today the arch is open for a few weeks each summer, allowing visitors to climb the interior staircase to the top and enjoy the 360-degree view of the surrounding area. The sidewalk paving, lights, and urns around the plaza were recently restored and look just as good—or even better—than they did a century ago.

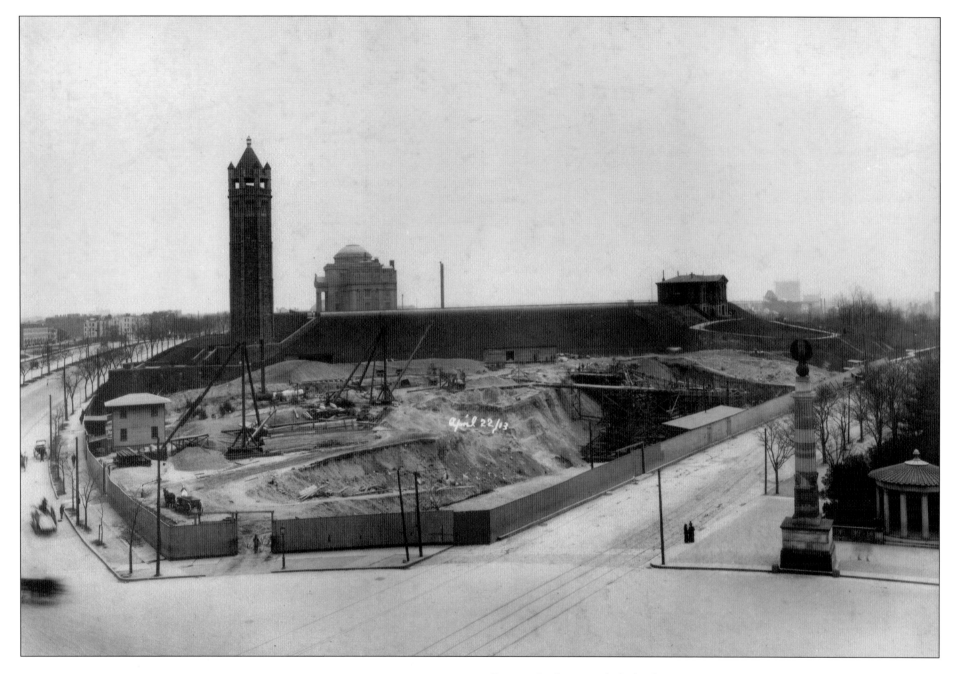

Eastern Parkway and Flatbush Avenue, 1913. The library that first rose on this site was a classical building that never reached completion. Its original design was not unlike that of the Brooklyn Museum, the domed building in the background (center). Begun in 1913, the library ran out of construction funds and was still an unfinished shell by the 1930s. Behind the construction site is the Mount Prospect Water Tower (left) and reservoir.

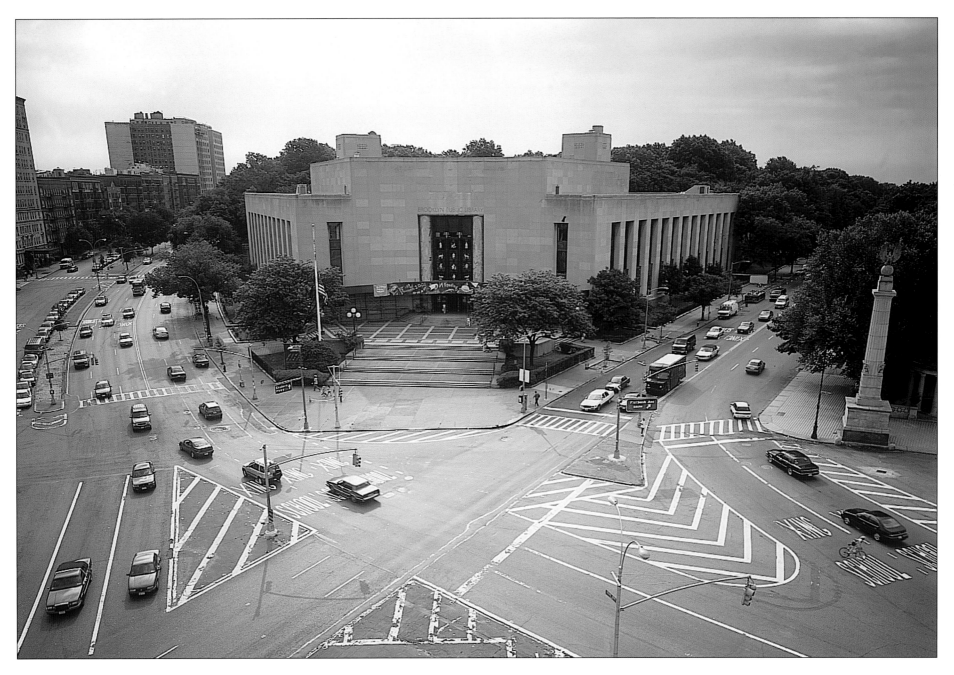

By the 1930s, classical designs were out of fashion and a new set of architects reshaped the library design to suit the times. Completed in 1941, the new library and its smooth, concave entrance is a Modernist niche in the classical design of Grand Army Plaza. This building is the main branch of the Brooklyn Public Library system, which includes nearly sixty neighborhood libraries throughout the borough. The water tower in the earlier photo was razed in 1930 and its reservoir was filled to create the Mount Prospect Park and Playground, visible here only as treetops behind the library. Across the street from the library (right), the same eagle-topped column and granite gazebo in the earlier photo still stand at the entrance to Prospect Park. Both photos were taken from the top of the Grand Army Plaza arch.

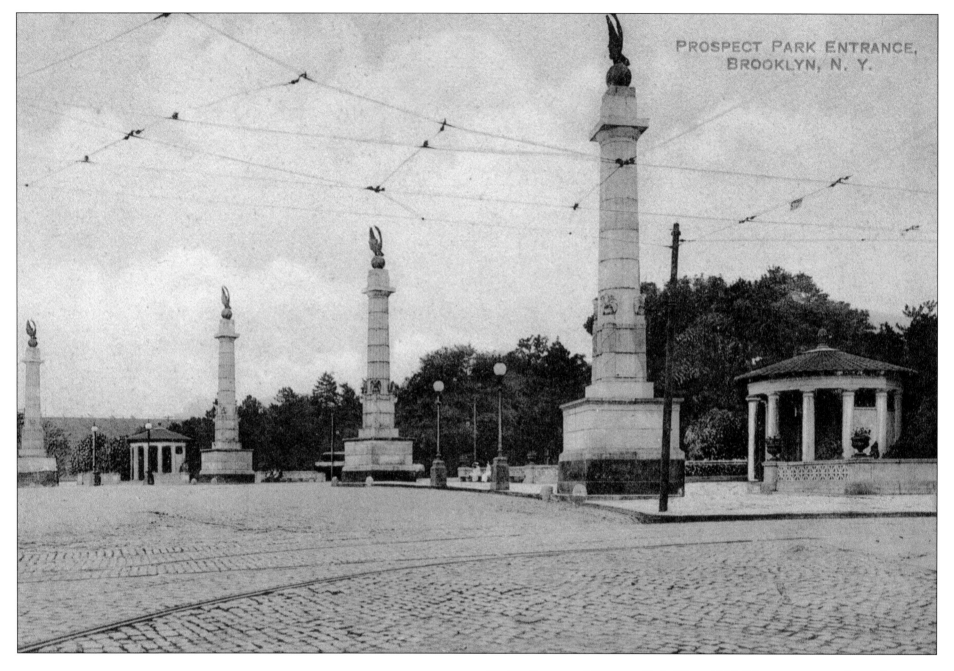

Union Street and Prospect Park West, 1910. The entrance to the park (between the two middle columns) is flanked by four fifty-foot columns, each topped with a bronze eagle and two temple-like gazebos with polished granite columns and vaulted tile interiors. Overhead are the electric wires for the trolleys in use during this time.

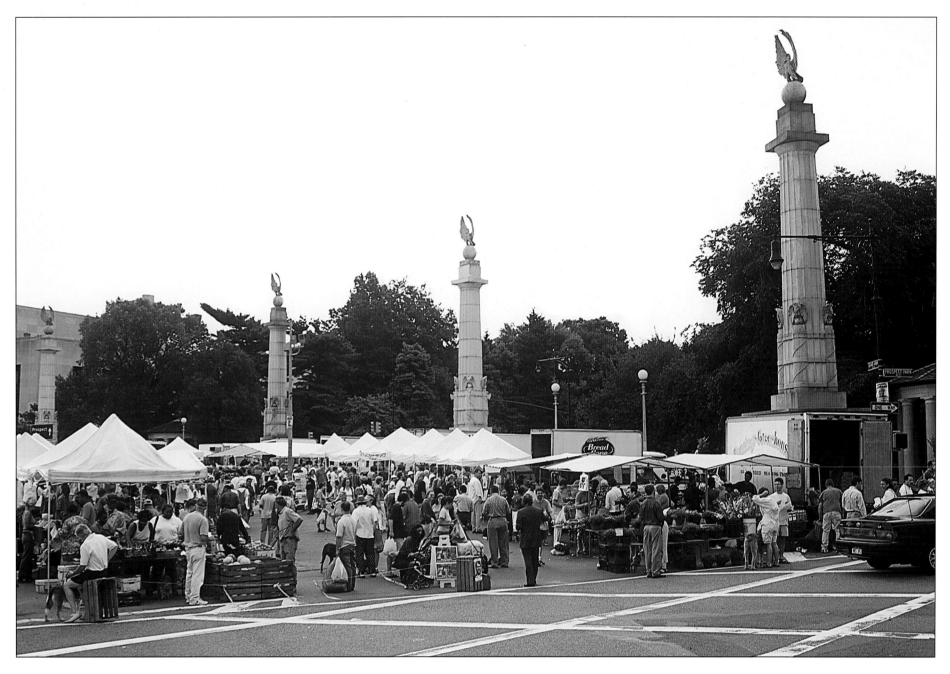

Normally filled with cars, the park entrance becomes a farmers' market twice a week, offering fresh vegetables and fruits to local residents. While some parts of Brooklyn still had active farms in the early twentieth century, today the farmers come from the New York and New Jersey countryside.

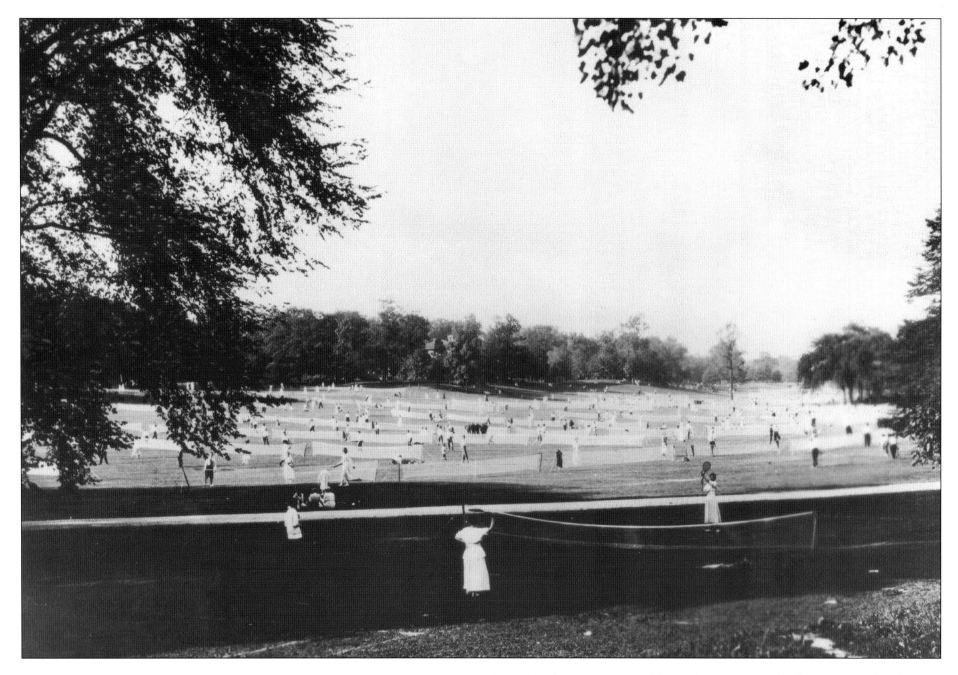

Long Meadow, circa 1900. Although Prospect Park's designers, Frederick Law Olmsted and Calvert Vaux, also created Manhattan's Central Park, Prospect Park is generally recognized as their masterpiece. Built in the center of Brooklyn, the 526-acre expanse includes rolling meadows, trails, lakes, streams, ball fields, a zoo, and Brooklyn's last forest. The Long Meadow, filled here with lawn tennis games, is the largest open space in the park.

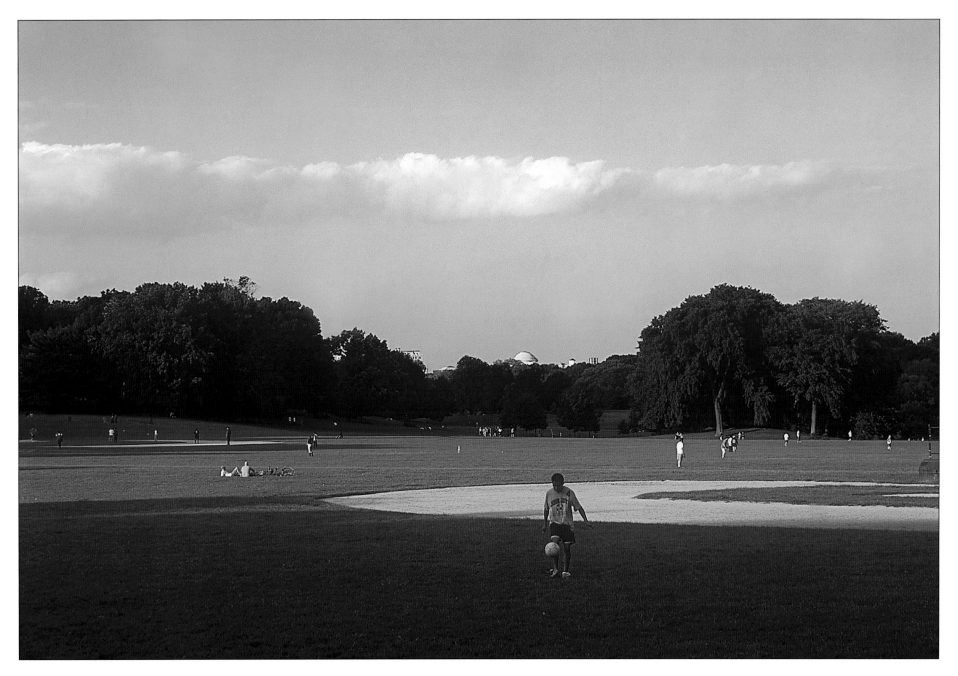

Much of Brooklyn was still undeveloped when Prospect Park was built between 1866 and 1873. Today, in the midst of a densely populated borough, the park is a priceless urban oasis. Soccer and baseball are now the games of choice in the Long Meadow. On the horizon is the dome of the Brooklyn Museum of Art.

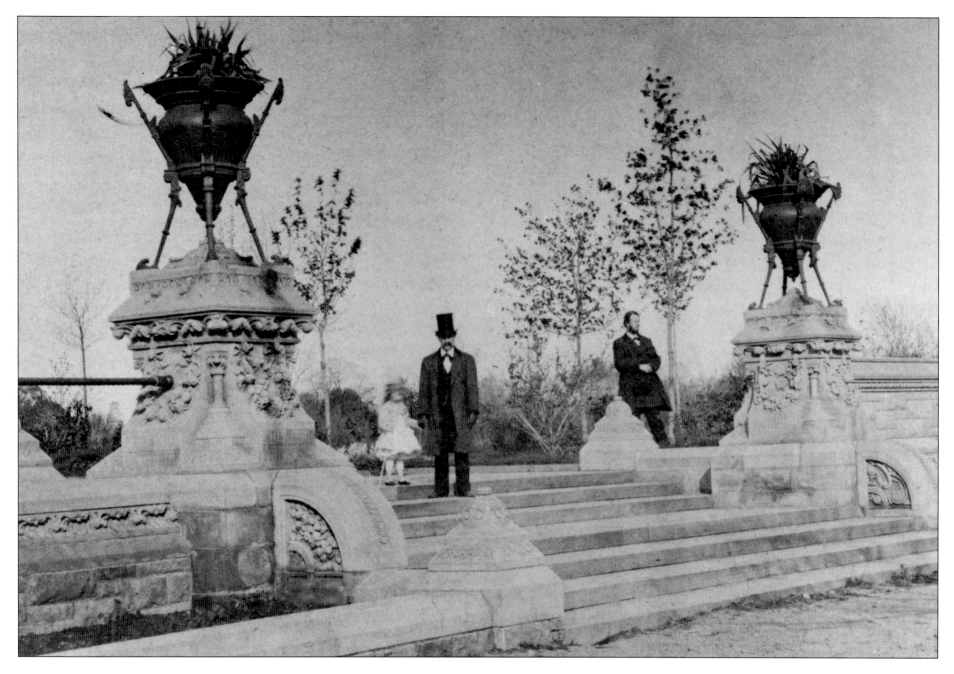

Prospect Park, 1880. One of the jewels of Prospect Park, the Music Grove included gardens, formal walks, and terraces overlooking a lagoon. Musicians played on "Music Island" in the middle of the lagoon, and the sound carried over the water to the audience. This is a view of the main terrace near the lagoon.

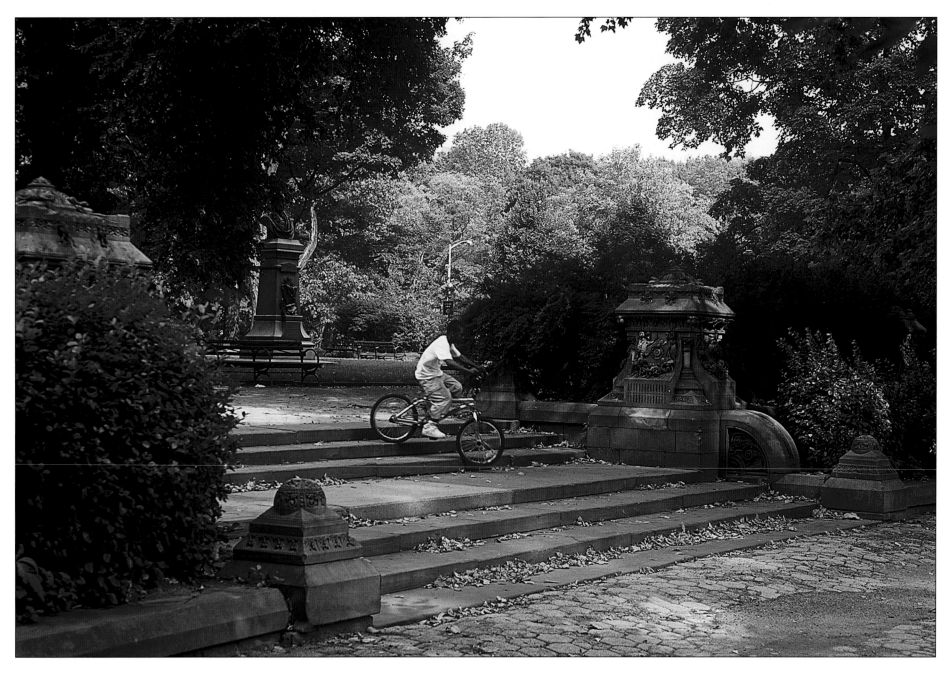

The Music Grove suffered a rude intrusion in the 1960s when a skating rink was built over the lagoon, obliterating Music Island and the opportunity for waterside concerts. Although the terraced steps and walks lined with statues of famous composers are the only remaining features, there are plans to restore the lagoon and Music Island. The skating rink, now three decades old, requires extensive repairs and will be relocated elsewhere in the park, opening the Music Grove once again to a beautiful waterfront vista.

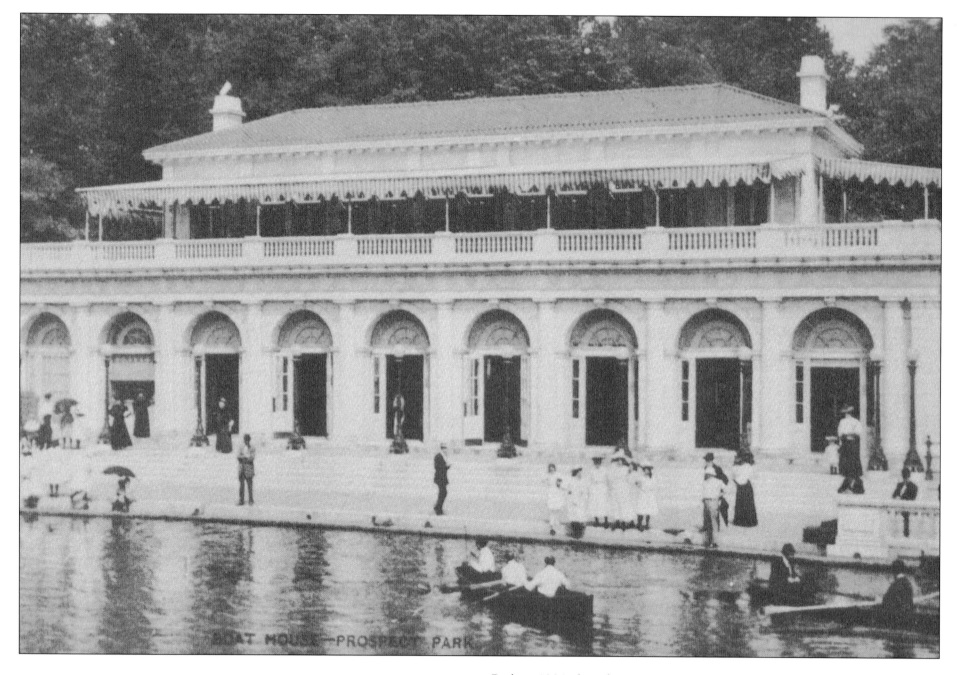

Built in 1904, this white terra-cotta clad pavilion was modeled on Venetian palaces along the Grand Canal. The architects were inspired by the English tradition of placing classical buildings within a naturalized setting.

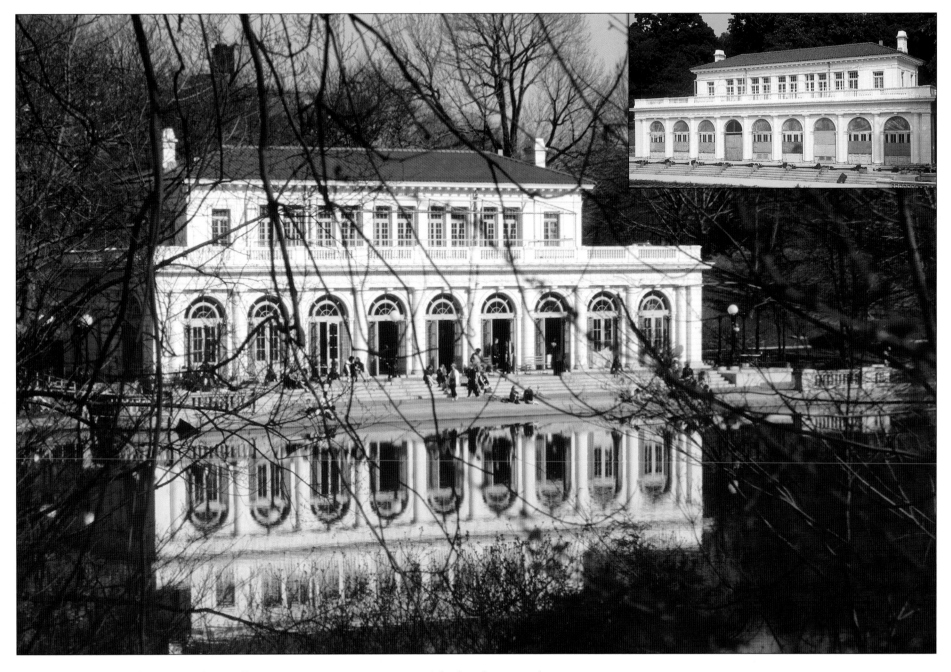

The man-made lake, known as the "Lullwater," creates a mirror image of the boathouse in this contemporary view that is just as romantic as the atmosphere of the archival photo. Today, the focus is on environmental education. Recently restored (see inset during renovation), the boathouse will reopen as the Prospect Park Audubon Center—the country's first urban Audubon Center. The opening date, April 26, 2002, is the shared birthday of ornithologist John James Audubon (1785–1851) and Prospect Park's chief designer Frederick Law Olmsted (1822–1903). The new center will offer citizen science programs, allowing schoolchildren and adults to collect data about the park's wildlife and native plants. *Photo by Charles Reiss (main image)*

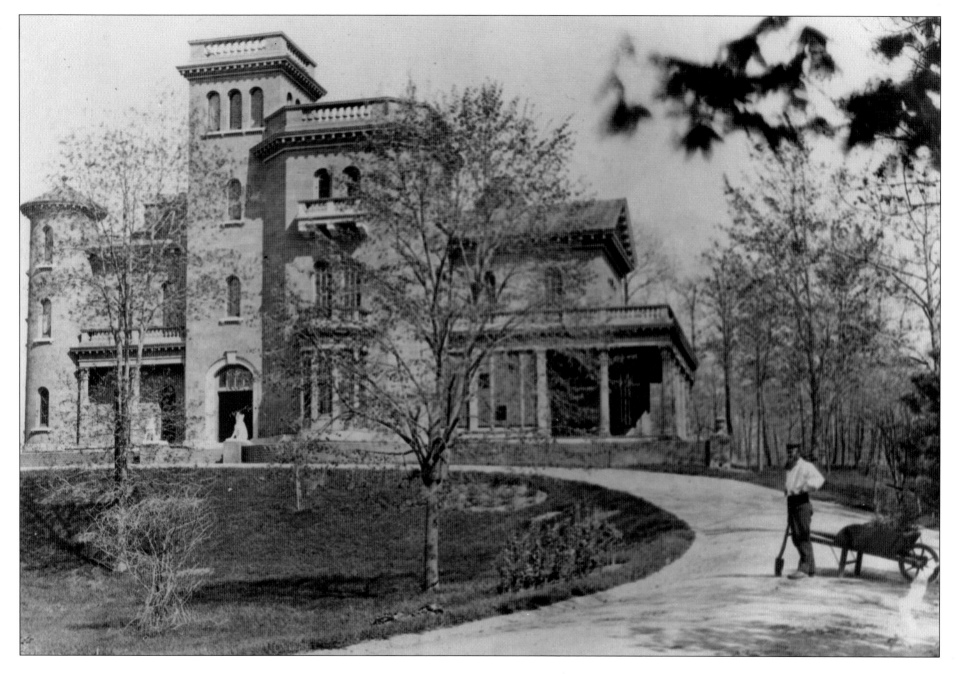

Prospect Park West, circa 1890. Edwin Litchfield, a railroad financier, built this Italianate villa as his country home in 1857. At the time, Brooklyn leaders were making plans to build Prospect Park nearby and Litchfield ventured into real estate speculation. He bought a square mile of vacant land sloping down from his villa and began to subdivide it for homes. The park was completed in 1873, and by the 1880s, Park Slope began to emerge as an affluent neighborhood.

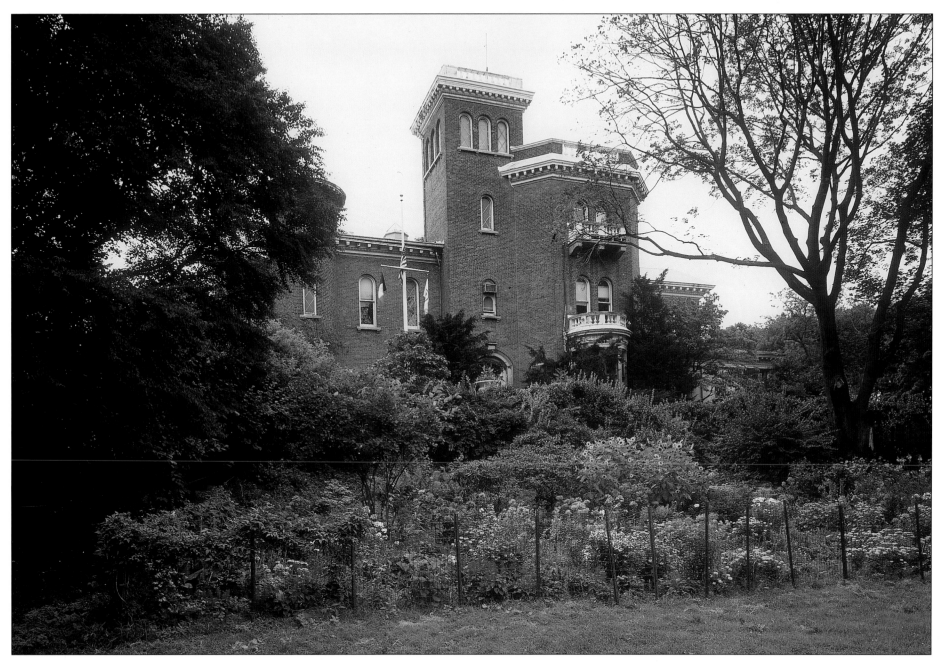

By the end of the nineteenth century, Park Slope was a premier address, and Litchfield Villa had become part of the park itself. The New York City Parks Department acquired the villa in 1892 and still uses the building as its Brooklyn headquarters.

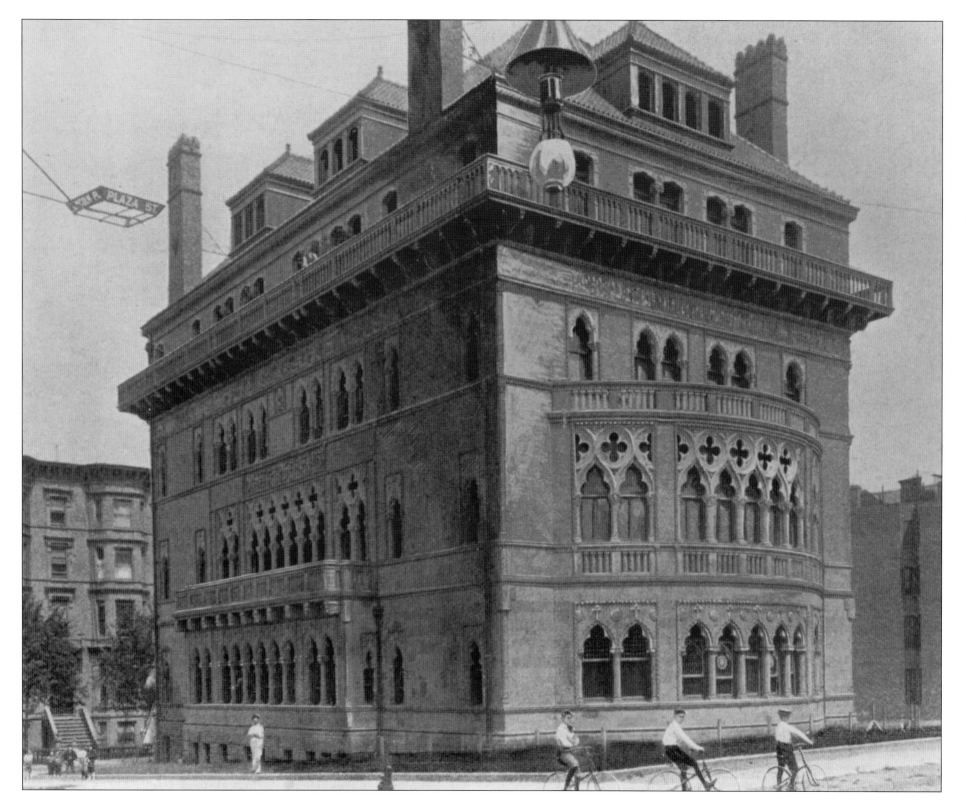

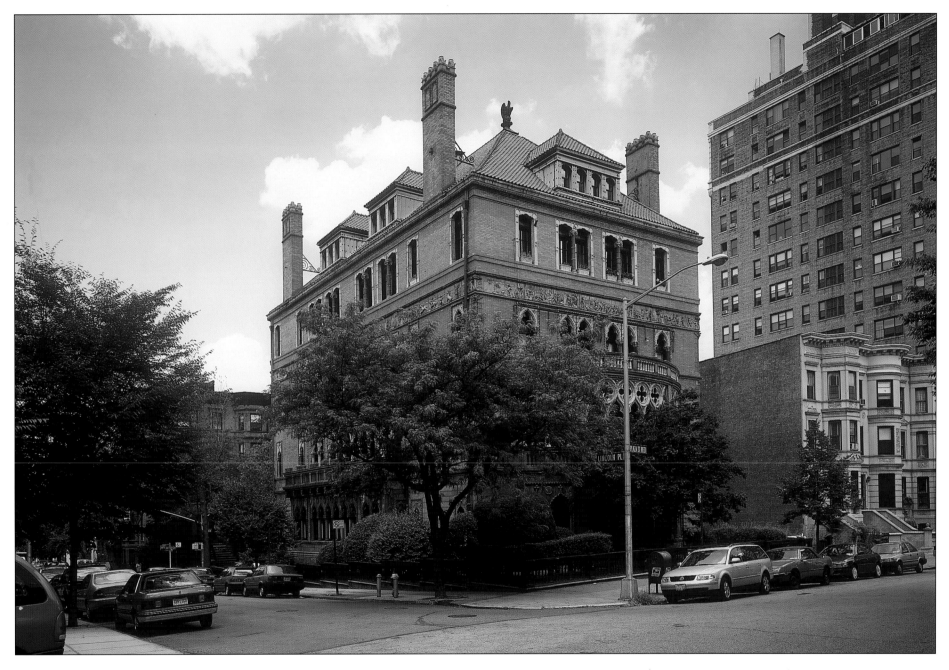

Left: Montauk Club, circa 1907. Chances are the boys on bicycles here never ventured inside this exclusive club. Built in 1891 to resemble a Venetian Gothic palazzo, the building was one of several lavish mansions developed in the new neighborhood of Park Slope, across the street from Prospect Park. The grand balcony afforded a stunning view of the park. The club was one of the first of the day to open its doors to women, although unescorted females used a separate entrance that bypassed the main lobby.

Above: Named after a Native American tribe, the Montauk Club has a frieze of native figures spanning three sides of the building. Although the north side (right) was left unadorned to allow for expansion, the lot next door is still vacant today. Prospect Park proved to be a continuing incentive for other development, as seen by the row of town houses and the large apartment buildings on the rest of the block. Still a private club, the Montauk is one of many historic buildings in this parkside neighborhood.

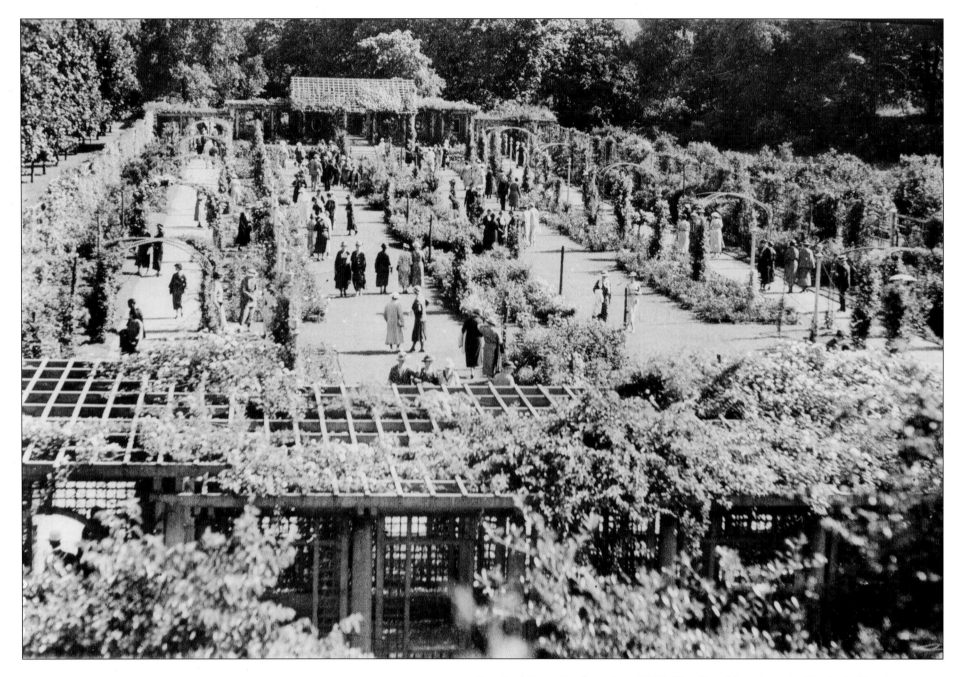

Cranford Rose Garden, circa 1927. The Brooklyn Botanic Garden's fifty manicured acres were carved out of a wasteland across the street from Prospect Park. The site was transformed using the by-products of Brooklyn's many breweries as fertilizer. Along with the park, library, and museum, the garden, planned since the 1890s and opened in 1911, was another milestone in Brooklyn's civic achievements. The Cranford Rose Garden, the gift of a private benefactor, had just opened when this photo was taken.

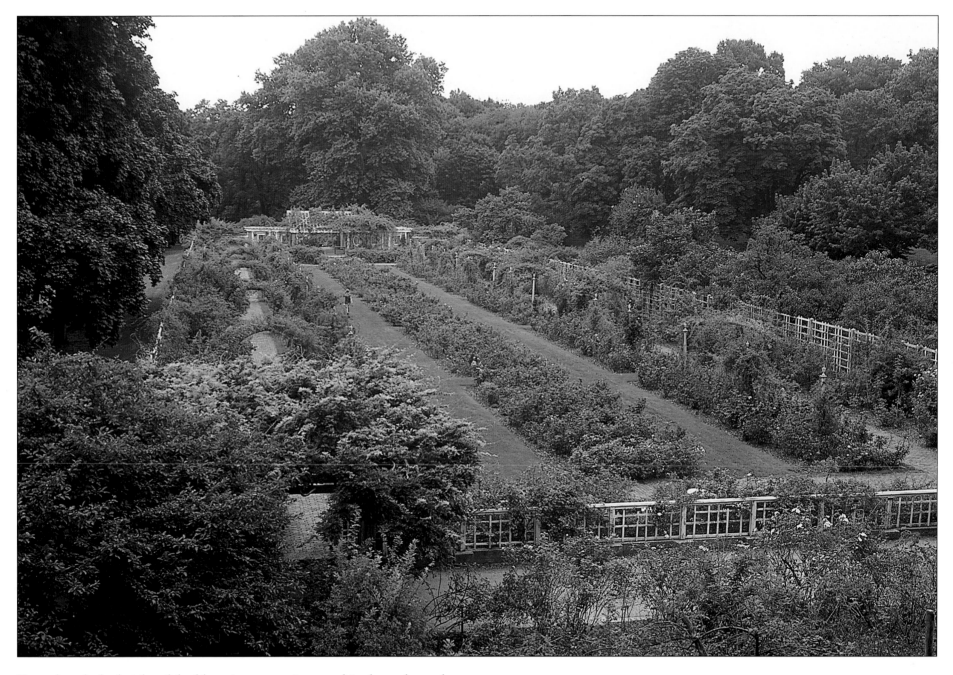

Even though the height of the blooming season is over, this photo shows the Cranford Rose Garden's trellised walks in lush surroundings. Both photos were taken from an elevated walk overlooking the garden.

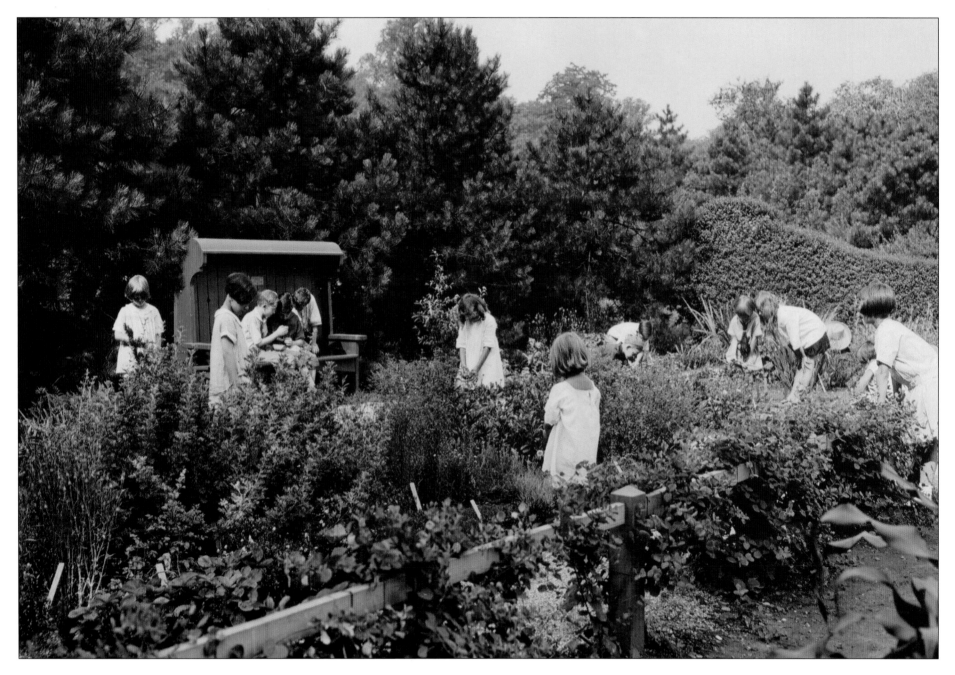

Shakespeare Garden, 1926. Just a year old in this photograph, this lovely spot was created in the style of the English cottage garden of Shakespeare's wife, Anne Hathaway, in Stratford-upon-Avon. Dressed in summer whites, the children here were introduced to botany and great literature in a single lesson. They learned to identify the flowers and herbs cited by Shakespeare by reading the excerpts from his plays and sonnets, which were included on the plant labels.

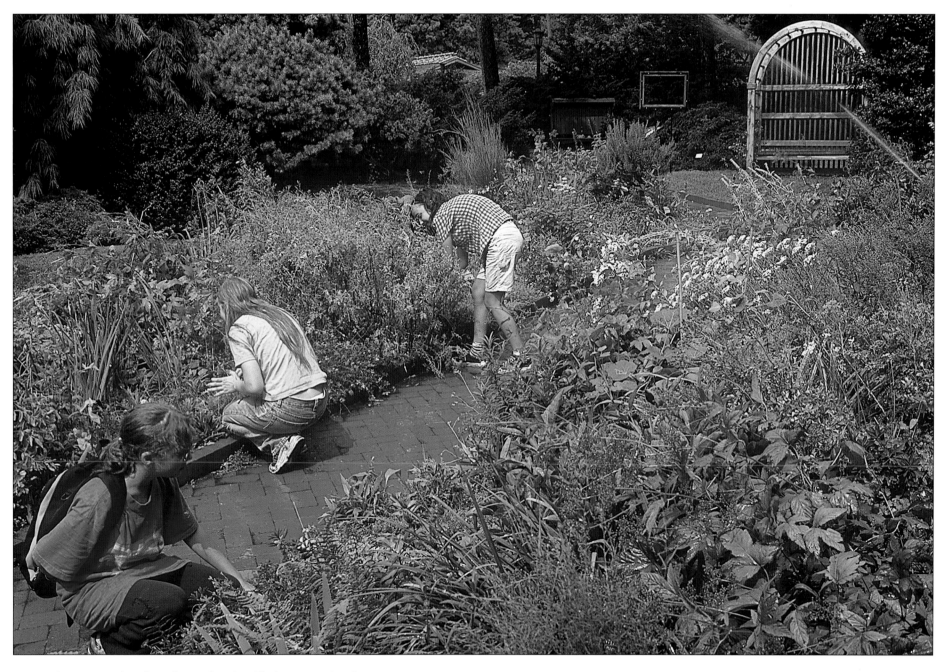

Recently improved with wider paths, the Shakespeare Garden continues
to be a popular way for visitors to appreciate both the Bard and the
beautiful flowers.

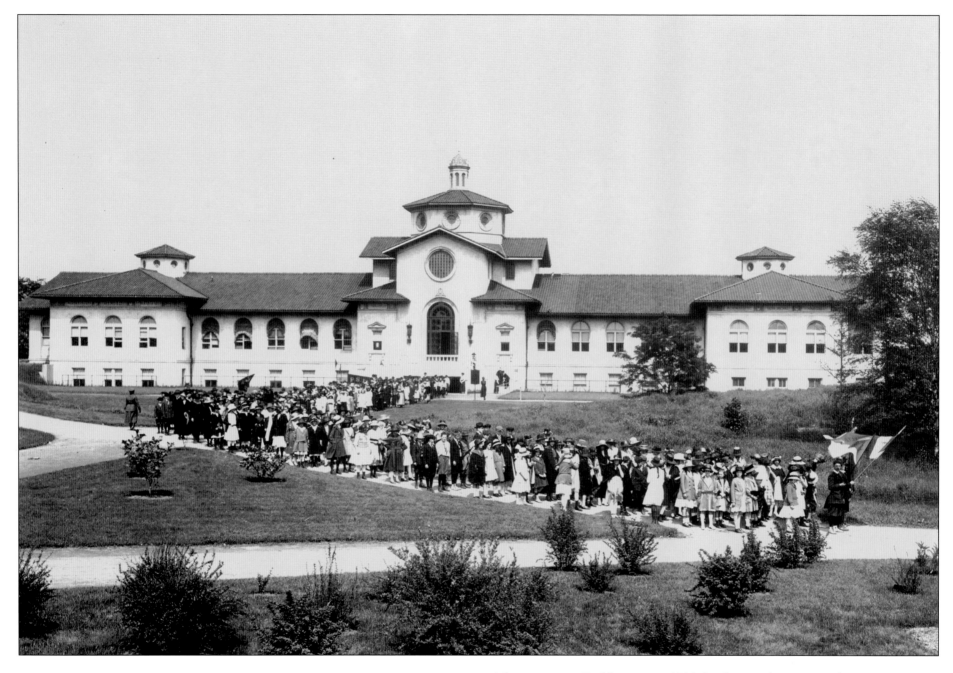

Administration Building, circa 1920. In this era, botanic gardens were generally attached to universities. The Brooklyn Botanic Garden introduced a new focus on public education and was the first in the country to teach botany to children. In this photo, over 600 schoolchildren are leaving classes held in the Administration Building. *Photo by Louis Buhle, from Brooklyn Botanic Garden Archive.*

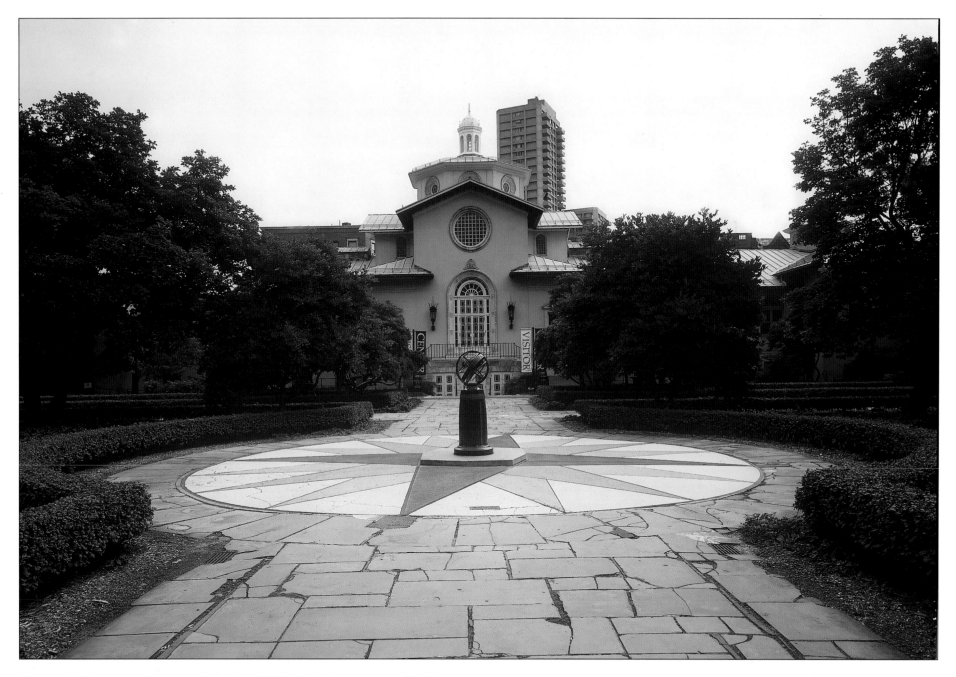

Surrounded by magnolia trees planted in 1933, the Administration Building is
today a beautiful visitor center. Hundreds of children still receive hands-on
instruction each summer in the nearby greenhouses and vegetable garden.

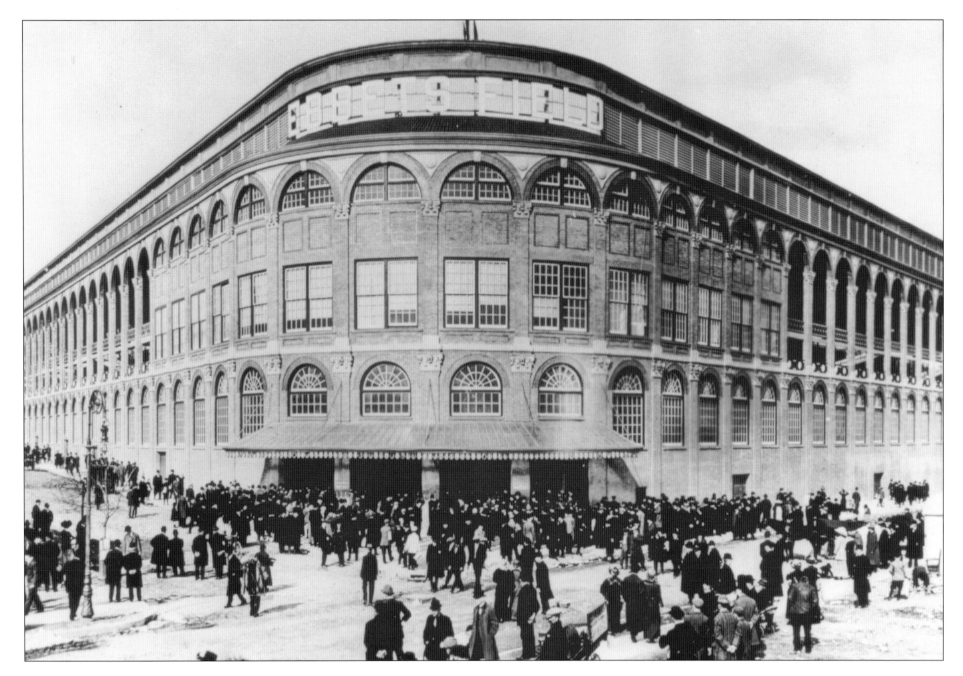

McKeever and Sullivan Place entrance, circa 1914. The game of baseball reached a pinnacle of popular support at Ebbets Field, the legendary home of the Brooklyn Dodgers. The concrete-and-steel stadium opened its doors on April 5, 1913, a day when 25,000 fans filled every new seat. As the *Brooklyn Daily Eagle* reported, "Twenty-five thousand hearts thumped with joy, twenty-five thousand pairs of feet pounded the concrete floor and twenty-five thousand voices roared with delight."

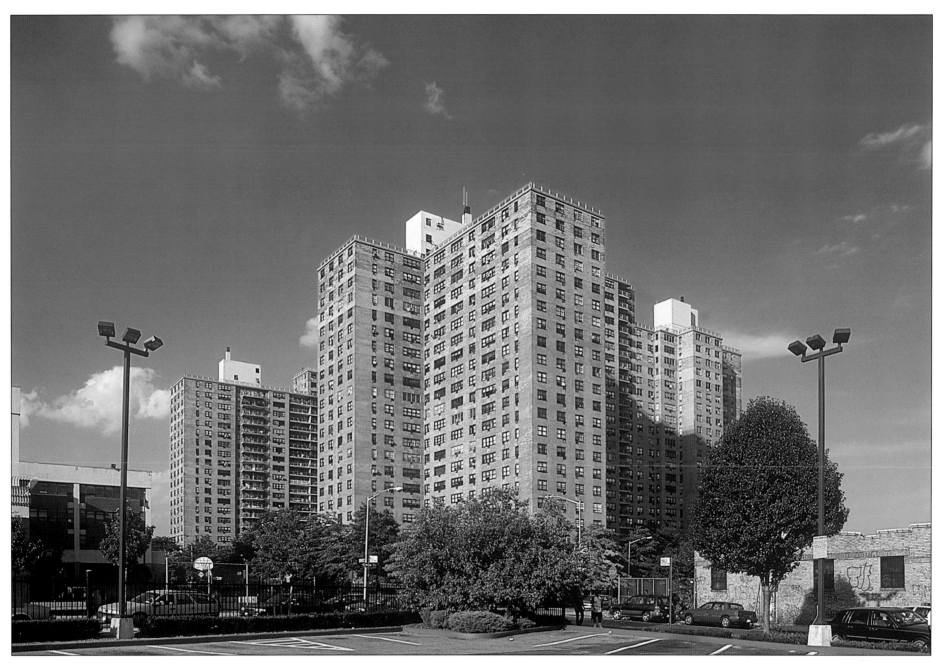

Half a century after its triumphant opening day, Ebbets Field was considered
small and out of date. After unsuccessful negotiations to build a new stadium
at another Brooklyn site, the Dodgers' owners moved the team to Los Angeles
in 1957. Three years later, the old stadium was demolished and replaced by
this public housing development, the Ebbets Field Houses. Besides the name,
the only trace of the stadium on its original site is a simple plaque on a brick
wall that reads, "This is the former site of Ebbets Field."

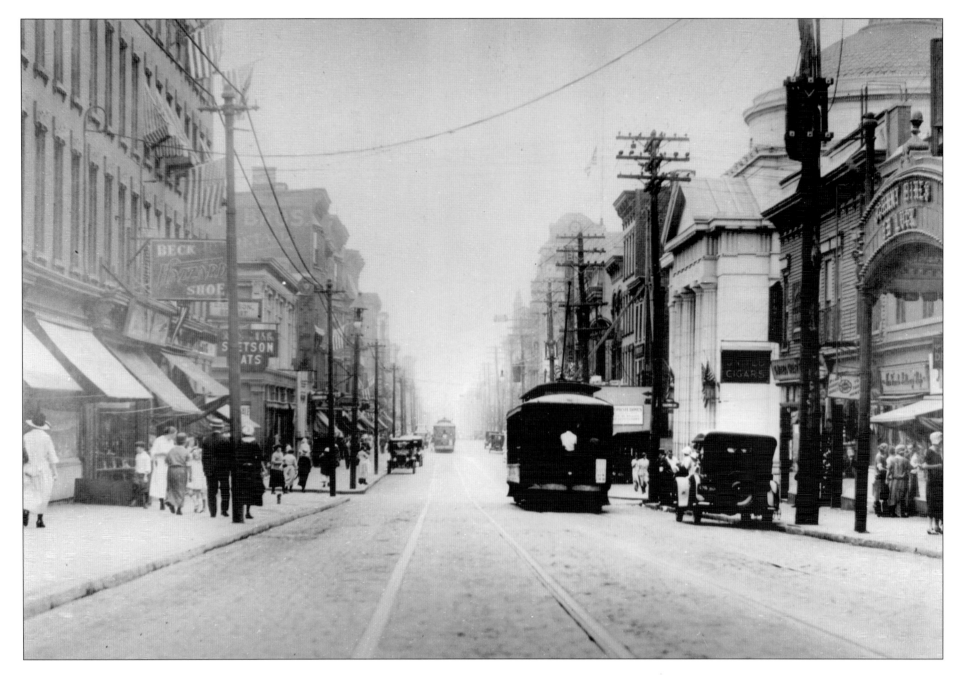

Manhattan Avenue, near Calyer Street, circa 1920. Greenpoint was the kind of neighborhood that evokes nostalgia today, a solid working-class community of modest homes and shops. Generations of immigrant families from Germany, Ireland, Italy, and Eastern Europe settled here in the nineteenth and early twentieth centuries. Everyone shopped on Manhattan Avenue and took pride in doing business at the Greenpoint Savings Bank, the domed building with Greek columns (right), which gave the neighborhood a touch of class.

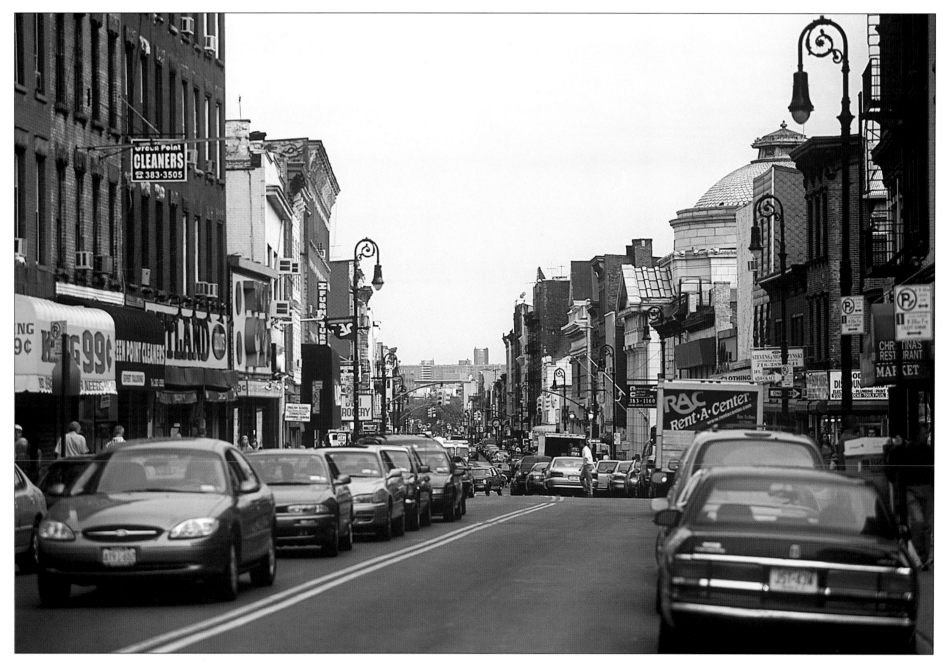

Although the signs are different, hardly a building has changed on the street. The domed bank, now nearly a century old, is still doing business and is one of several landmark buildings in the area. Despite hard times during the Depression, when Greenpoint had the highest unemployment rate in the city, the neighborhood has remained a cohesive urban village. Reinvigorated by waves of immigration still rising today, Main Street is even busier today than it was in the old days. Today, Greenpoint has the largest Polish-American population in New York City.

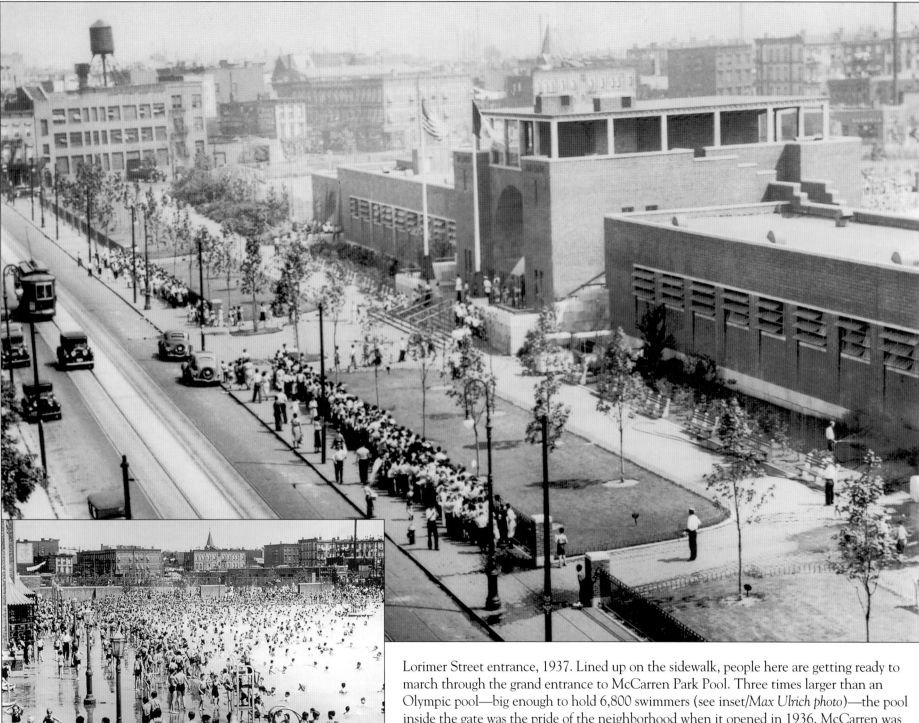

Lorimer Street entrance, 1937. Lined up on the sidewalk, people here are getting ready to march through the grand entrance to McCarren Park Pool. Three times larger than an Olympic pool—big enough to hold 6,800 swimmers (see inset/*Max Ulrich photo*)—the pool inside the gate was the pride of the neighborhood when it opened in 1936. McCarren was the last of eleven pools built in New York City during the Depression, but as Mayor Fiorello LaGuardia said to the crowd gathered at the opening: "No pool anywhere has been as much appreciated as this one." *Photos from New York City Parks Archives*

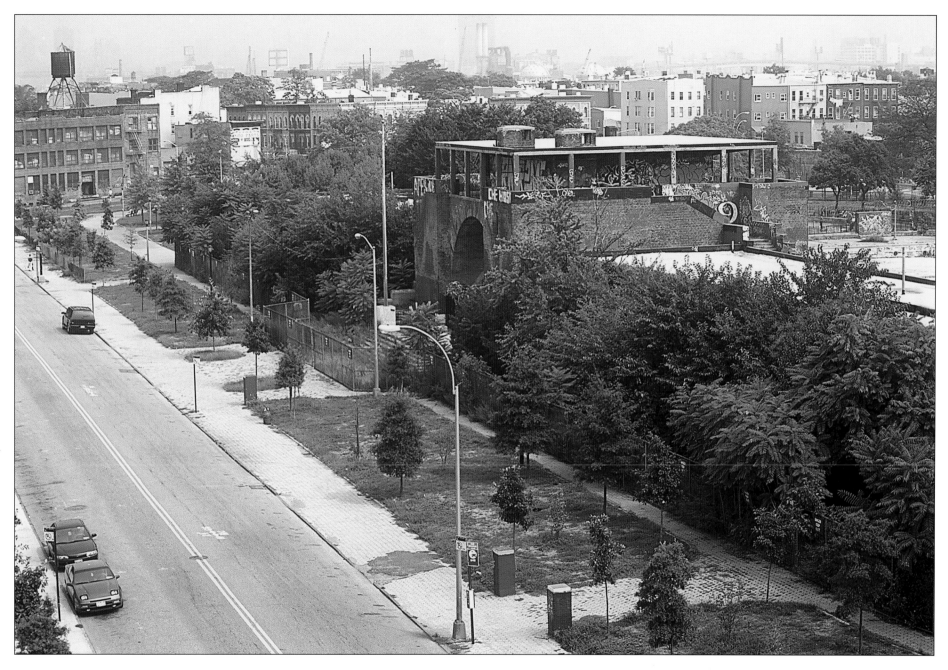

Closed for more than fifteen years, McCarren Pool is now in ruins and is the only one of the city pools built during the 1930s that has not been restored. Community members disagreed for years about the appropriate size of a new facility. Some wanted a smaller pool for better security, while others did not want to sacrifice the original design. Now city officials are searching for the millions of dollars needed to restore the facility.

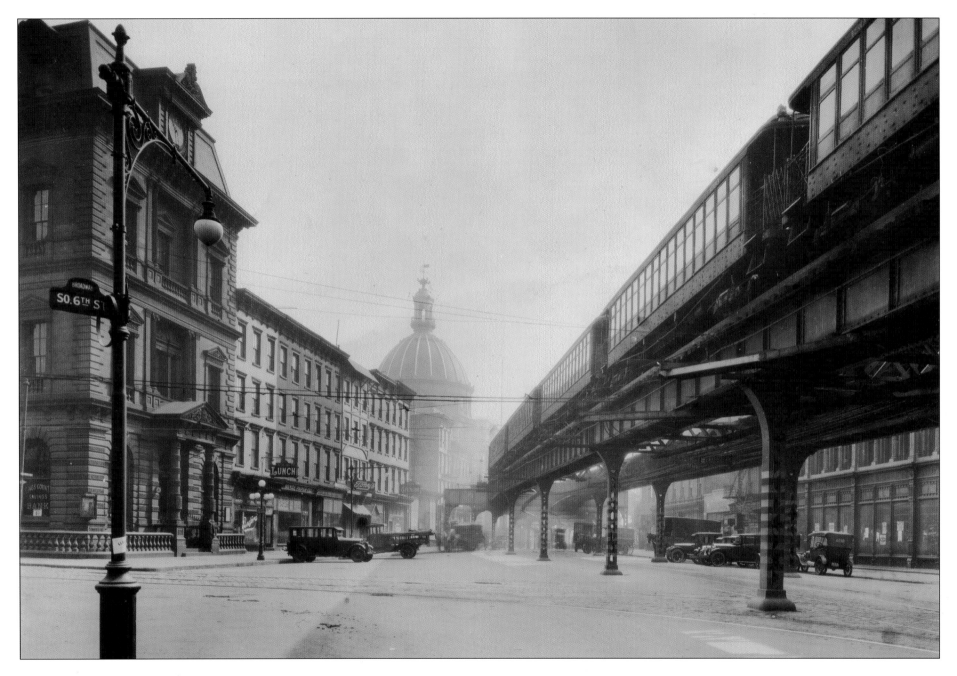

Broadway at South Sixth Street, circa 1924. Williamsburg was once an independent city fueled by giant oil and sugar refineries on its waterfront. When the industrialists needed a local bank, they wanted one important enough to warrant their business. They found one in the Williamsburgh Savings Bank, which in 1875 built the structure with the towering Italian Renaissance dome (center). Even with the elevated rising in the foreground, the dome stands out here and continued to dominate Brooklyn's skyline for many years. (Unlike the neighborhood, the bank retained the final "h" in its name.)

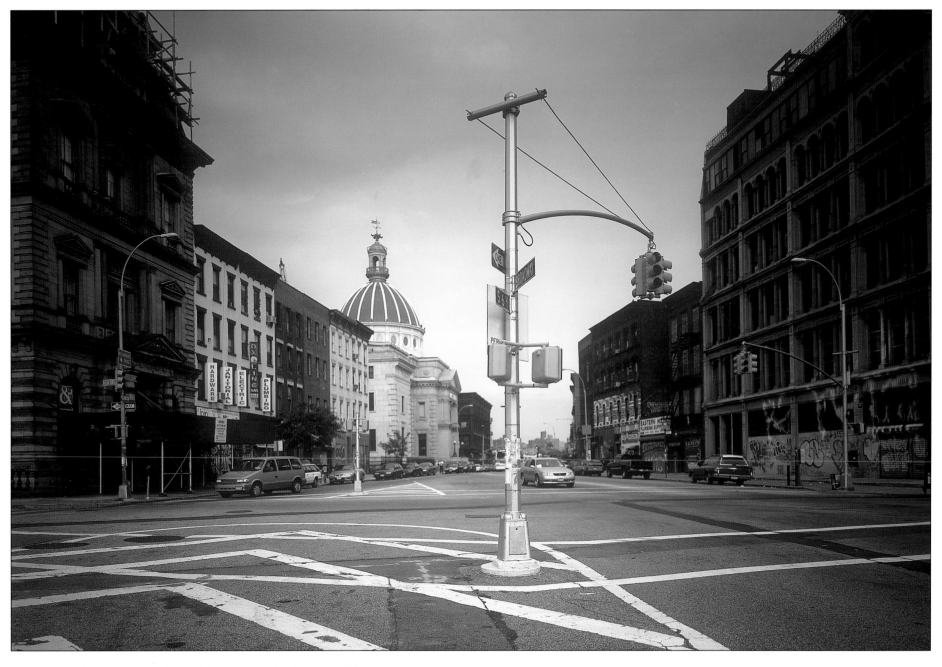

The elevated is gone, but the buildings lining both sides of the street are
much the same as they were in 1924. The Williamsburgh Savings Bank built a
new tower in 1929 on Flatbush Avenue, a much taller structure, but one with
a smaller dome. The original building has remained a bank and its gilded
dome was recently restored. A smaller bank on the street (far left), which
dates from 1868, is currently being restored and has a new life as an art gallery.

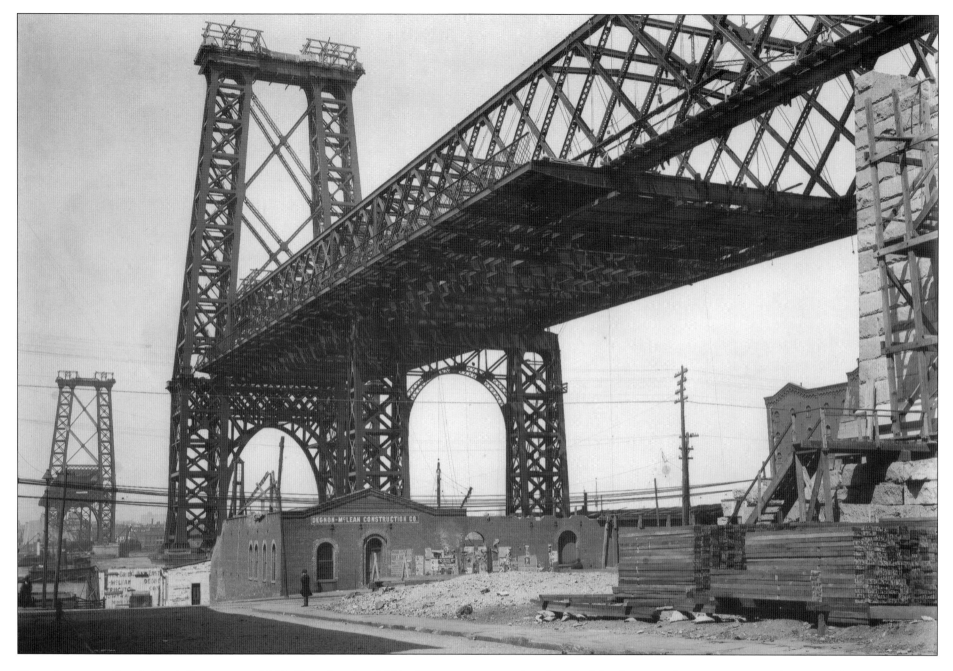

Kent Avenue at South Sixth Street, circa 1900. Completed in 1903, the Williamsburg Bridge was the second structure to span the East River between Brooklyn and Manhattan. It took seven years to build—half the time required for the Brooklyn Bridge—and was the first suspension bridge with towers made entirely of steel. At 1,600 feet, the span is slightly longer than that of the Brooklyn Bridge. The steel trusses provide extra strength, but critics immediately called the design a clumsy contrast to the graceful span of the Brooklyn Bridge. The Williamsburg Bridge created a direct connection to the crowded tenement district of Manhattan's Lower East Side and became an avenue for immigrants seeking better living conditions in Brooklyn. Thousands, mostly from Eastern Europe and Italy, found jobs and cheap housing along Williamsburg's industrial waterfront.

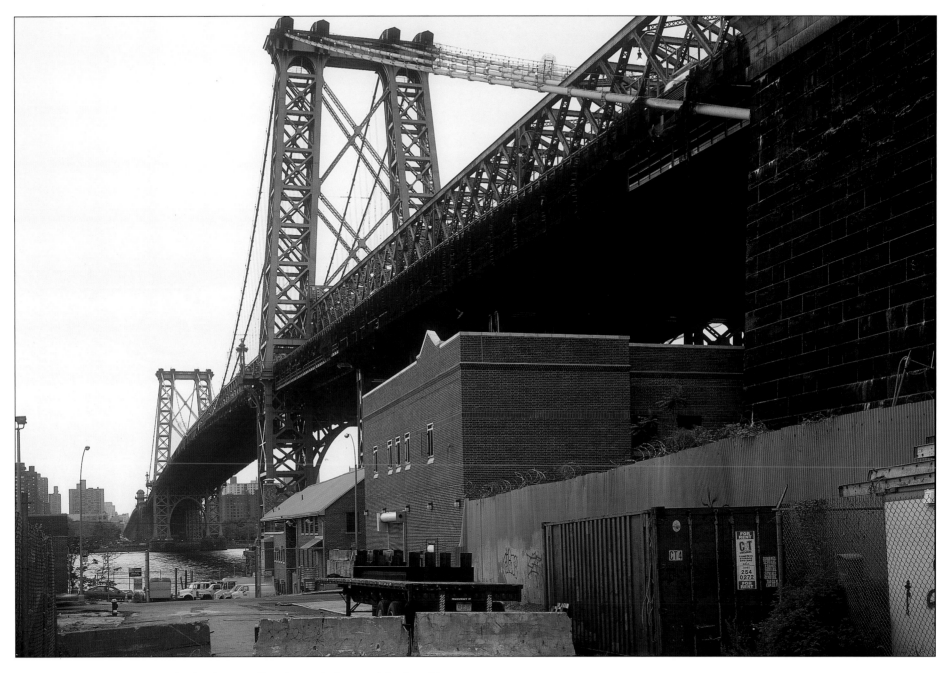

While the waterfront near the bridge is still industrial, the neighborhood has
a new mix of residents. Hispanics and Hasidic Jews account for the majority of
the population. Many artists have also migrated from Manhattan to set up
studios in Williamsburg's old factories.

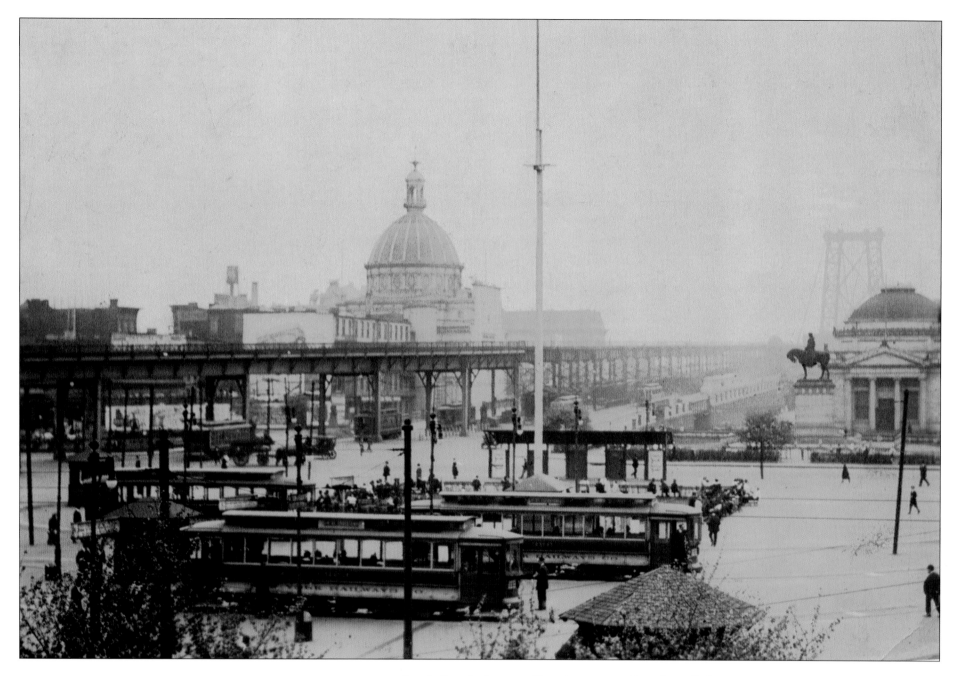

South Fourth Street at Broadway, circa 1920. Installed in 1906, three years after the bridge opened, the statue of George Washington on horseback (far right) was the inspiration for calling this area "Washington Plaza." But as traffic increased, the statue and the name got lost in this transportation hub. Trolley cars fill the plaza, elevated tracks lead to the Williamsburg Bridge, and the bridge tower looms above the statue. The massive dome of the Williamsburgh Savings Bank (center) rises over the scene, echoed by the smaller dome of a bank immediately behind Washington (far right).

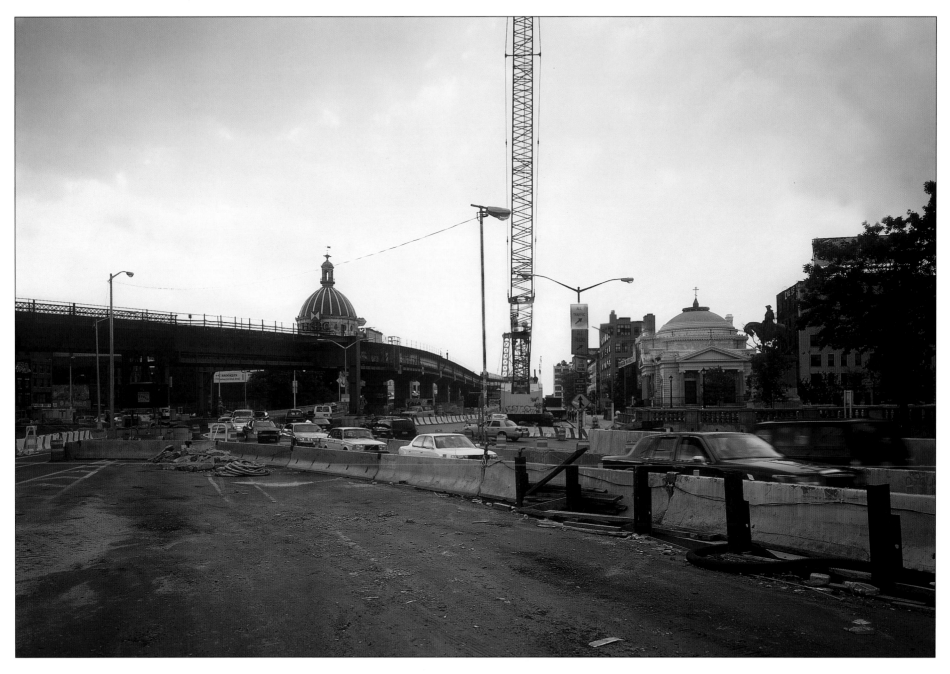

Although the Williamsburg Bridge was built to last, after nearly a century of punishing traffic, weather, and poor maintenance, it was in such terrible condition that the city seriously considered replacing it. However, the task of building a new bridge was infeasible, and in 1991 the city began a program of total rehabilitation. The work in progress here will complete more than a decade of reconstruction of the bridge supports, roadways, walkways, and subway tracks. The towering construction crane (center) seems larger than the bridge tower behind it. Still in its place is the statue of George Washington (far right). Depicting the general in reflection at the Battle of Valley Forge, the statue has been a solemn witness to the unending work and rerouting of traffic. The small bank behind the statue has become a church, a switch that seems to indicate that completing the bridge project requires renewed faith.

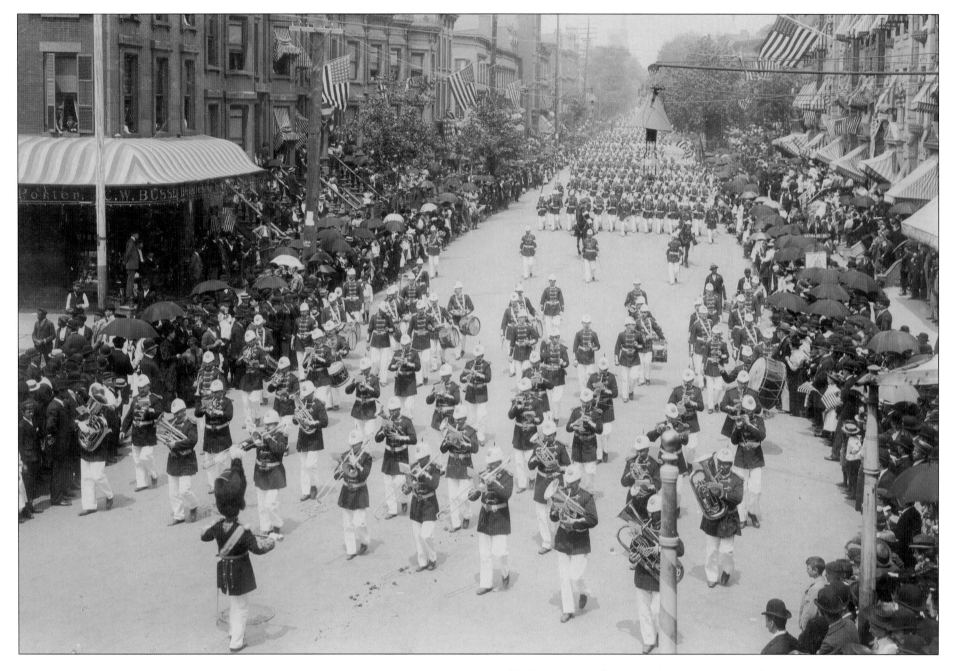

Bedford Avenue and Heyward Street, Memorial Day, 1895. Many Americans think of Memorial Day as a holiday honoring World War II veterans, but the celebration has much older roots. Here, thinning ranks of Civil War veterans and active military units are marching in a Memorial Day parade, heading south on Bedford Avenue to the new Soldiers and Sailors Monument Arch, erected just three years earlier at the entrance to Prospect Park.

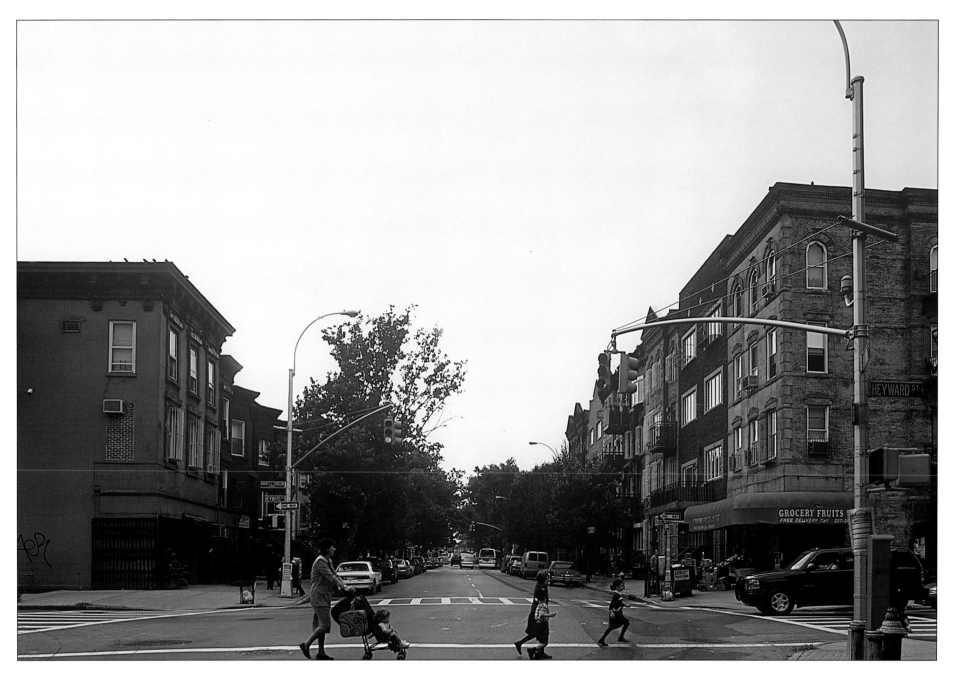

As in other parts of Williamsburg and Greenpoint, the streetscape is relatively unchanged, but a new wave of immigrants has brought a new ethnic culture to the neighborhood. Some 50,000 Hasidic Jews now live in this part of Williamsburg, a pattern of immigration that began after World War II.

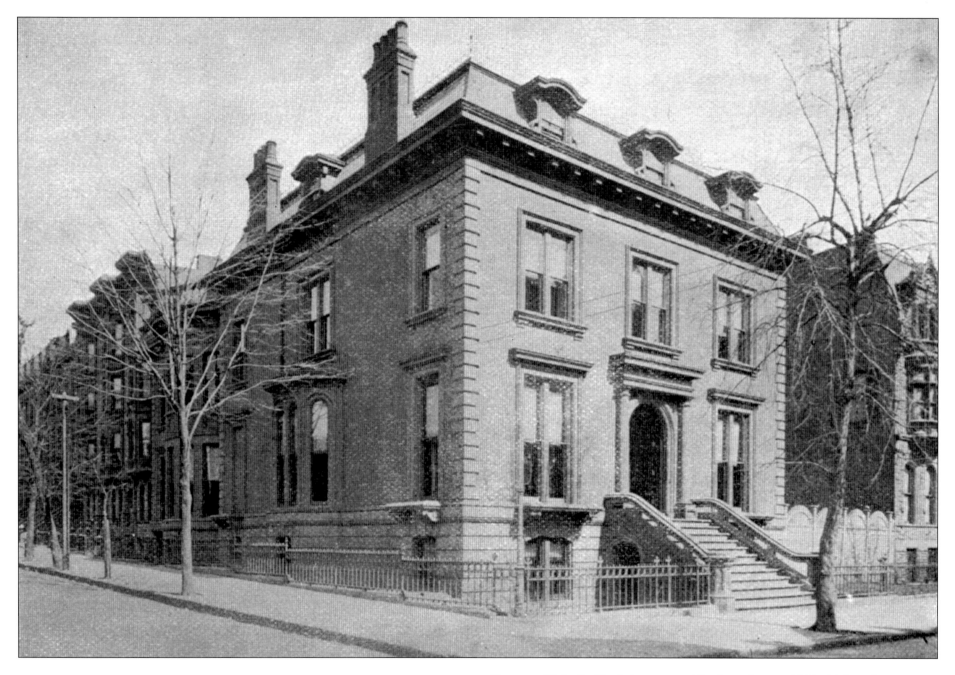

Hanover Club, Bedford Avenue and Rodney Street, 1893. Although Williamsburg had blocks of tenements housing its factory workers, the factory owners, including the founders of the Domino and Jack Frost sugar refineries, also built handsome town houses in the neighborhood. This building, originally a private residence, became a club for businessmen and civic leaders in 1891.

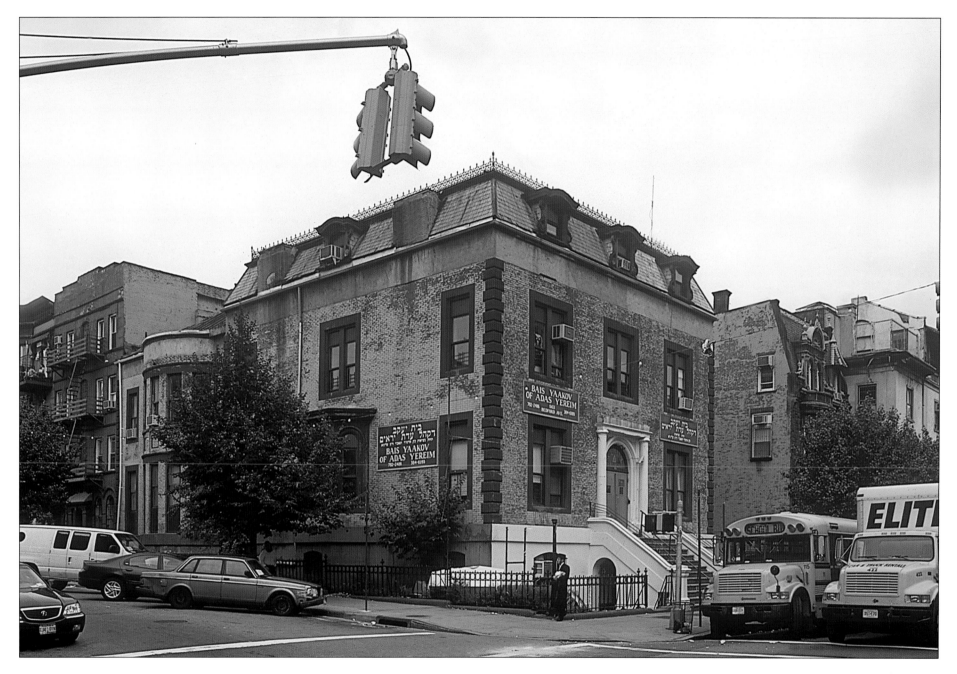

Williamsburg's large Hasidic community, including many refugees from the
Holocaust, have adapted the old buildings to their needs. Today, the Hanover
Club is a yeshiva, a school for orthodox Jewish studies.

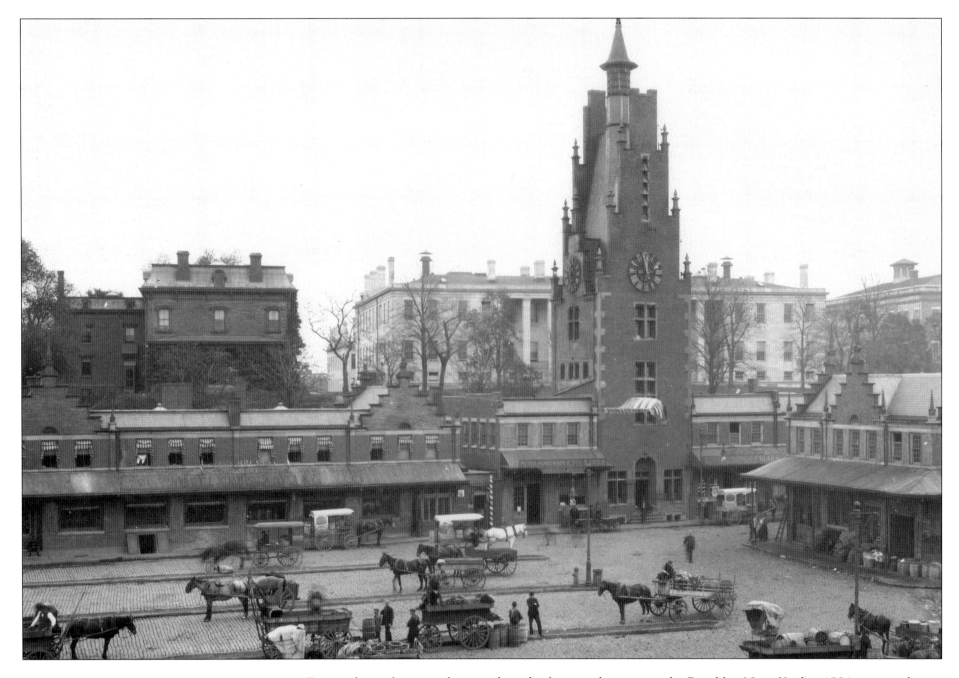

Farmers began bringing their goods to this busy market next to the Brooklyn Navy Yard in 1884, a time when many farms were still operating in southern Brooklyn. Overlooking the market are several Navy buildings from the early nineteenth century, including officers' quarters and a hospital, the building with columns behind the market clock tower (center). Built in the 1830s, the Greek Revival hospital saw peak activity treating injured Union soldiers during the Civil War. The navy yard opened in 1801, but the market's name, taken from nearby Wallabout Bay, which borders the navy yard, has an even earlier history. In 1642, Walloons (Dutch Huguenots) settled the waterfront area and it soon became known as "Wallabout," Dutch for "Walloon's Bay."

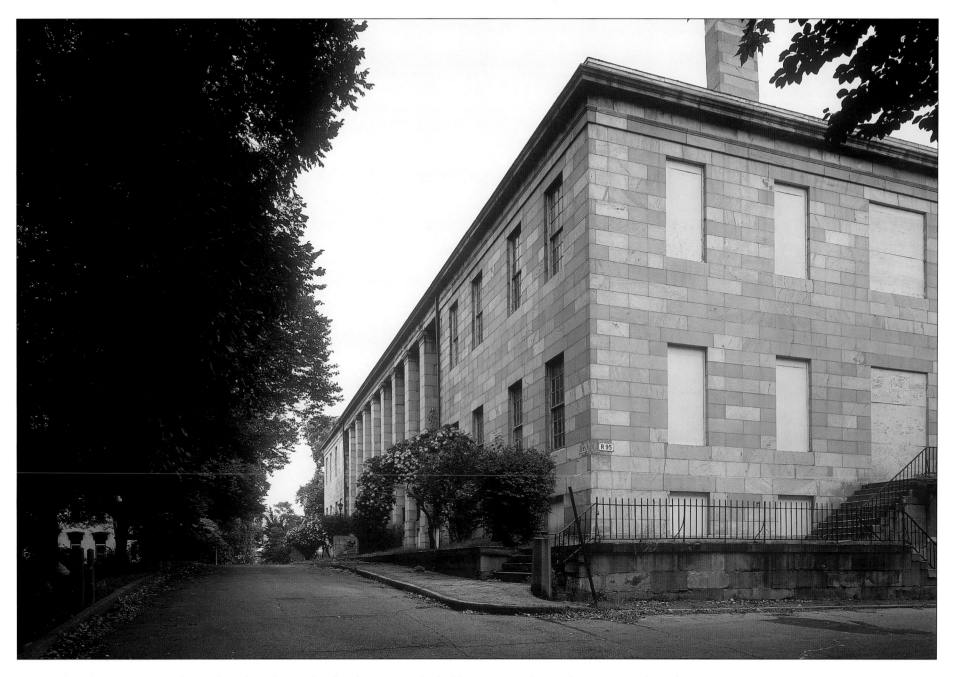

Today, the old hospital is still standing, but the market has been gone for half a century. The market continued until the outbreak of World War II when the Navy built a huge dry dock in its place. The navy yard, originally a forty-acre facility, grew to 300 acres during World War II when it employed 70,000 men and women in round-the-clock shifts. The yard closed in 1966 and most of the Navy's industrial buildings switched to private manufacturing and warehouse operations a few years later. However, the old officers' quarters and hospital fell into disrepair. These buildings were declared historic landmarks and local preservation groups have helped raise funds to prevent further deterioration. With windows sealed against the elements, the marble hospital awaits plans for its future use.

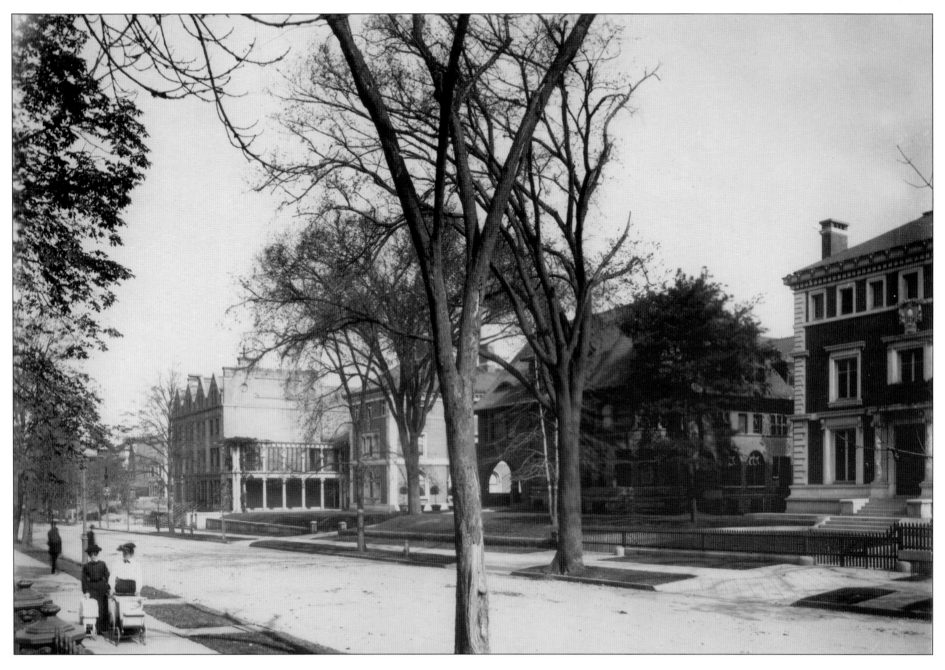

Clinton Avenue, between Willoughby and DeKalb Avenues, circa 1902. A few years after Charles Pratt, a Brooklyn oil refiner, merged his business with John D. Rockefeller's Standard Oil in 1874, Pratt built the mansions on this block as wedding presents for each of his sons. With Pratt leading the way, other titans of Brooklyn industry built lavish homes on adjoining blocks and Clinton Avenue became known as "Brooklyn's Showcase Street." Pratt's neighbors included Dr. Cornelius Hoagland, who created the formula for Royal Baking Powder, and John Arbuckle, the largest coffee importer in North America and the first to package coffee for consumers in small paper bags. The Pfizers and the Bristols (Bristol-Myers), founders of today's pharmaceutical companies, and the Underwoods, who made early typewriters, also lived nearby.

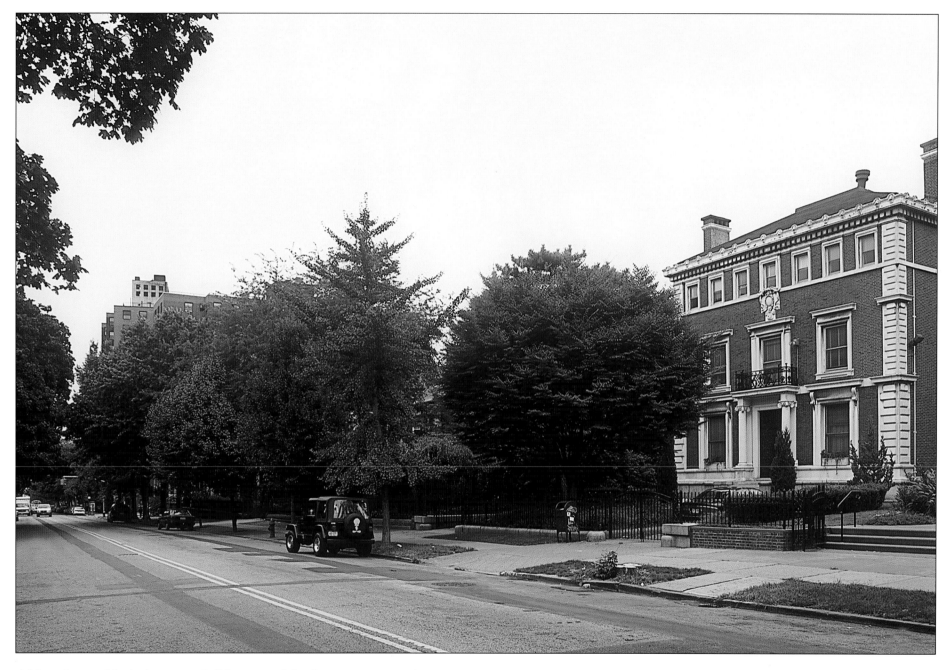

Although trees block the view of all but one of the four mansions in the earlier photo, they all still stand today, occupied by several prestigious individuals and institutions. The visible building (right), built in 1901 for George Dupont Pratt, is now St. Joseph's College. The Roman Catholic Bishop of Brooklyn resides in another former Pratt mansion (center in previous photo), and the others are now part of Pratt Institute, the art and architecture university founded by Charles Pratt in 1887.

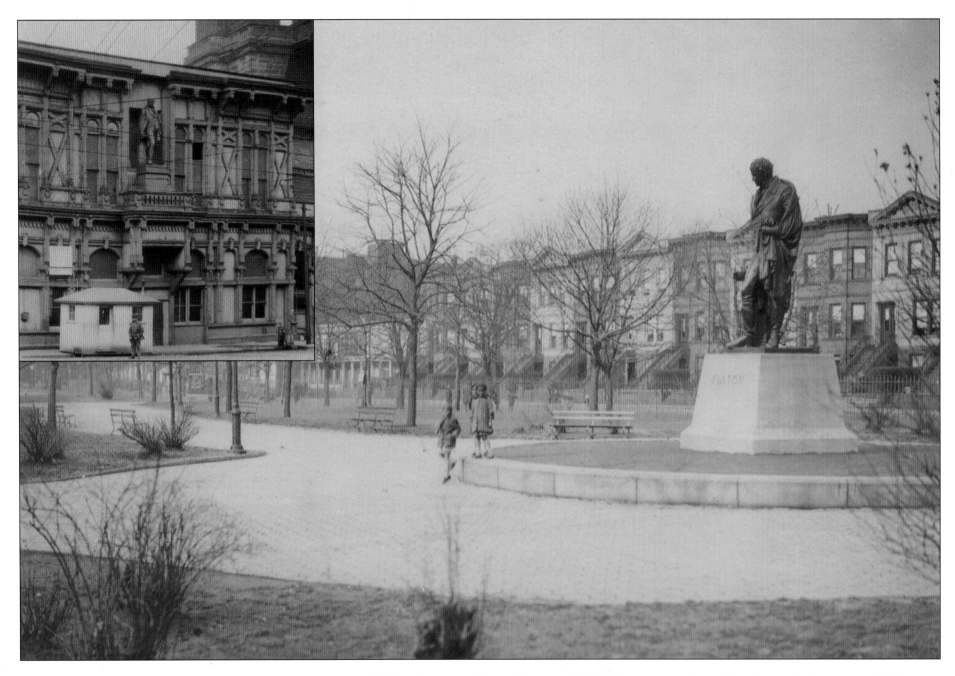

Fulton Street and Lewis Avenue, 1934. Before it was relocated to this park, the statue of Robert Fulton stood for more than fifty years on the East River waterfront. Leaning on a model of the steamboat that Fulton put into service between Brooklyn and Manhattan in 1814, the statue was once prominently displayed in front of the Fulton Ferry Terminal (see inset). After the terminal was demolished in 1926, the statue was placed in storage. The Society of Old Brooklynites, which had commissioned the statue, urged the city to find a new location, and the statue was installed in Fulton Park in 1930.

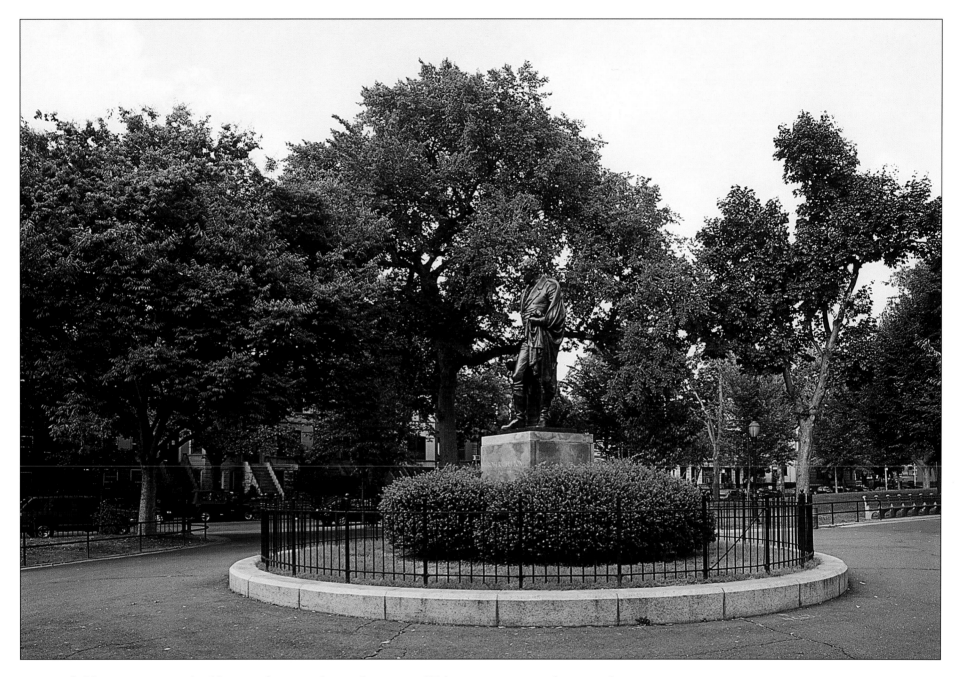

Surrounded by mature trees, shrubbery, and an iron fence, the statue of Fulton seems more at home in this view than when it was first placed in the park. However, the current statue is actually a bronze replica cast in 1955. The zinc original, too deteriorated to remain outside, is in the collection of the Museum of the City of New York. The homes in the 1934 photo still face the park. The surrounding neighborhood of Bedford-Stuyvesant is a combination of two middle-class neighborhoods of the nineteenth century: Bedford and Stuyvesant Heights. Once a white enclave, "Bed-Stuy" has the largest African-American population in New York City and largely retains its original streetscape of Victorian row houses.

Saratoga and Howard Avenues, 1897. Before this park was created, traveling circuses pitched their tents here, just east of the old Stuyvesant Heights section of today's Bedford-Stuyvesant. Freshly graded and planted with saplings, the park in this view is just a year old, even younger than the small children (left) who seem pleased to be photographed in this new setting. The policeman (far left) also appears interested, although perhaps a bit suspicious of the photographer. The park is named for the Battle of Saratoga, the turning point for America in the Revolutionary War.

Today, the park has grown along with the neighborhood. Despite the modern intrusion of the bathroom structure, this green preserve and its adjacent buildings retain the nineteenth-century scale of the surrounding historic area. At least one of the mature trees (far left) looks old enough to be an original planting.

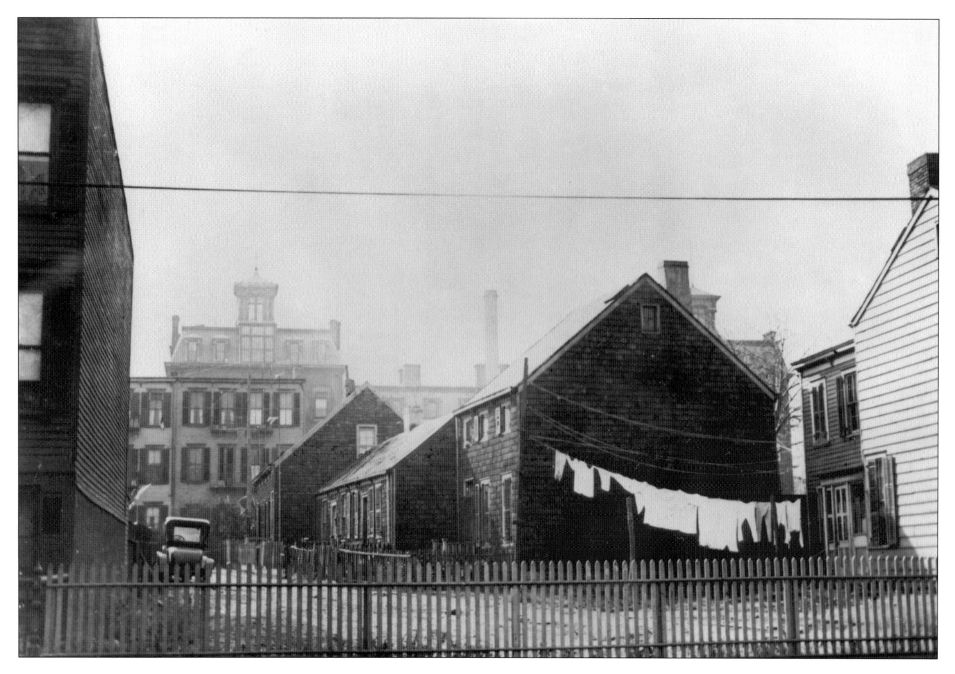

Bergen Street, between Buffalo and Rochester Avenues, 1920. The four wood-frame houses are mid-nineteenth-century remnants of a large, vibrant African-American community known as "Weeksville." Founded shortly after the abolition of slavery in New York in 1827, Weeksville was home to teachers, ministers, the first African-American female physician in New York, and the first African-American policeman in the City of Brooklyn. The neighborhood had its own newspaper, schools, and orphanage, and was an important refuge for hundreds of African-Americans who fled Manhattan during the brutal race riots that took place in the city during the Civil War. The clothes hanging on the line indicate that the old houses were still occupied in this view.

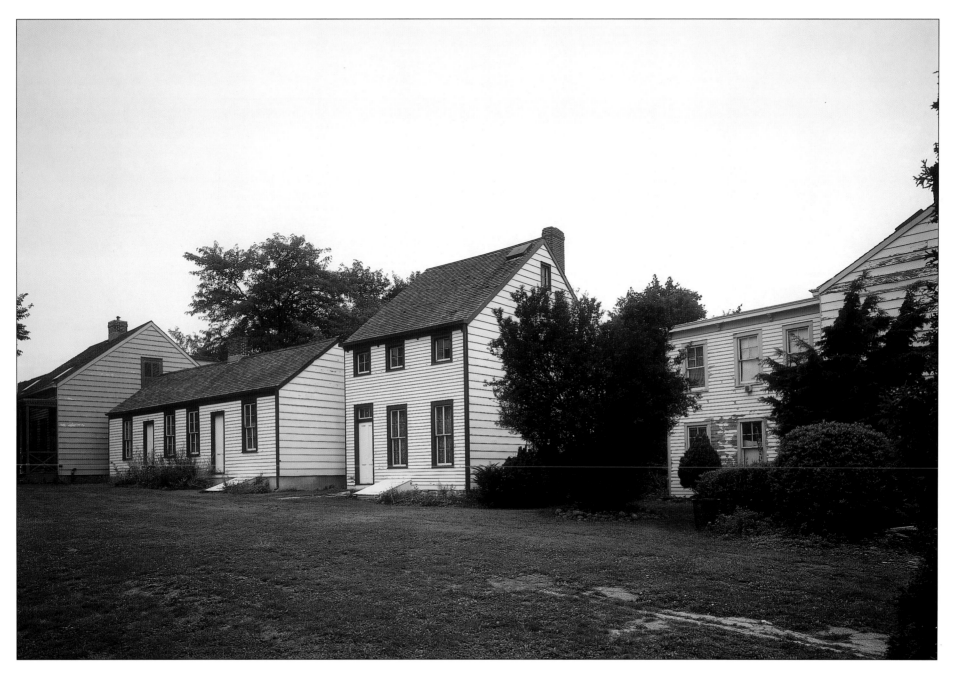

Overlooked during Brooklyn's rapid growth in the late nineteenth and early
twentieth centuries, Weeksville's place in history was rediscovered in student
workshops in the 1960s. The area, including two churches and a school built
in the 1840s, was designated a city historic district in the 1970s. The four
houses are operated as a museum and are being restored by the Society for the
Preservation of Weeksville and Bedford-Stuyvesant History. African
storytelling and other cultural programs are held on the grounds.

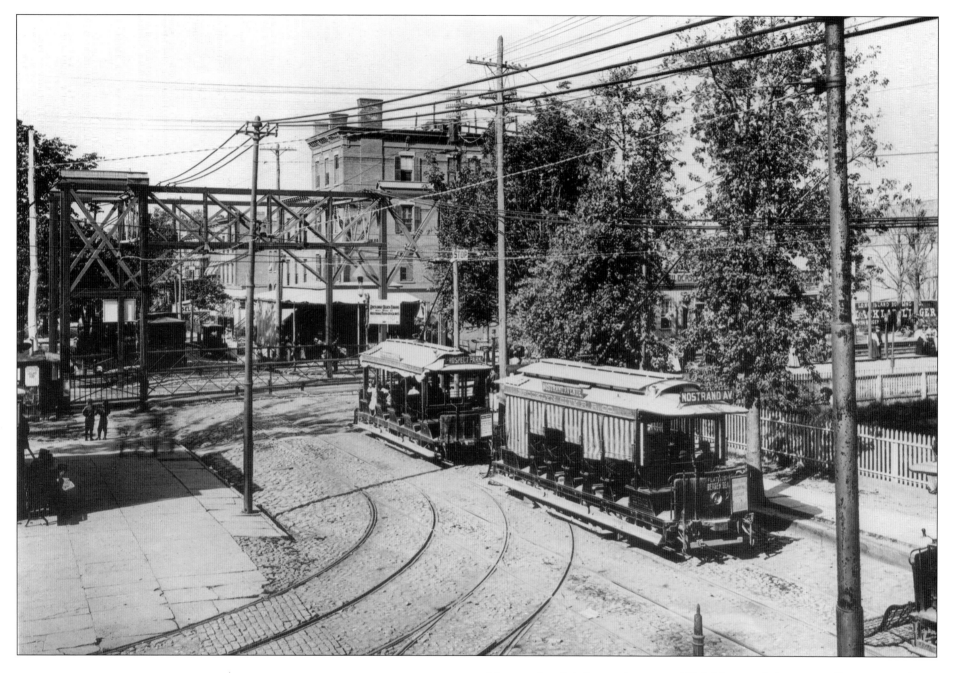

Nostrand and Atlantic Avenues, 1896. Nostrand Avenue trolley cars on the Brooklyn City Railroad Line are waiting at the closed gates of a grade crossing for the Long Island Railroad train to pass by on Atlantic Avenue. According to the sign on the gate, the train goes to Rockaway Beach, which may be its destination on this summer day.

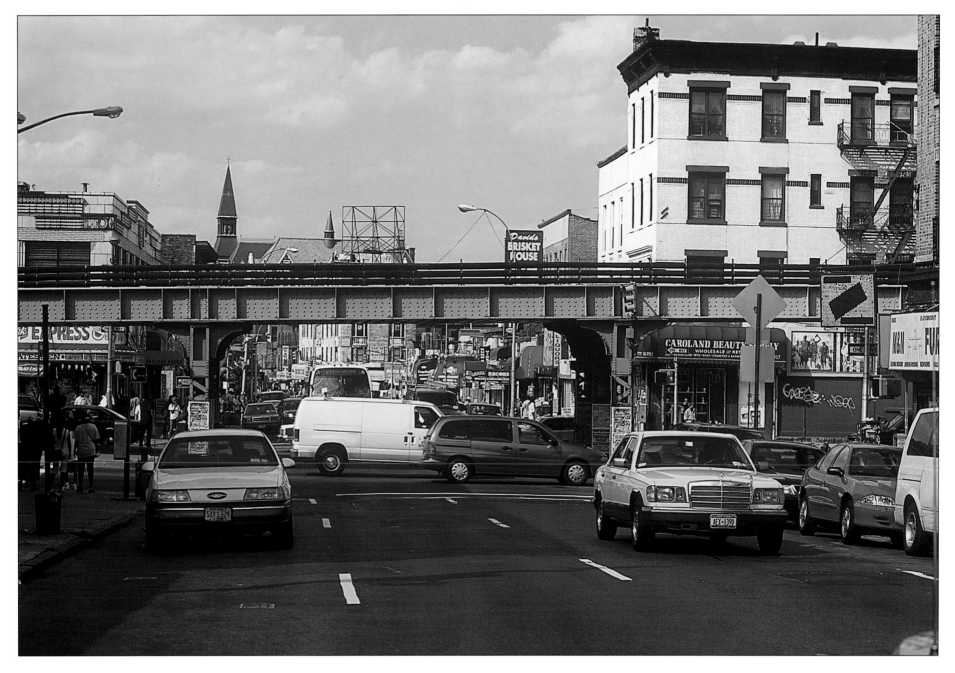

The Long Island Railroad still passes by this spot, but it now runs on elevated tracks. Although the busy intersection is hardly recognizable from the earlier photo, a closer look reveals the same buildings on one side of the street (right).

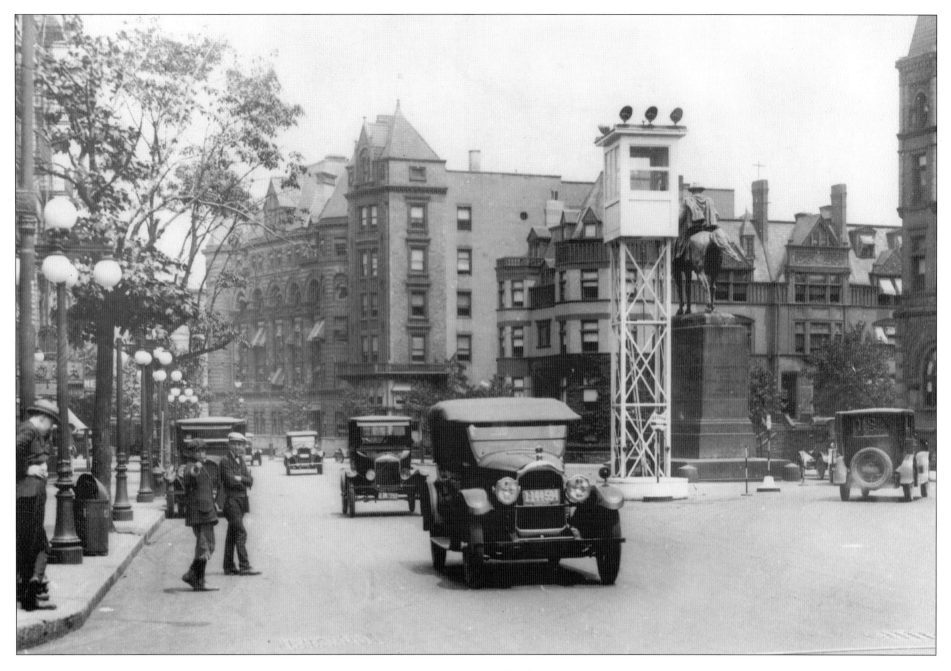

Bedford Avenue near Bergen, Dean, and Pacific Streets, 1924. This intersection was busy enough to require a traffic signal, the white tower next to the equestrian statue of Ulysses S. Grant. It was also a fashionable address in the 1890s and early twentieth century. At the corner of Dean Street (far right), part of the Union League Club, a gathering place for Brooklyn's leading citizens, is visible. On Pacific Street (left), are the Imperial Apartments, whose grand arches enclosed immense apartments.

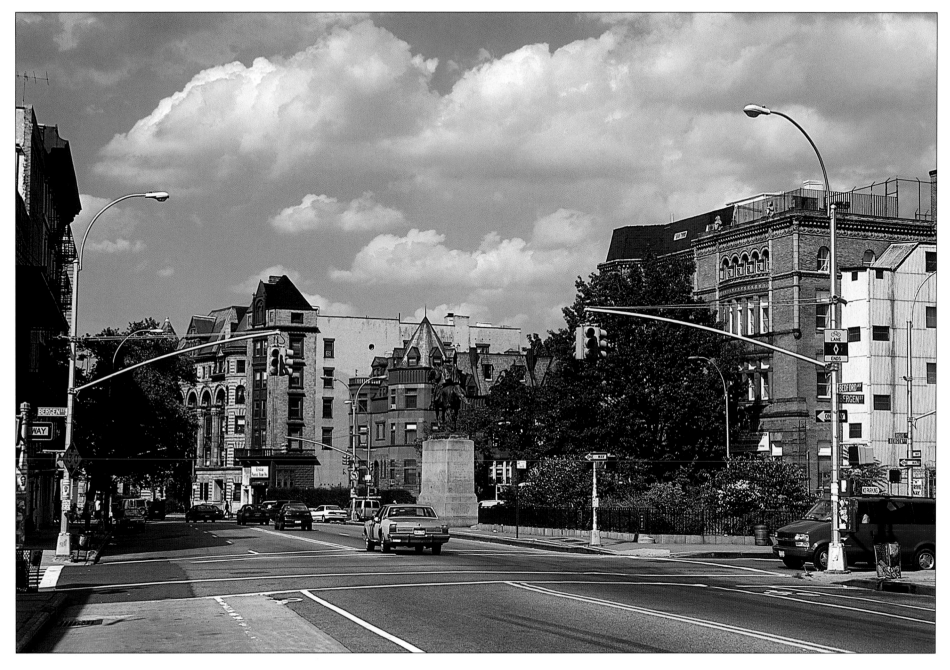

Today, the traffic signal is gone, but Grant's statue is still there and so are
the landmark buildings on either side of the square. The Union League
Club, built in 1890, is now a senior citizen center for local residents.
The Imperial Apartments, still an elegant structure, now contains smaller,
more affordable units.

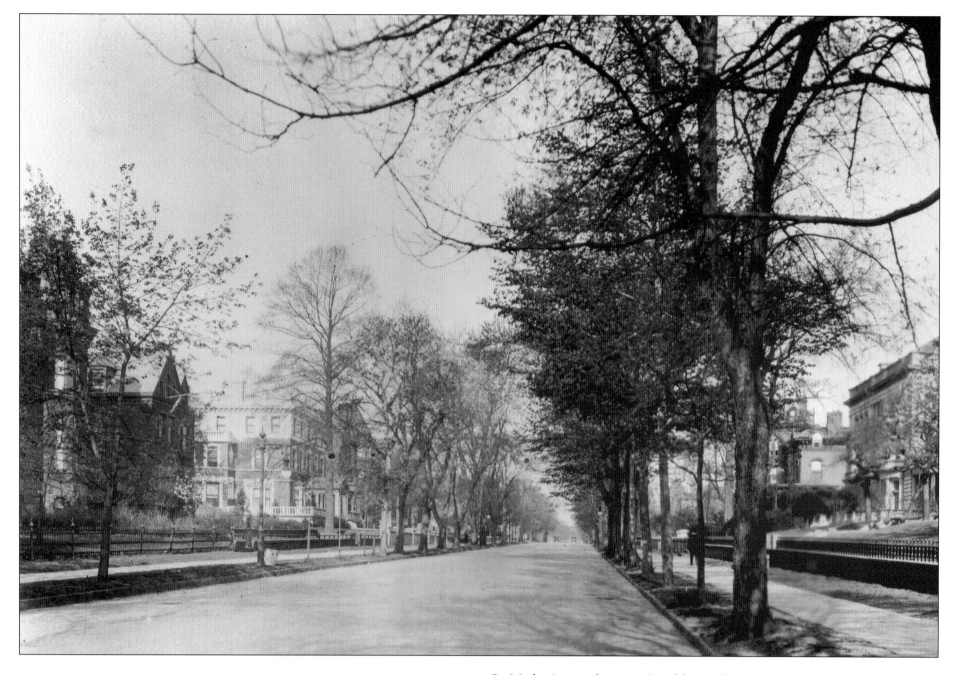

St. Marks Avenue between Brooklyn and New York Avenues, 1915. After the Civil War, wealthy businessmen began to build grand homes on St. Marks Avenue. In this view, the broad street is still one of Brooklyn's most fashionable addresses.

Only a few years after this view, the mansions began to give way to apartment buildings. This pattern was repeated in many neighborhoods as Brooklyn's transportation system and population grew, creating a market for larger buildings. By 1930, Brooklyn's population was 2.5 million, about what it is today.

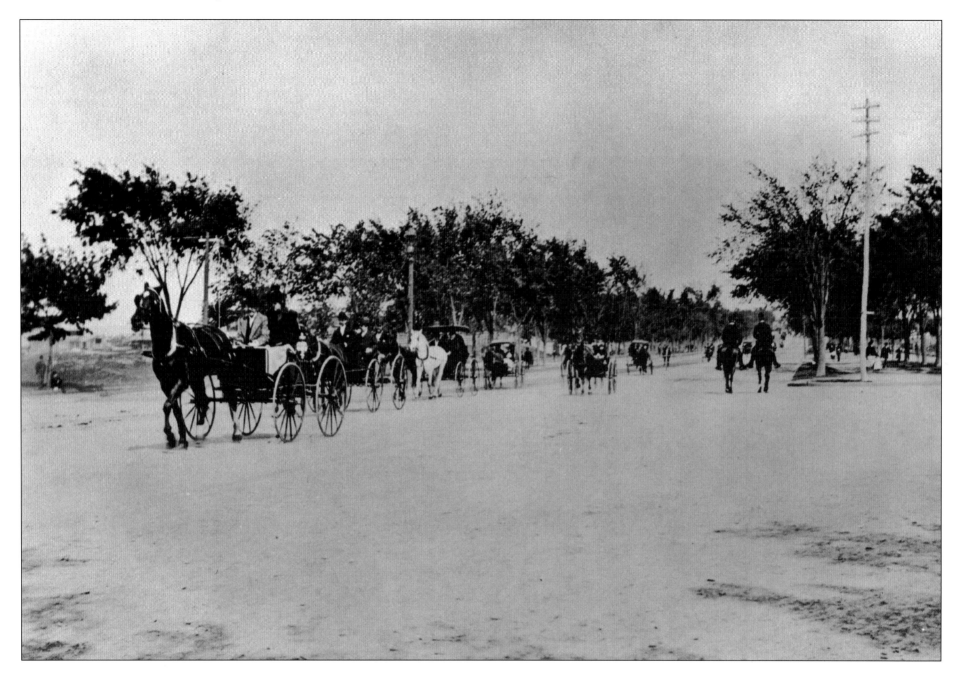

Eastern Parkway and Nostrand Avenue, 1897. A parkway, a landscaped road expressly for "pleasure-riding and driving," was a new idea of the mid-nineteenth century. These smartly dressed carriage riders are making good use of Eastern Parkway, the first one of its kind in the country. Its designers, Frederick Law Olmsted and Calvert Vaux, the same men who created the nearby Grand Army Plaza and Prospect Park, even coined the word "parkway." While their plan for an interconnecting system of parks and parkways was never fully realized in Brooklyn, they brought similar projects to many other American cities.

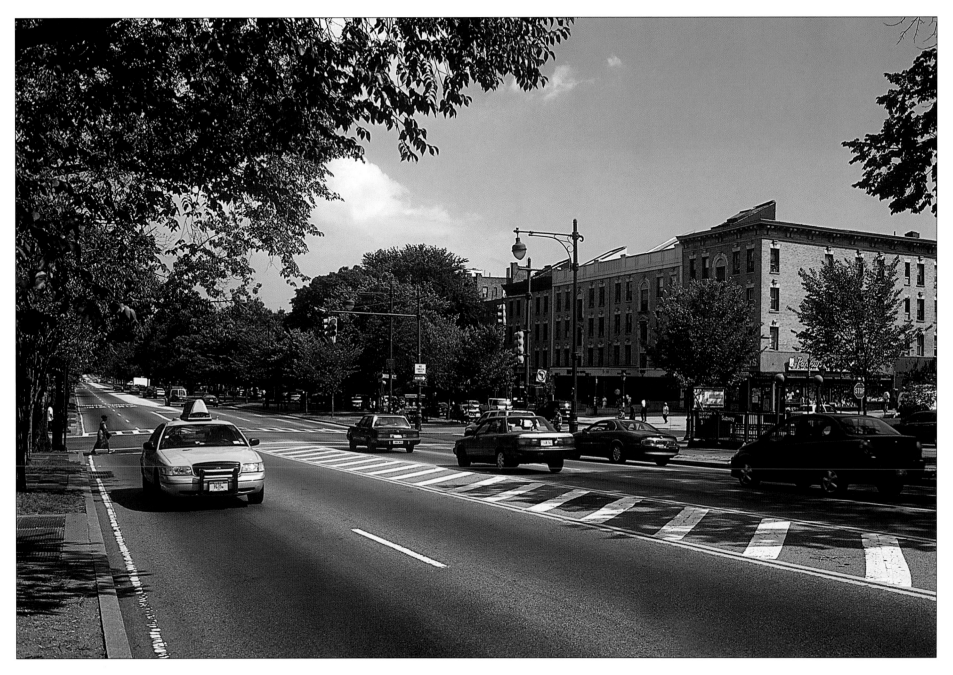

Eastern Parkway lost its original sidewalk and many of its beautiful trees
and light fixtures during subway construction in 1915. While Olmsted and
Vaux never envisioned a parkway for cars, recent improvements have
restored the historic character of the streetlights and landscaping. Today the
parkway is the main street for two racially and culturally different
communities, African-Americans and Hasidic Jews, who live within the
adjacent Crown Heights neighborhood.

Condover Street Pier, circa 1910. Indoor bathrooms were a luxury in Brooklyn tenements in the early twentieth century. The next best thing for waterfront neighborhoods like Red Hook was a floating bath, a barge with a wooden deckhouse that simply enclosed the harbor water below. When summer arrived, tugboats towed the floating structures out to working-class neighborhoods throughout New York City, and took them away for storage during the winter months. For local residents, like the boys in this photo, the indoor pools were places not only to bathe, but also to swim and play. Sadly, the harbor waters were also the place for industrial and sewage outfalls, and as the city's population and industrial activity increased, the water became too polluted for these simple pleasures. In the 1930s, the city built sanitary indoor pools away from the waterfront in Red Hook and many other neighborhoods.

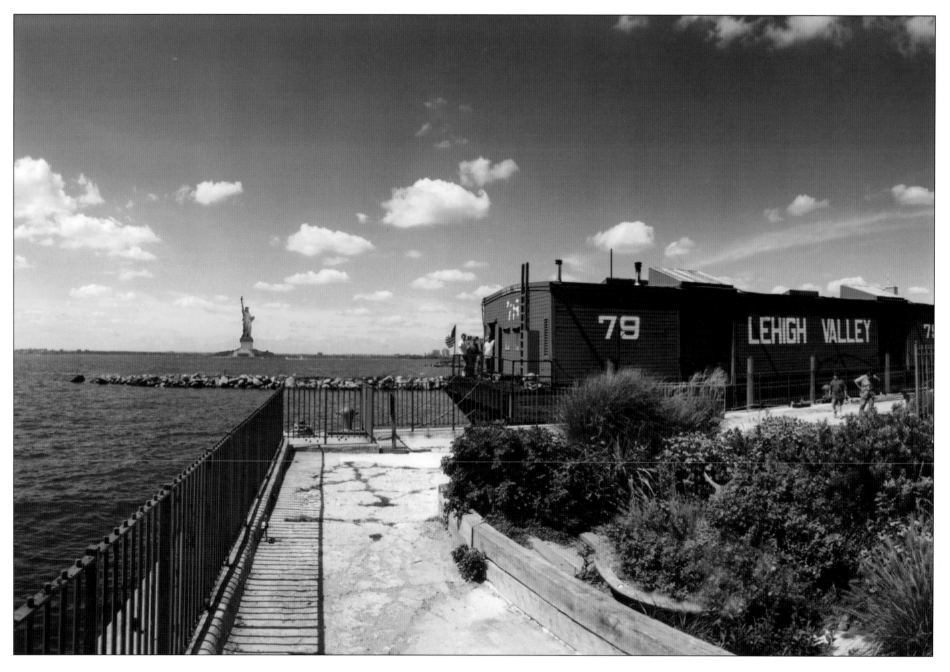

Like most of New York Harbor, Red Hook's waters are much cleaner today due to environmental controls. This pier, which offers spectacular views of the Statue of Liberty, is now home to the Waterfront Museum, a restored freight barge from the same era as the floating bath and the only one of its kind accessible to the public. Founded in 1986, the museum is a unique venue for performances by local musicians, and also offers educational programs and events for children. *Photo by Frank Zimmerman*

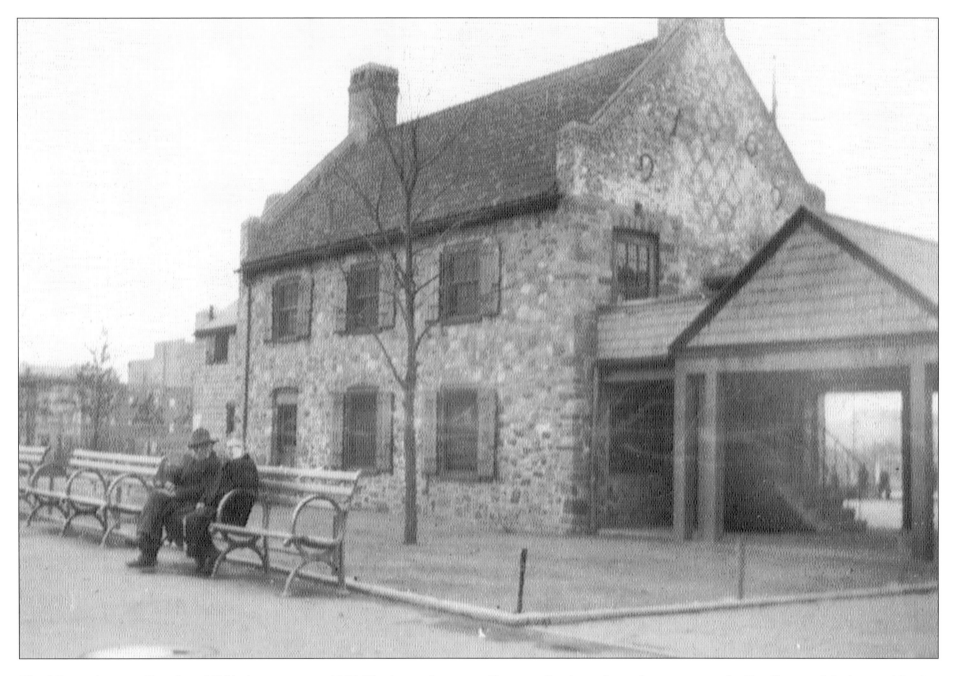

Third Street, between Fourth and Fifth Avenues, circa 1935. The house shown here is a replica built in 1935 to commemorate one of the earliest and bloodiest confrontations of the Revolutionary War. The original Old Stone House of Gowanus was built in 1699 and occupied by the British in 1776 during the first battle of the war. Continental troops from Maryland attacked the house, engaging the British for hours and allowing Washington's forces to cross the Gowanus Creek nearby and escape across the East River to Manhattan. Nearly all of the Marylanders—some 400 soldiers—were killed in the barrage of cannon fire from the house and many of their bodies are believed to lie buried under the surrounding streets. In the late nineteenth century, the site was a baseball field, used by the team that later became the Brooklyn Dodgers. The building, used as their clubhouse, was destroyed in the 1890s.

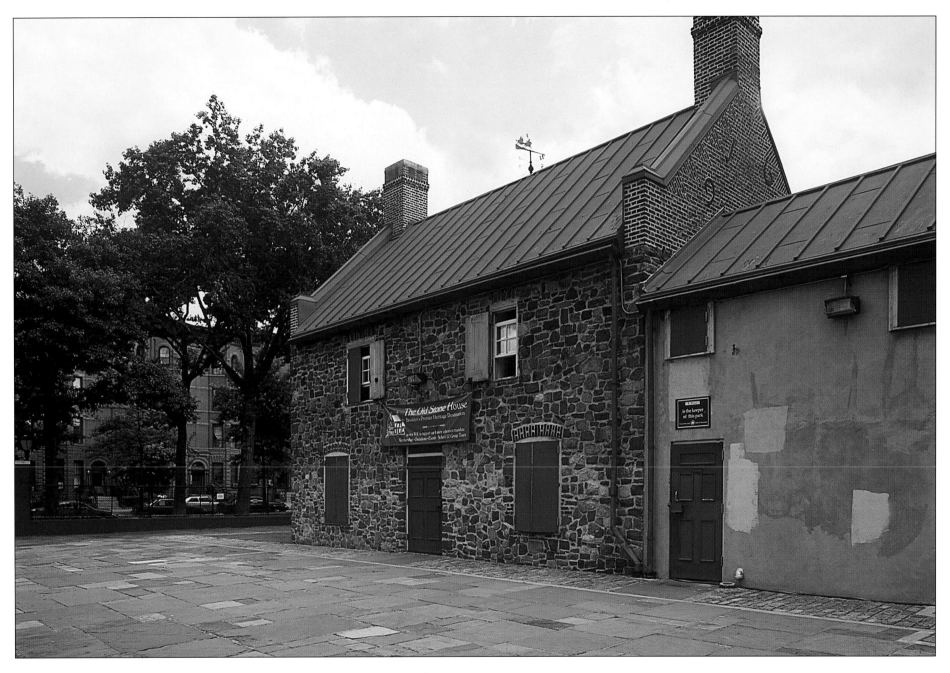

The Parks Department built the replica of the Old Stone House in 1935 using old photographs and what are believed to be the original stones unearthed at the site. Today, the house is located within a playground on the western edge of Park Slope. Operated by the First Battle Revival Alliance, the house is the site of lectures and exhibits about Brooklyn history.

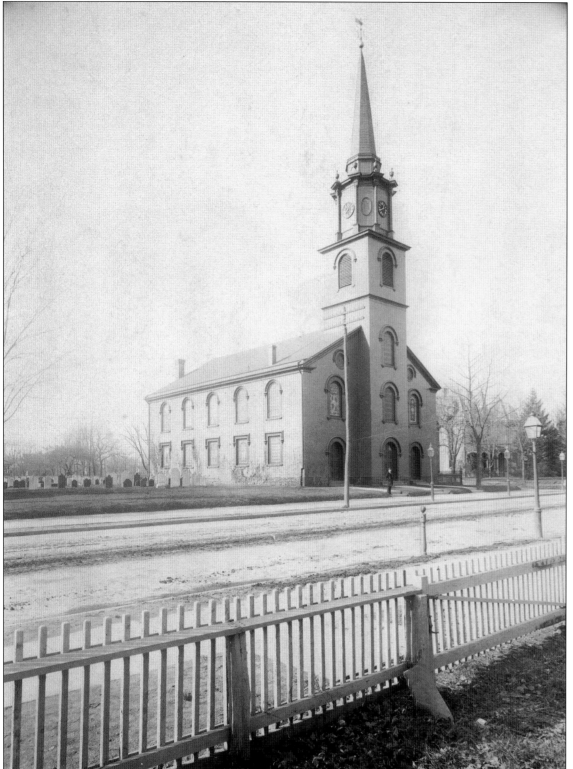

Flatbush and Church Avenues, 1892. This church was built in 1793 in Flatbush, one of the six Dutch towns that became Brooklyn and one of the last to change from farmland to an urban streetscape. Flatbush Avenue opened in 1858 and two years later, horse-drawn trolleys connected the area to the more developed parts of Brooklyn. At the time, a local historian warned: "The doom of Flatbush as a country place was forever sealed when in July 1860, the first car of the Brooklyn City Railroad Company was driven into the town." Steam-powered railroads followed in 1878, yet the long trip to downtown Brooklyn and Fulton Ferry, requiring transfers to horse-car connections, slowed the pace of development. At the time of this photo, the church is still surrounded by largely open land.

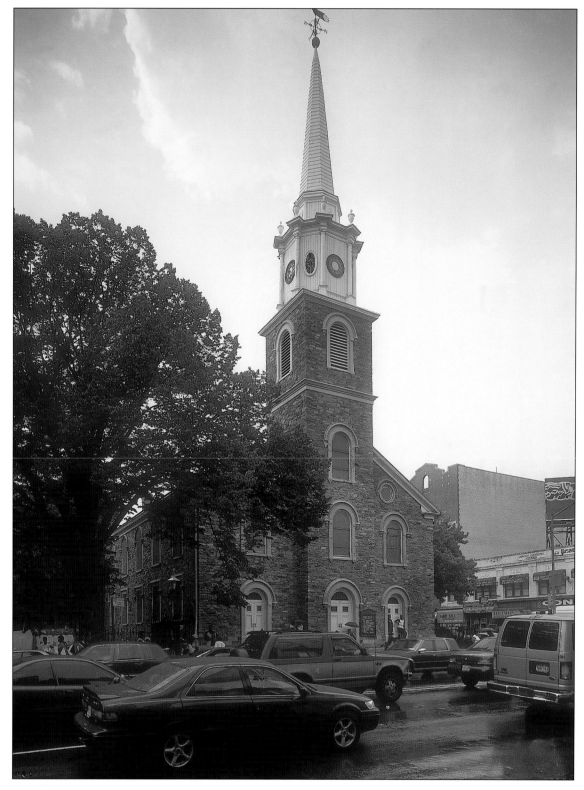

The open landscape in the earlier scene changed soon after the photo was taken. In 1899, the year that the rail line to Flatbush was electrified, providing direct service to the Brooklyn Bridge and Manhattan, farmland surrounding the church was sold for building lots. Today, the church and graveyard are in the midst of one of Brooklyn's busiest intersections. The large structure on the adjoining street (right) is the marquee of a multiscreen movie theater that overlooks the graveyard behind the church. The headstones in the graveyard bear the names of prominent Dutch families: the Vanderbilts, Lotts, Lefferts, Cortelyous, and Bergens, early settlers whose names are better known today as Brooklyn's heavily trafficked streets.

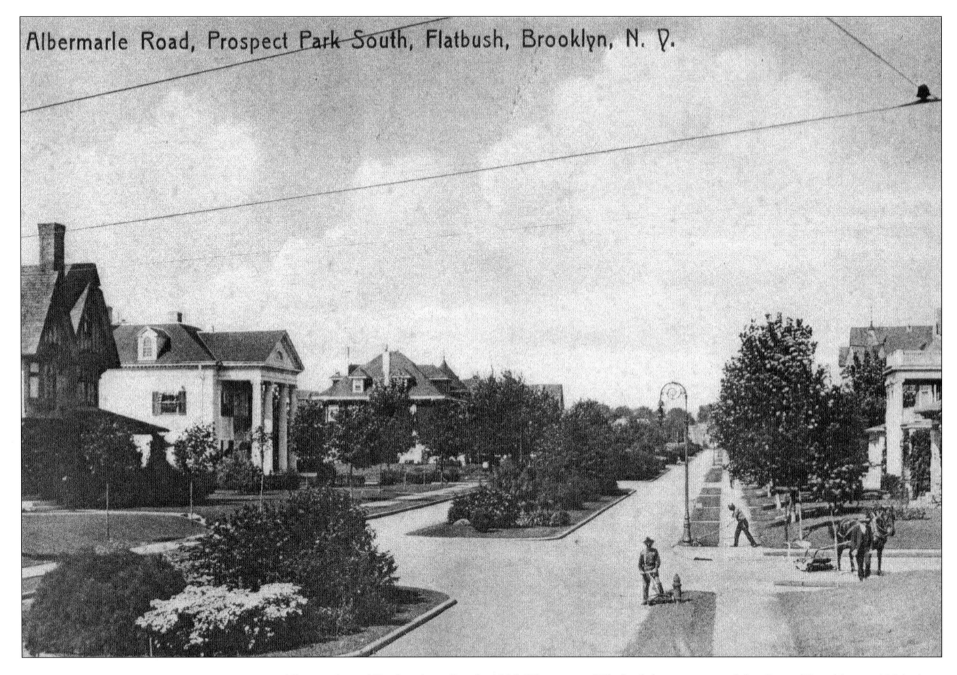

Albermarle and Buckingham Roads, 1905. The town of Flatbush became part of the City of Brooklyn in 1894. At the time, neighborhoods like Brooklyn Heights, Greenpoint, and Williamsburg were already urban villages, but in Flatbush, farms were just being subdivided and developed for homes. Instead of row houses, which would have created an urban image, several areas in Flatbush were developed as "rural parks." One of the loveliest was a planned community called "Prospect Park South." The homes here had ample front yards and the streets had central planting areas to enhance the sense of nature and open space. The British street names, Albermarle and Buckingham, added an air of refinement.

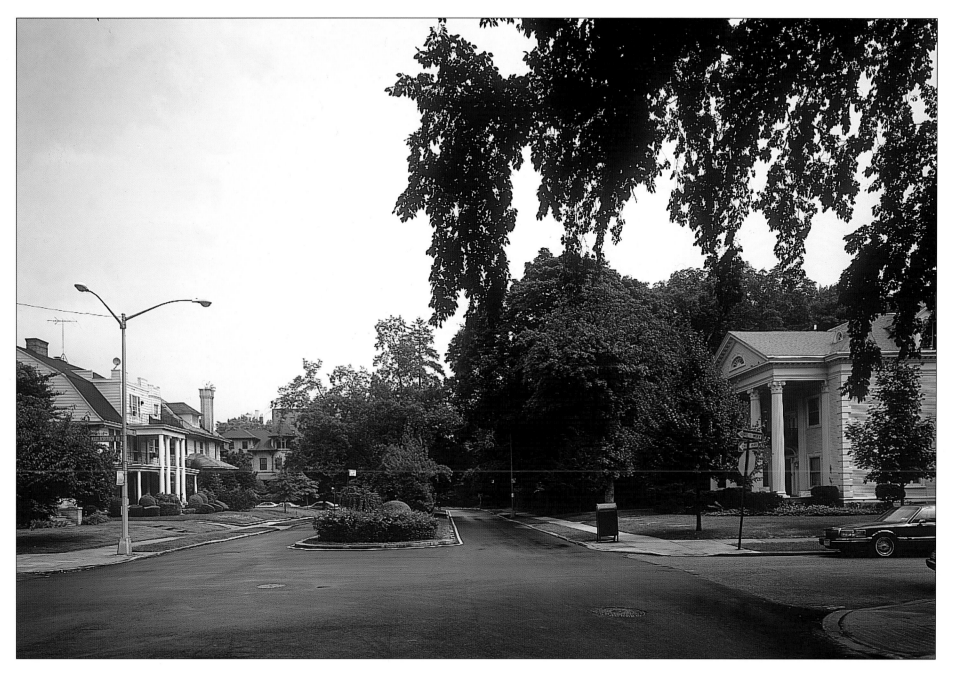

This photo is a mirror image of the earlier view, taken from the other side of
the street to avoid the full-grown trees that now block some of the houses. In
this landscaped setting, the century-old homes retain their original grace.

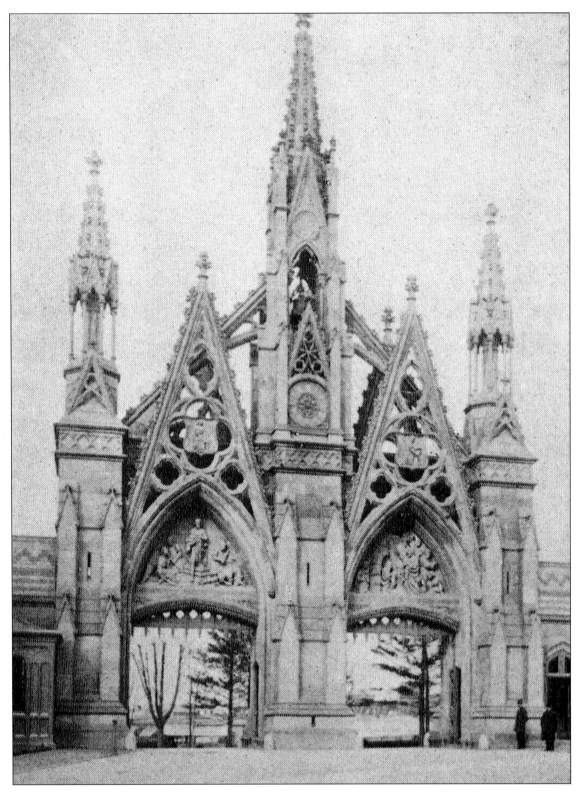

Fifth Avenue, near Twenty-fifth Street, circa 1900. Created in 1840 on 478 acres of rolling landscape, Greenwood was both a cemetery and Brooklyn's first large park. In fact, the cemetery was an inspiration for the later development of Prospect Park. People came to Greenwood not only to visit their families' and friends' graves, but also to stroll, enjoy views of the harbor, and even picnic on the beautifully landscaped grounds. On more serious occasions, the bell in the central steeple of this elaborate brownstone entrance tolled as funeral processions passed through the gate.

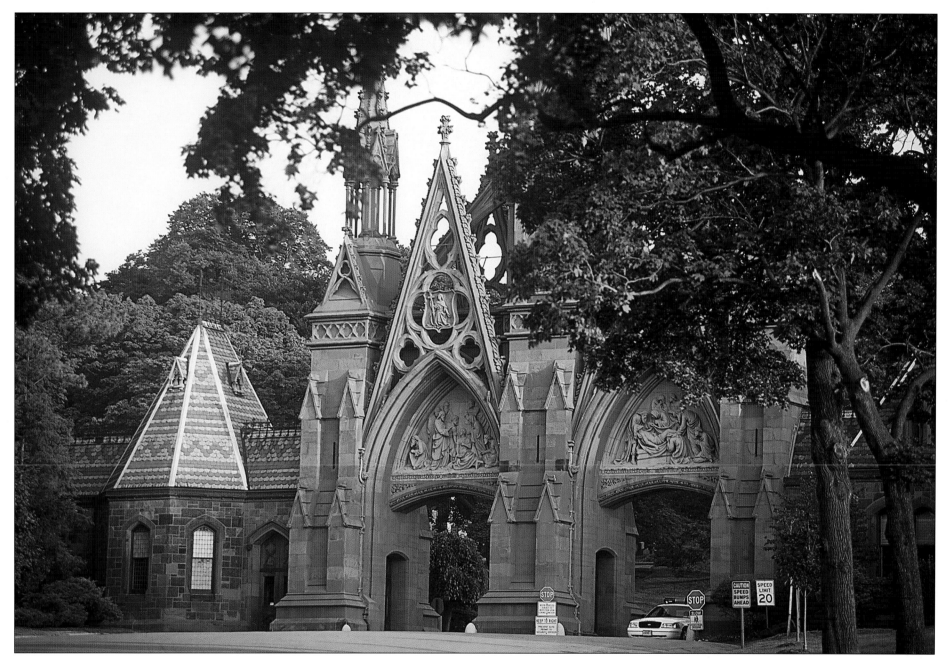

The gate, completed in 1865, is still an impressive entrance, and the cemetery continues to be the final resting place of many famous New Yorkers. It includes the graves of nineteenth-century notables such as Henry Ward Beecher, "Boss" Tweed, Nathaniel Currier, James Ives, and more recently, composer Leonard Bernstein.

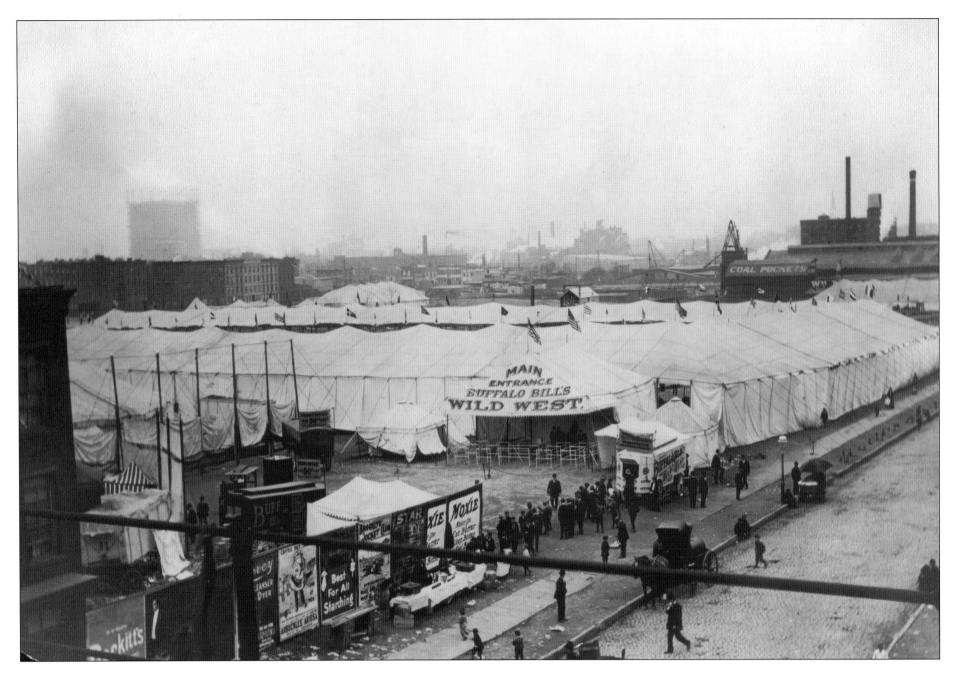

First Avenue, near Thirty-ninth Street, circa 1894. Brooklyn got a taste of the Wild West in traveling shows like this one that set up their tents on the waterfront's wide open spaces before they were developed for industry. Located near the Thirty-ninth Street Ferry to Manhattan, this site was not only big, but also easy to reach. A few years later, starting in 1902, Irving T. Bush developed this area as Bush Terminal. The facility became a 200-acre complex of warehouses, a waterfront railroad, and eighteen piers serving twenty-five steamship lines. By World War II, the terminal was known as "Industry City" and employed 25,000 workers, most of whom lived in the adjacent Sunset Park.

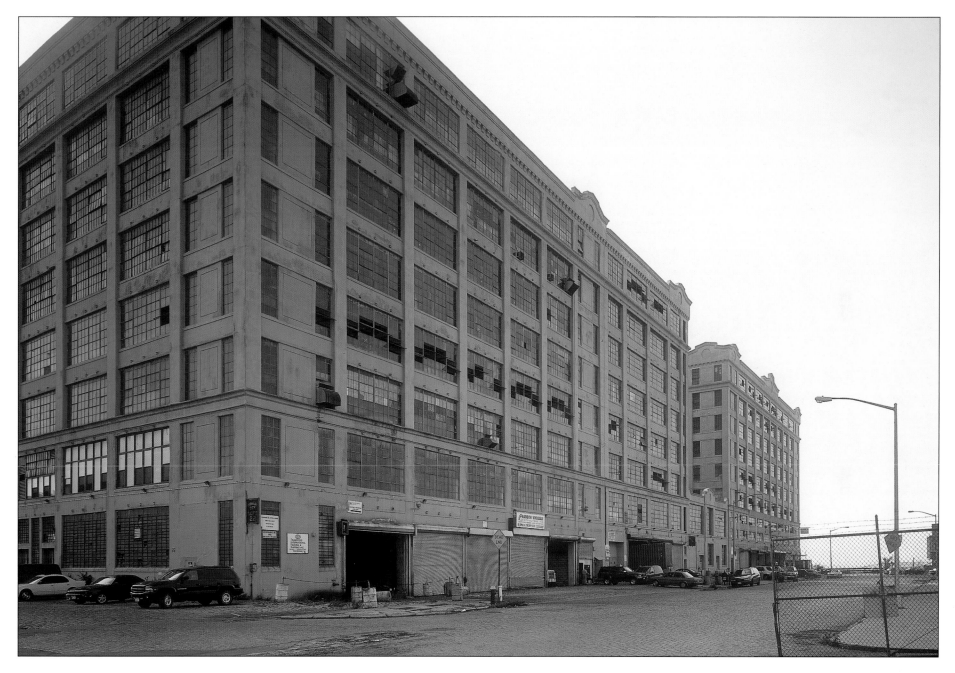

In the 1950s, even bigger shipping facilities, known as "containerports," were developed across the harbor in New Jersey. Bush Terminal, like piers and warehouses all along Brooklyn's waterfront, could not compete with the newer ports that handled cargo in much less time. However, manufacturers still operate in many of Bush Terminal's industrial buildings and many are being equipped with high-speed internet connections to attract new businesses. In a possible return to the days when people gathered on the waterfront, local residents are urging the city to develop part of the area for a park.

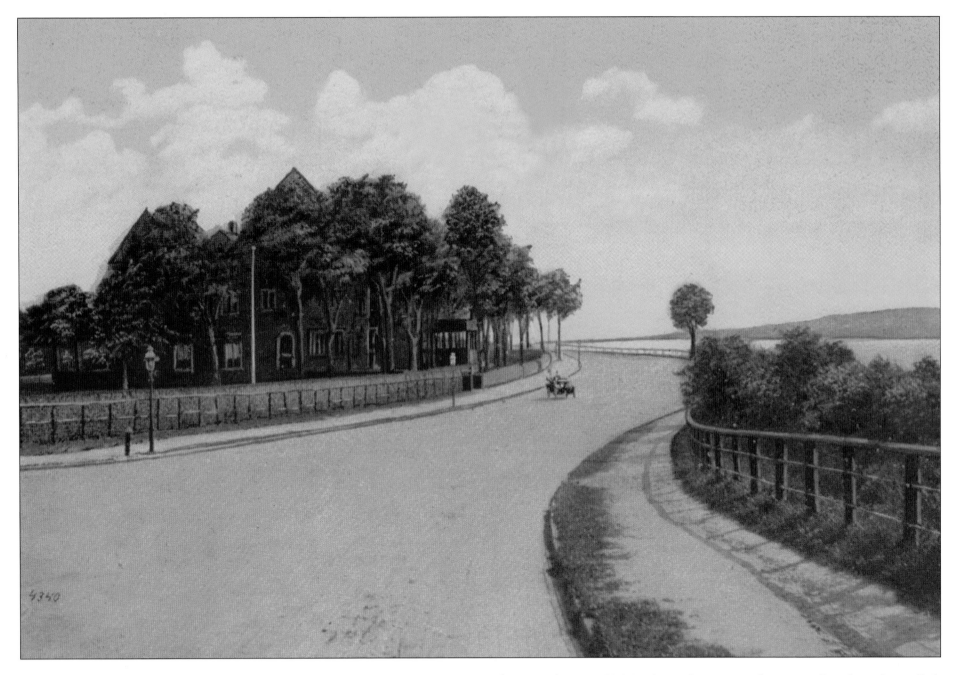

Shore Road, circa 1926. In the mid-seventeenth century, Dutch settlers called this area "Yellow Hook" for the color of the soil. After the yellow fever epidemic of 1848, local residents chose a more appealing name, Bay Ridge, for its location on New York Bay. This view is looking south toward the Narrows, the entrance to New York Harbor, and shows Staten Island across the bay.

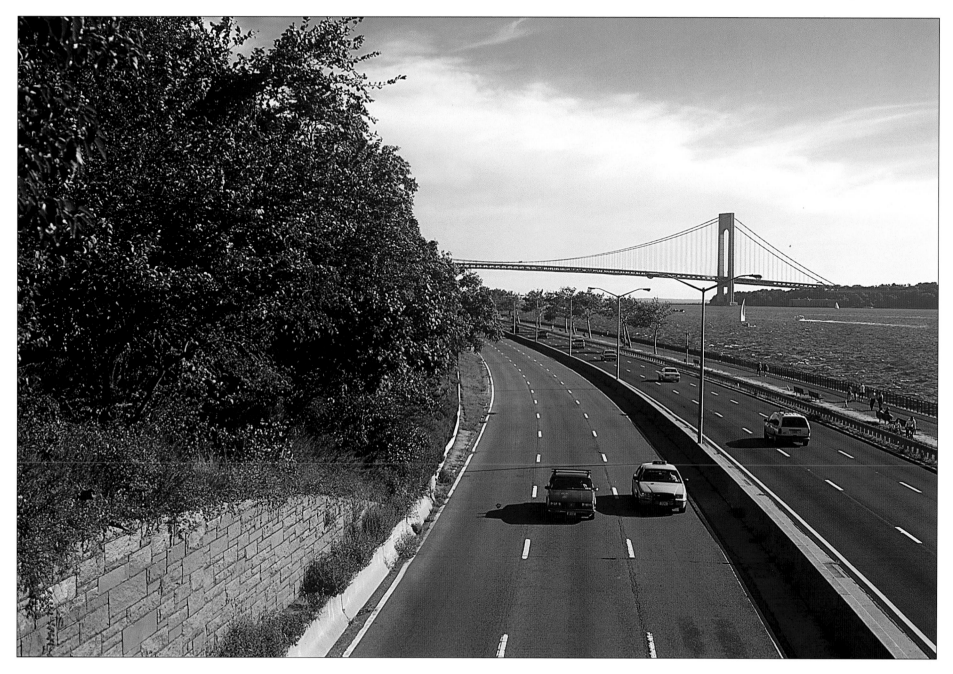

Today Bay Ridge is a bustling neighborhood with two major transportation connections, the Verrazano Narrows Bridge and the Belt Parkway. Built in the 1960s, the bridge, which connects Brooklyn and Staten Island, is named for Giovanni da Verrazano, Brooklyn's first European visitor, who sailed into these waters in 1524. This view is from a bridge that crosses the parkway and leads to an esplanade along the waterfront (right). Four miles long, the esplanade is a popular place to stroll, jog, or bike along the Narrows and bay.

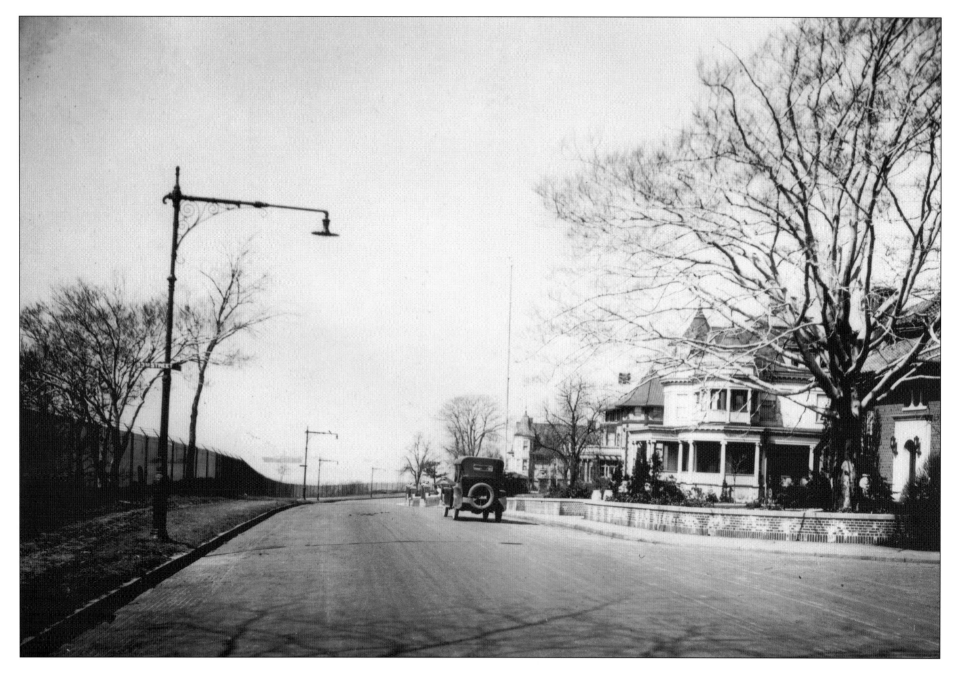

Shore Road at Ninety-third Street, circa 1920. Railroads began to bring people to Brooklyn's southern areas in the 1870s, a time when affluent New Yorkers built summer "cottages" like these on the high bluffs of Bay Ridge overlooking New York Bay. By the time this photo was taken, subways had reached the neighborhood and the area was in the midst of change.

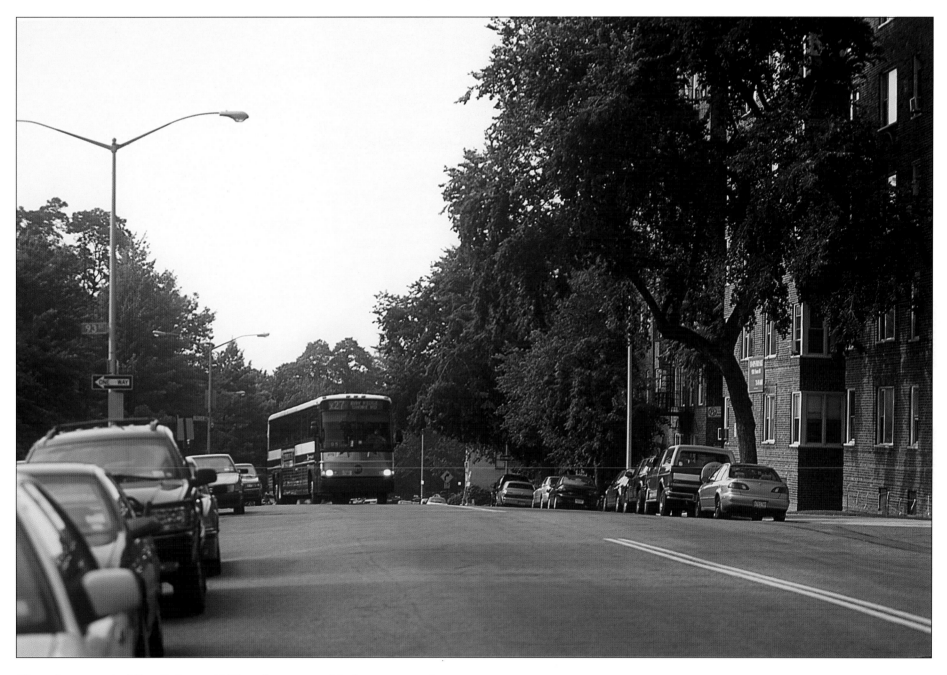

The subway reached Bay Ridge in 1915, making it possible for more people to work in Manhattan and live in Brooklyn's outlying neighborhoods. Following the subway, developers built large apartment buildings like these, tall enough for many more people to enjoy Shore Road's view of the bay.

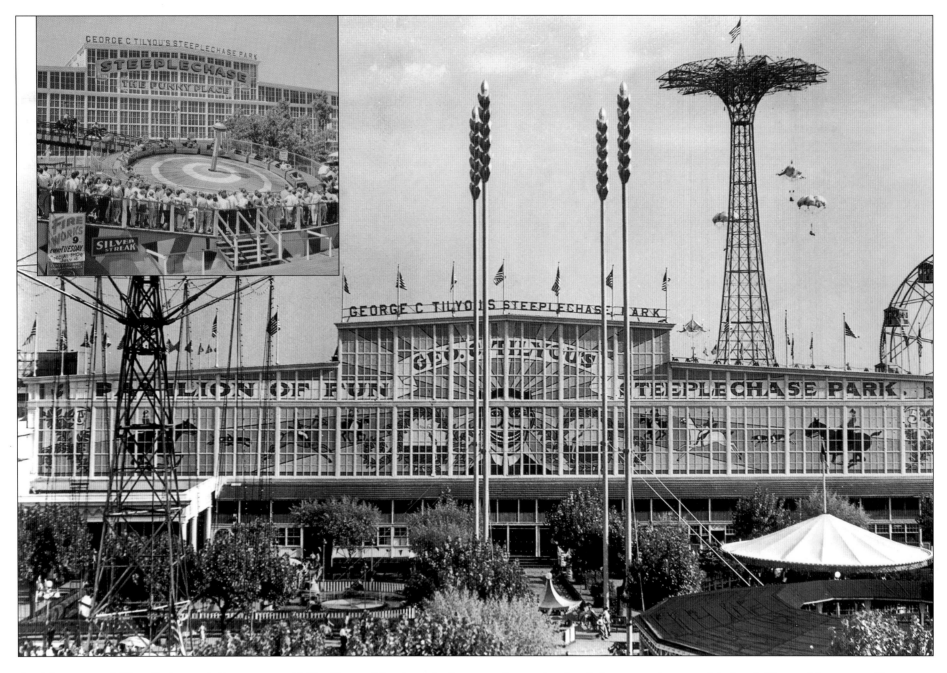

Surf Avenue and West Eighteenth Street, circa 1950s. Coney Island reached its heyday in the 1890s when developers created elaborate new amusement parks and tried to outdo each other with unique rides and attractions. The longest lasting of these great pleasure palaces was Steeplechase Park, an enclosed, fourteen-acre facility that operated continuously from 1897 to 1965. Inside, attractions such as "The Funny Place" (see inset) offered jostling, jerking rides that left visitors dizzy yet delighted. The park's creator, George Tilyou, also introduced a simulated racecourse ride, the mechanical horses shown to the left in the inset that gave Steeplechase its name. He also moved the parachute jump here, the tower to the right, after its debut at the 1939 World's Fair. *From the Brian Merlis Collection (main image)*

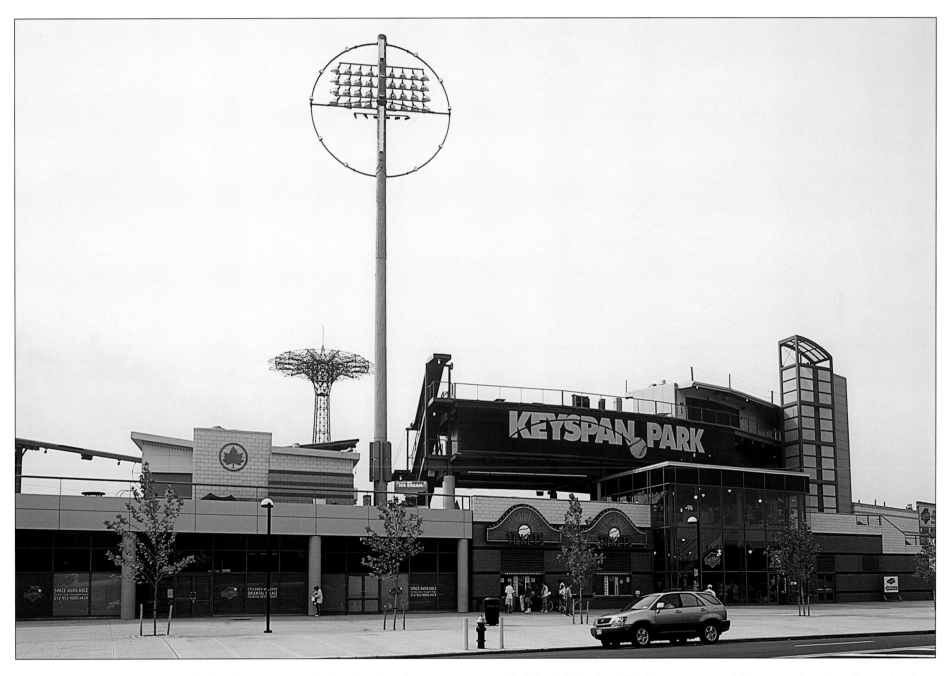

Steeplechase Park was demolished in the 1960s, and after four decades as a barren site, a new baseball park opened here in June 2001. The brand new stadium, named for its sponsor, is the home of the Brooklyn Cyclones, a minor league team whose namesake, Coney Island's famous roller coaster, operates a few blocks away. The new stadium has given this part of Surf Avenue a much-needed facelift. It also affords great views of the ocean (on the other side of the stadium) and the parachute jump (left) which is still standing on the beachfront. Although the tower has been closed for many years, the structure is preserved as an historic landmark.

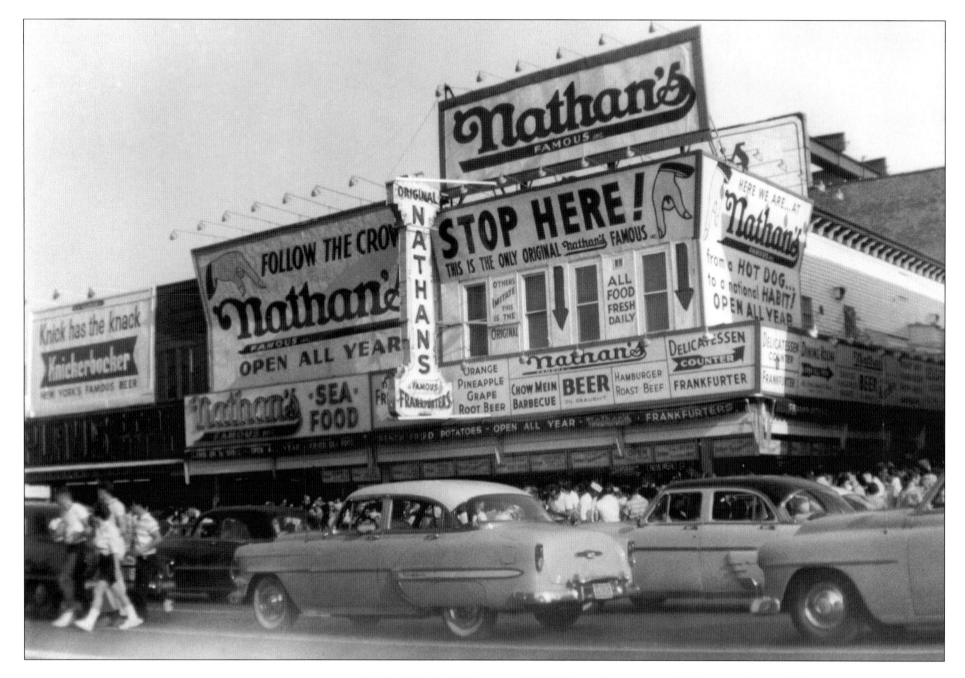

Surf and Stillwell Avenues, 1958. This is the same stand where Nathan and Ida Handwerker made the Coney Island hot dog famous. In 1916, they sold hot dogs for a nickel—five cents cheaper than Feltman's Dining Gardens did a few blocks away. Charles Feltman, the German-American proprietor of a huge restaurant and roller coaster, is credited with introducing the frankfurter to American patrons in the 1870s. Starting out as a waiter at Feltman's, Nathan Handwerker turned this hot dog stand into a more lasting attraction. Covered with signs, the open storefront was at the peak of its operation in this summer photo.

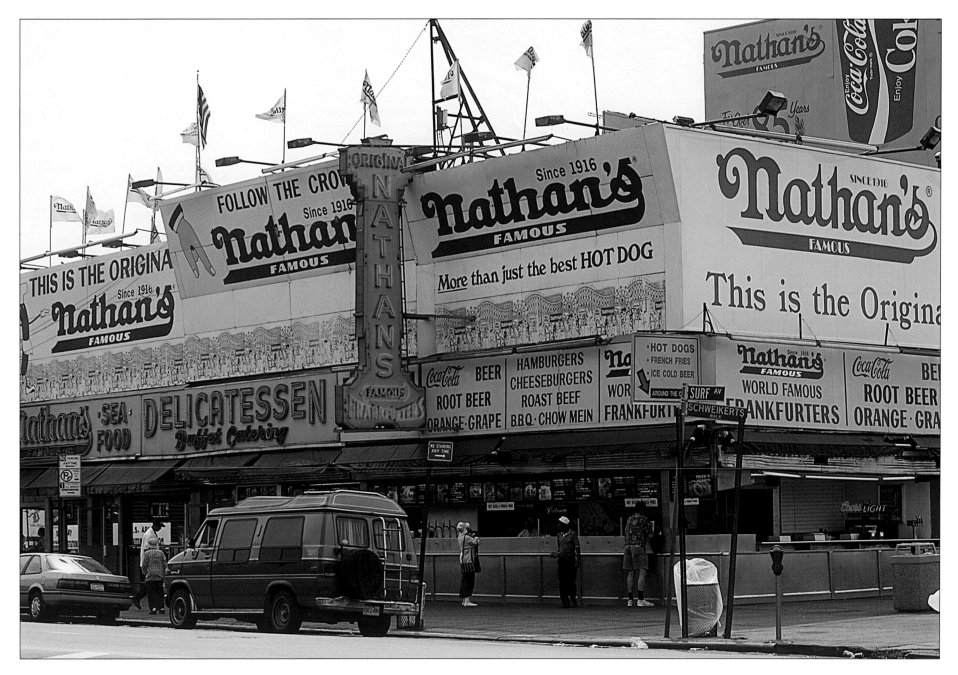

Looking much the same as it did in 1958, this self-serve restaurant makes McDonald's seem serene. Even in the 1970s and 1980s, when Coney Island had lost its glitter and was drawing fewer visitors, Nathan's was handling crowds in all seasons and at all hours of the day or night. Today, Nathan's franchise operations are located throughout the country, but this is the real thing—noisy, garish, and to millions of New Yorkers, irresistible. People continue to come here from all over the city to devour hot dogs, french fries, and unusual menu selections, like the chow mein sandwich.

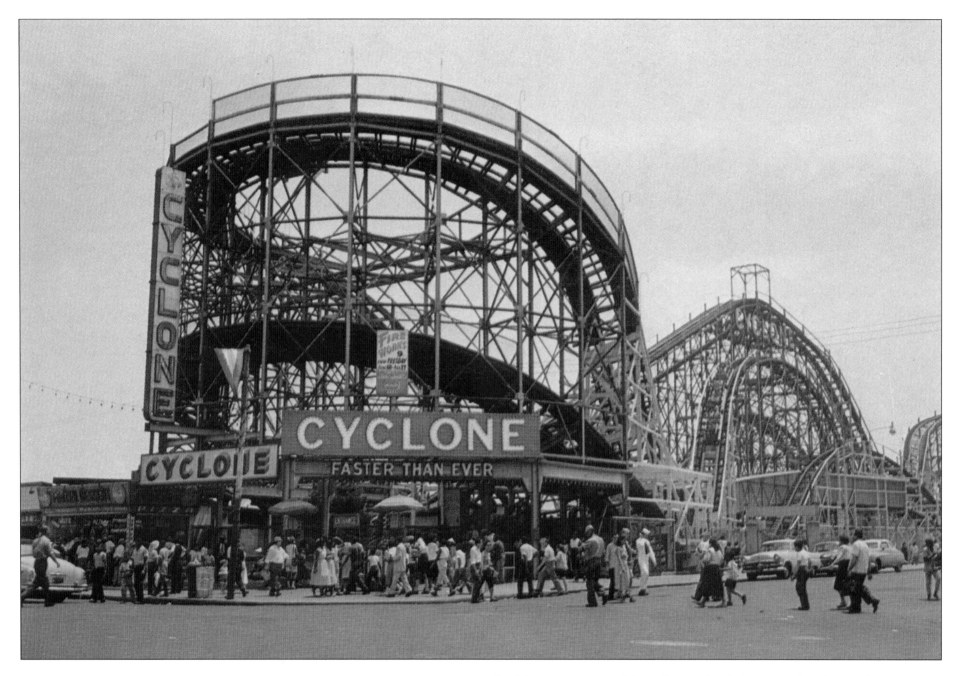

Surf Avenue and West Tenth Street, 1955. Covering 3,000 feet of wooden track in less than two minutes, this roller coaster was the biggest and fastest ride of its kind in the country when it was built in 1927. Pulled by a chain to the top of the first steep hill, the three-car train plunged and ran on its own momentum, traveling up and down nine hills and around six curves at 68 miles an hour.

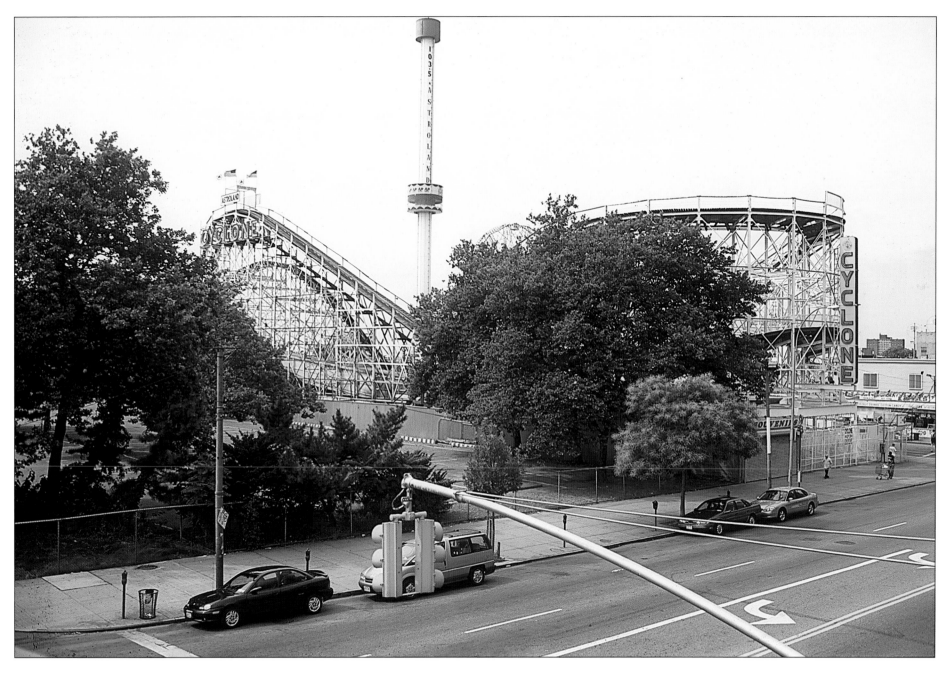

While modern rides are higher and faster, the gravity-propelled Cyclone still
provides a thrilling ride. Nearly demolished in the 1970s, the structure was
saved through an outpouring of local support and later designated an historic
landmark. "Unlike the Dodgers," a neighborhood civic leader predicted, "the
Cyclone will never leave Brooklyn." The slender tower in this photo (center)
is Astroland, a ride created in 1964 that is 260 feet high.

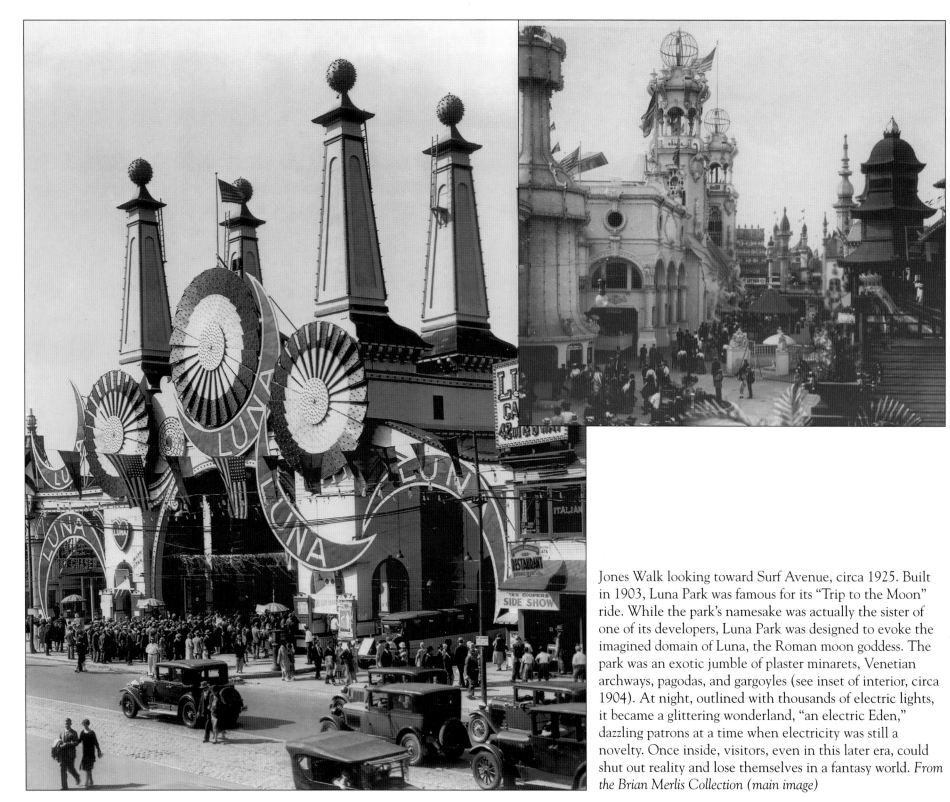

Jones Walk looking toward Surf Avenue, circa 1925. Built in 1903, Luna Park was famous for its "Trip to the Moon" ride. While the park's namesake was actually the sister of one of its developers, Luna Park was designed to evoke the imagined domain of Luna, the Roman moon goddess. The park was an exotic jumble of plaster minarets, Venetian archways, pagodas, and gargoyles (see inset of interior, circa 1904). At night, outlined with thousands of electric lights, it became a glittering wonderland, "an electric Eden," dazzling patrons at a time when electricity was still a novelty. Once inside, visitors, even in this later era, could shut out reality and lose themselves in a fantasy world. *From the Brian Merlis Collection (main image)*

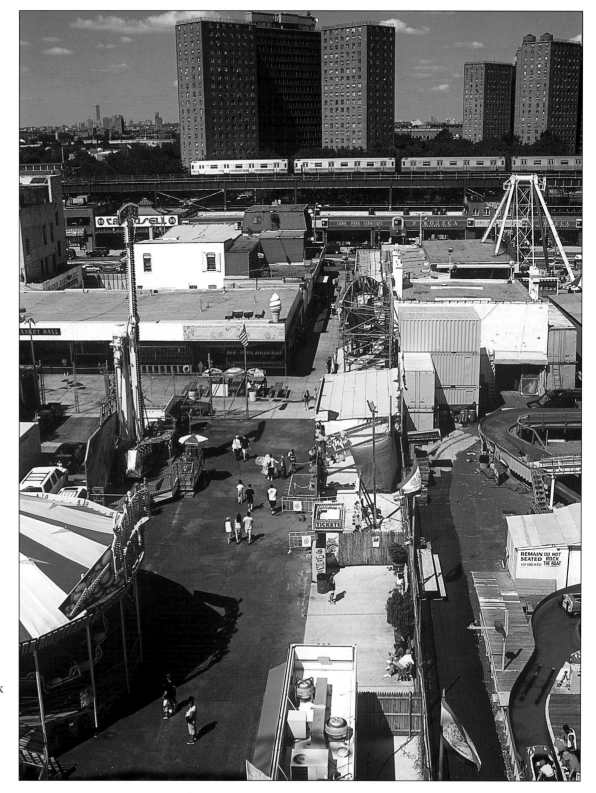

Damaged by fire in 1944, Luna Park afterward closed its doors and never reopened. Decades before, when its neighboring attraction Steeplechase Park had burned, its enterprising owner had charged people to view the smoldering ruins and soon rebuilt the entire park. But the Luna Park fire, in the midst of World War II, presented a greater challenge. After the war, apartment houses, not amusement parks, were in much greater demand. Luna Park was demolished and the Luna Park Houses (background) were built in its place. Smaller attractions still operate on the Coney Island beachfront (foreground).

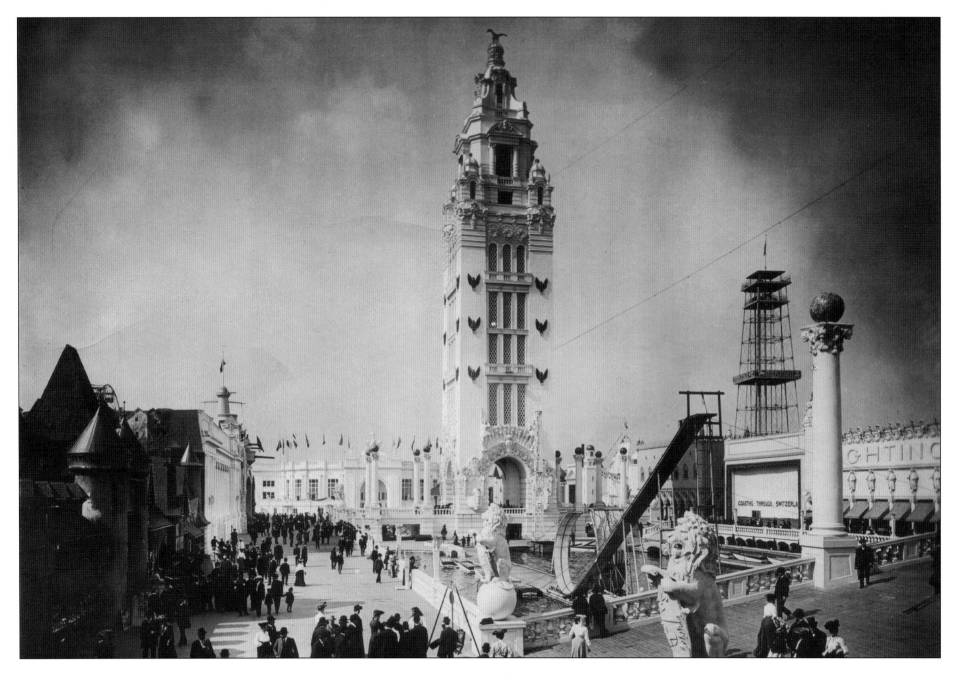

Surf Avenue at West Eighth Street, circa 1905. Just a year old in this view and still wearing its new coat of gleaming white paint, Dreamland was the Disneyland of its day. Designed to reach a middle-class audience, it offered "educational" re-creations of famous places and events. Beyond this peaceful lagoon and 375-foot-high tower (center), visitors could "travel" to the "four corners of the world" just off the central plaza. They could take a sleigh ride through Switzerland, glide in a gondola past the Doge's Palace in Venice, ride a miniature locomotive to a Lilliputian village, or witness the terrors of a lava flow inside the Fall of Pompeii Building.

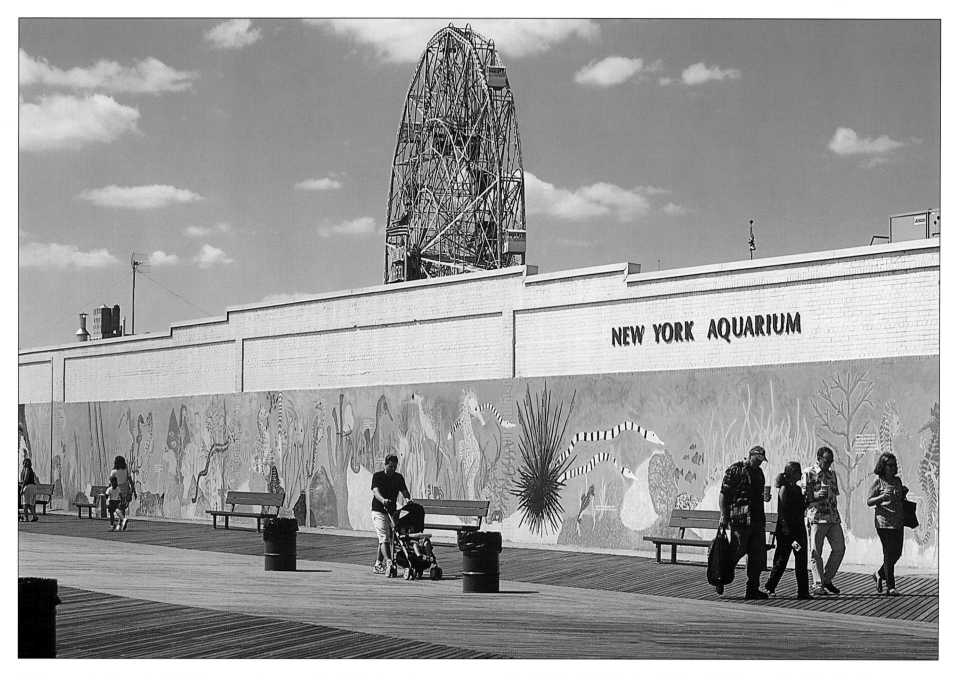

Unfortunately, Dreamland, the last great fantasy park to be built in Coney Island, was also the first to be destroyed. Its world of make-believe came to an end in an all-too-real fire that destroyed the park in 1911. Never as popular as Steeplechase or Luna Park, Dreamland was never rebuilt. Today the site is home to the New York Aquarium where visitors can see whales, walruses, octopuses, electric eels, and other real-life monsters of the deep. Originally in Manhattan, the aquarium was rebuilt on this site in 1955. Rising above its wall is the Wonder Wheel, a 150-foot-high Ferris wheel that has been operating here since it was completed in 1920. The ride's height is not its only excitement. Sixteen of the twenty-four cars swing out, giving riders the sense of flying off the structure as the wheel turns.

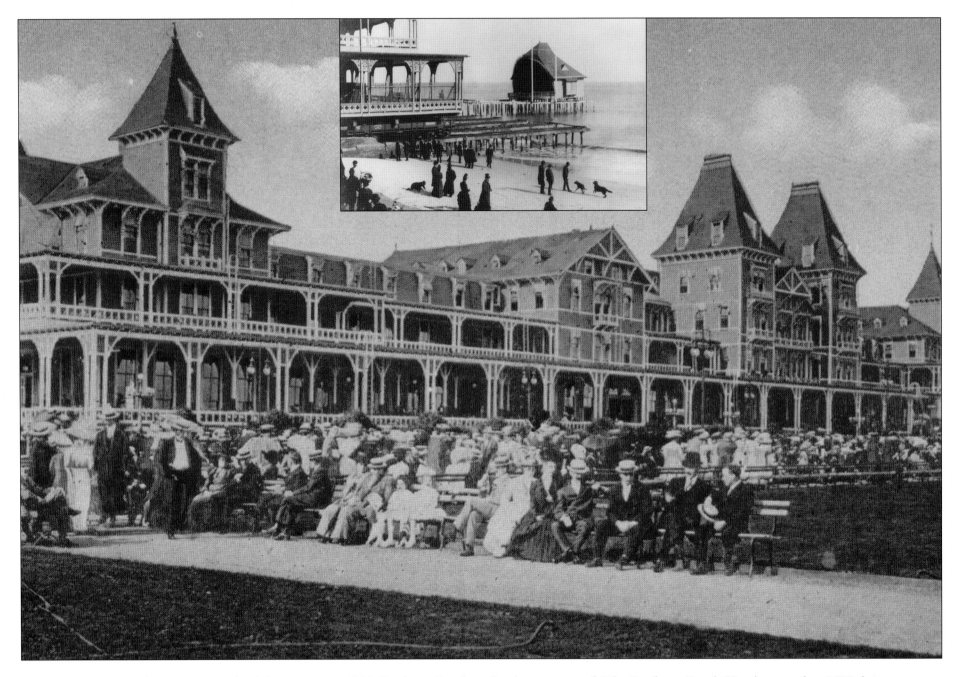

Brighton Beach Hotel, near Coney Island Avenue, circa 1910. Brighton Beach is actually part of Coney Island, but in the first half of the nineteenth century, the island had developed an unsavory reputation as a place for gamblers, pickpockets, pimps, and prostitutes. In the 1870s, railroad owners and businessmen began to build grand hotels on the island, directed toward a better clientele. Seeking a new image, they came up with new names for the area: "Brighton Beach" for Coney Island's midsection and "Manhattan Beach" for the eastern end. The Brighton Beach Hotel, opened in 1878, became famous during the blizzard of 1888 when high seas washed away the hotel's shoreline. In spring, the undaunted hotel owners pulled the building back from the encroaching sea. The 300-foot-long building was jacked up, railroad tracks were laid underneath, and the entire structure was placed on 100 flatcars, that pulled the hotel back from the shore. The inset shows the music pavilion stranded in the water. Before the storm, it had been on the hotel's front lawn.

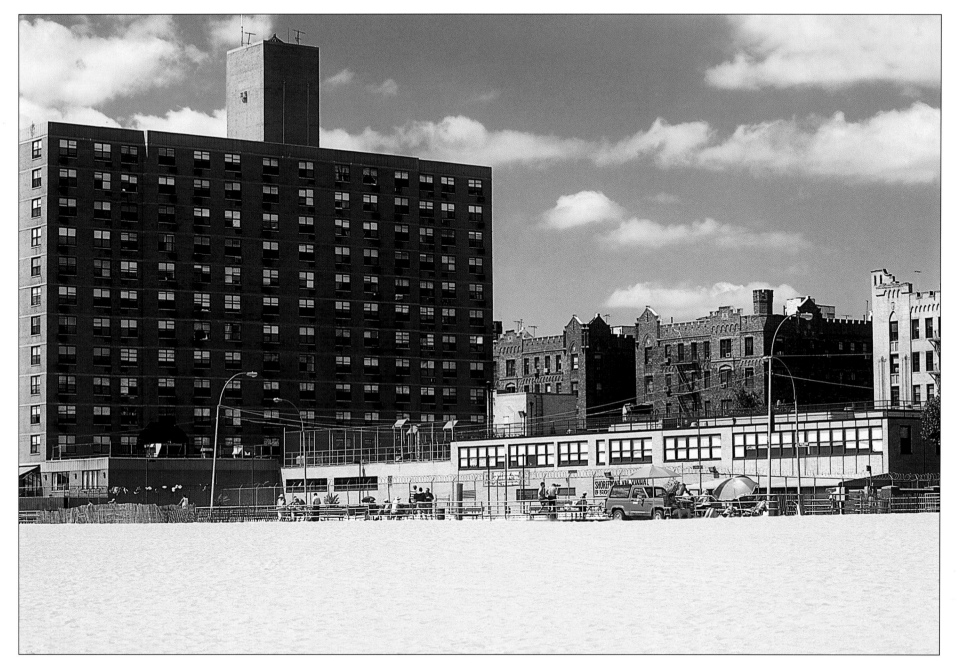

Gone by the 1920s, the Brighton Beach Hotel led the way to the development of the neighborhood of Brighton Beach, which continued to grow as subway connections brought permanent residents to the area. Today, all traces of the hotel are gone. In its place, buildings from different eras of development—small apartment houses, a low-rise YMHA, and a taller residence for senior citizens—now look out on the ocean.

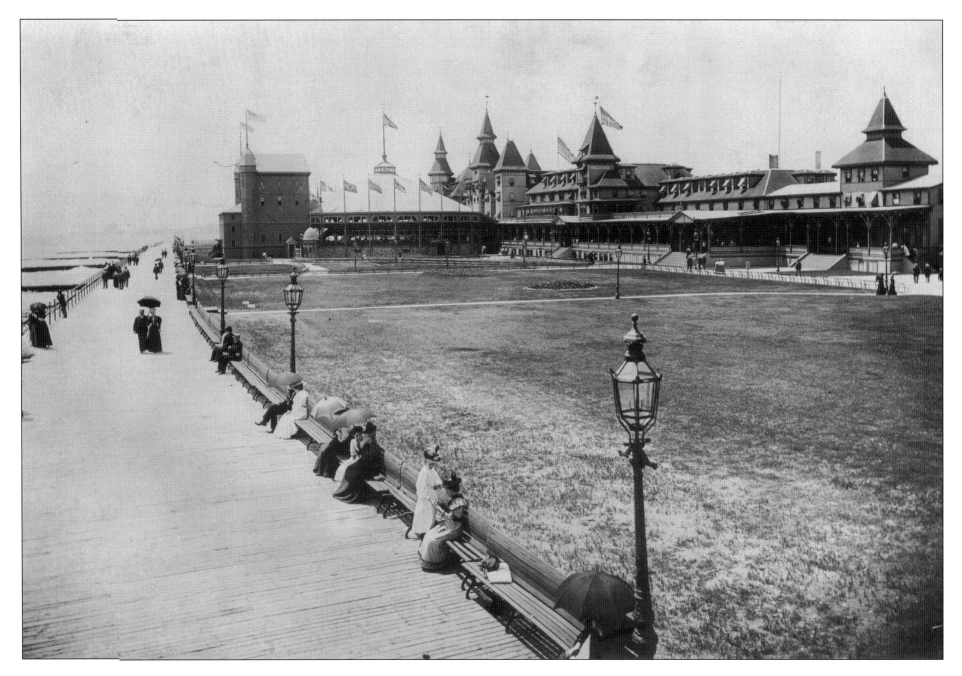

Manhattan Beach Hotel, Oriental Boulevard near Corbin Place, circa 1895. As its name suggests, the Manhattan Beach Hotel was developed with Manhattan patrons in mind. The hotel's developer, Austin Corbin, a New York banker, also built a railroad leading to the hotel, with depots and ferry connections in Manhattan. The hotel was twice as long as the one at Brighton Beach and had even more extensive grounds facing the ocean. Former President Ulysses Grant presided at the opening ceremonies in 1877, and the hotel soon became the summer home for Manhattan society. Corbin ensured that it was off-limits to everyone else, hiring private detectives to meet arriving trains and intercept unwanted guests.

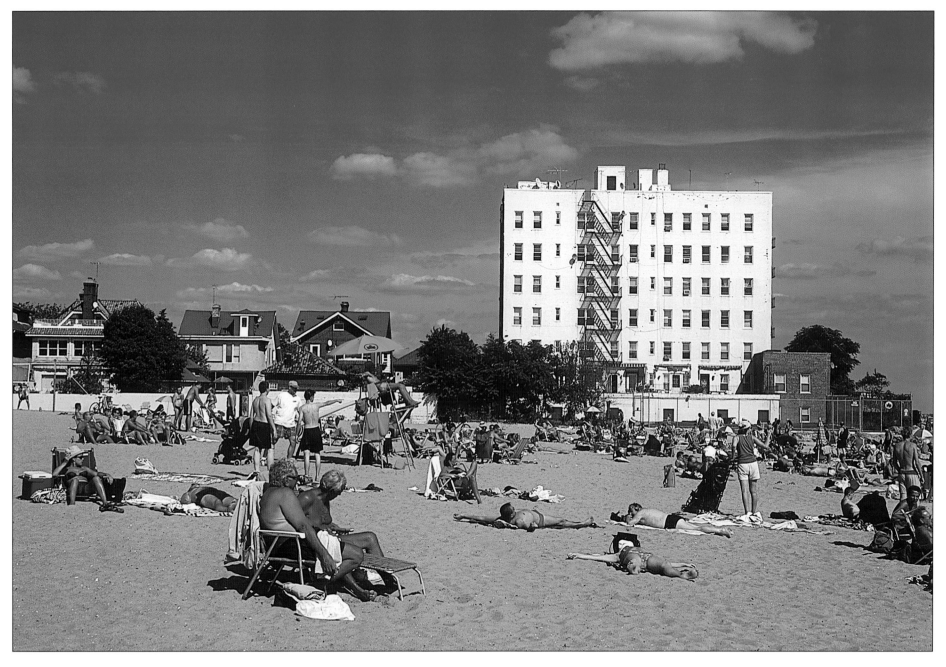

Today, the only evidence of this grand hotel is Corbin Place, the street named for the developer. After the hotel was demolished, the area was divided into building lots and developed as homes and apartment houses that now line the ocean beach. Ironically, although Corbin banned Jews from his hotel, they make up the majority of residents in the neighborhood today.

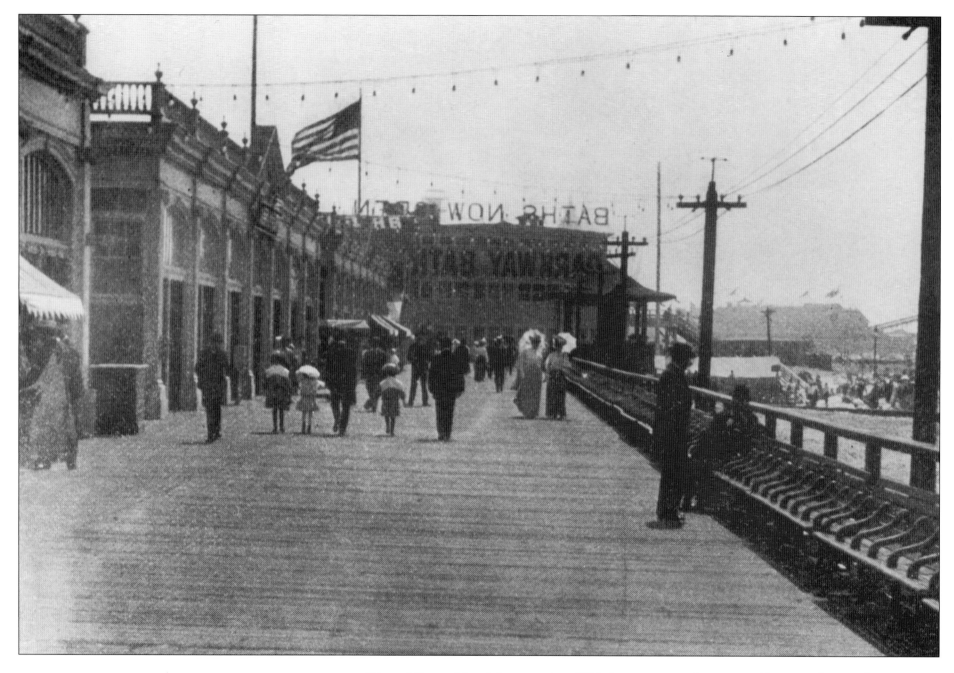

West of Coney Island Avenue, circa 1910. In contrast to the groomed lawns and genteel surroundings of the grand hotels, this section of the boardwalk was lined with bathing pavilions and places to play games of chance. The businesses here once divided the boardwalk and restricted beach access to paying customers only. That changed in the early 1920s when under the direction of the Brooklyn Borough President, Edward Riegelmann, the city acquired and enlarged the entire beachfront from Brighton Beach to the western end of Coney Island. The new eighty-foot-wide boardwalk opened to the public with great fanfare in 1923 as "Coney Island's Fifth Avenue."

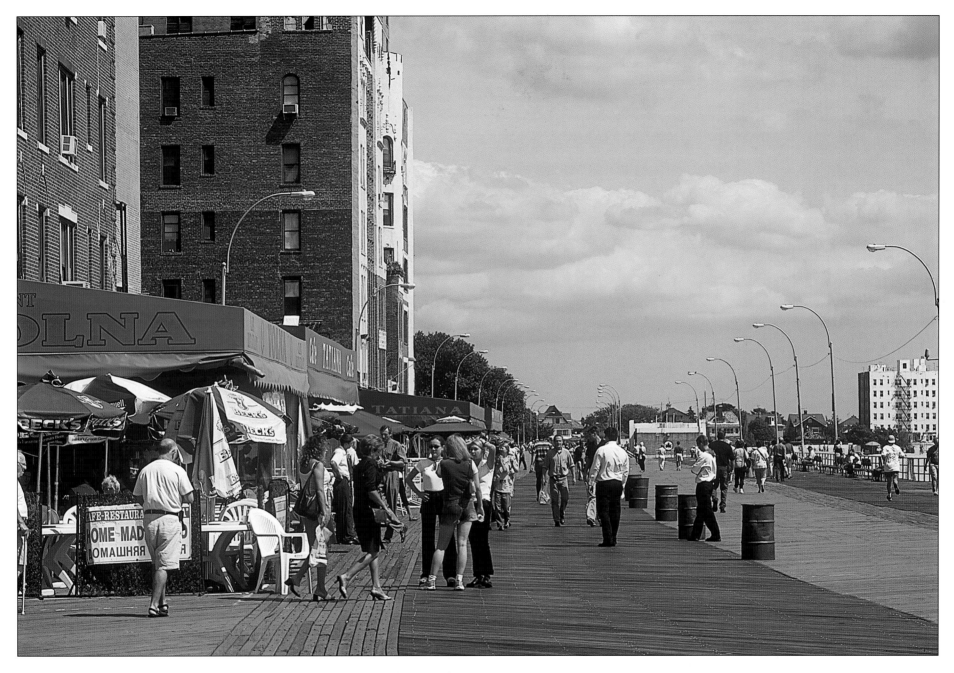

In the 1930s, New York City Parks Commissioner Robert Moses eliminated many of the boardwalk's amusement stands in an effort to create more room for "healthy outdoor recreation." As the population of Brighton Beach continued to grow, apartment buildings were built right up to the boardwalk (left). Many of the people here today are Russian immigrants, who make up a large part of the neighborhood. Many of the shops along the boardwalk are Russian restaurants, where vodka and herring are as common as hot dogs and ice cream.

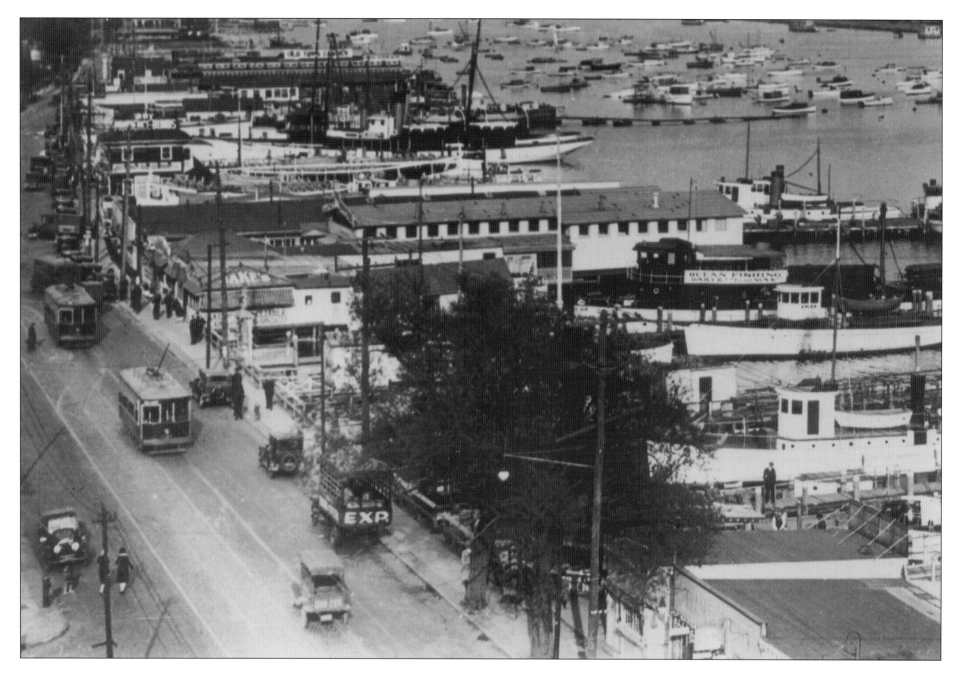

Emmons Avenue, circa 1926. Named for a fish, not a sheep, Sheepshead Bay lies east of Coney Island and Brighton Beach and has been a favorite fishing spot for centuries. Native Americans and, later, European settlers fished here. The bay likely got its name in 1844, when the area's first hotel, the Sheepshead, was built. When this photo was taken, trolley cars brought most people to the Sheepshead Bay piers. Local restaurants bought fish from the boats and gained a reputation for the freshest fish in Brooklyn.

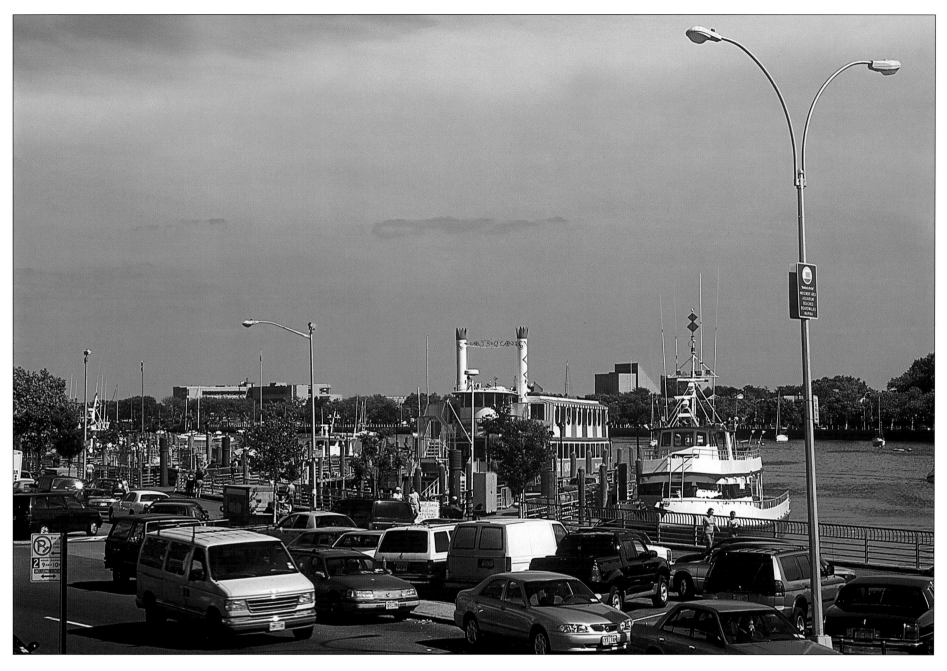

No longer a sleepy fishing village, Sheepshead Bay nonetheless is still the place to fish. Emmons Avenue is almost always crowded with drivers looking for a place to park their cars and board the fishing boats, which still depart from the piers each day. The city rebuilt the piers in 1936, changing them from wood to concrete, and added modern conveniences in the 1990s.

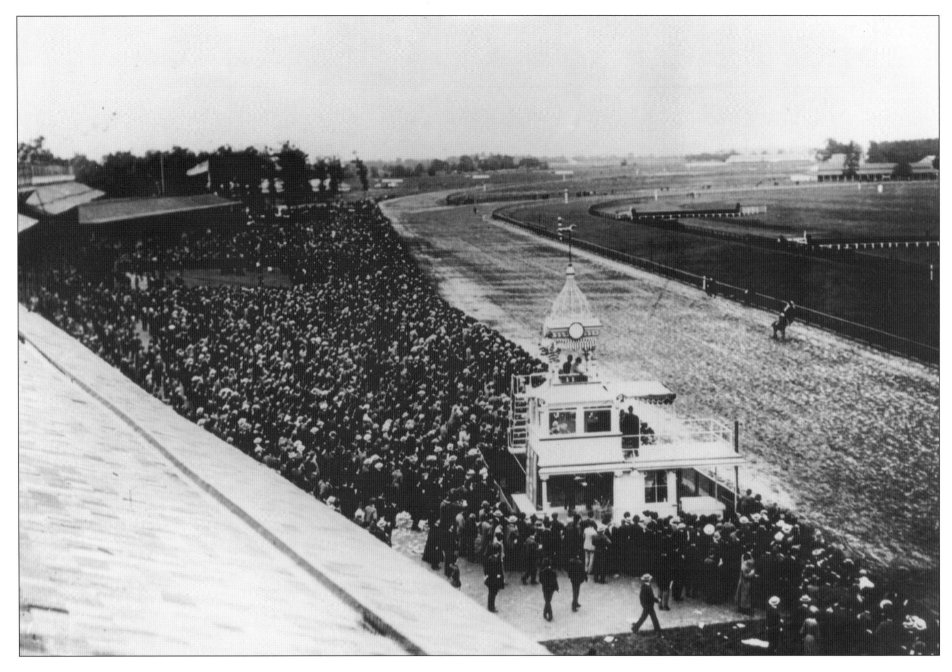

Ocean Avenue near Jerome Avenue, circa 1890. If you lived in Brooklyn in the late nineteenth century and were part of the fashionable set, there was only one place to go—the Sheepshead Bay Racetrack, the swankiest track in the city. Leonard Jerome—father of Winston Churchill's American bride, Jenny—was a founder of the Sheepshead Bay Racetrack. Prompted by the success of his Jerome Park track in the Bronx and by new rail service to Brooklyn's shorefront, Jerome established the elite Coney Island Jockey Club, which opened the Sheepshead Bay track in 1880. Covering 125 acres north of the bay, the track soon had some of the best horses and highest-paying purses of the day. With no other buildings around the track, people in the grandstand seats most likely had a view of the bay. Grand hotels at the nearby oceanfront provided a steady supply of race patrons. In 1908, New York State outlawed the system of betting practiced at that time, and by 1910 Brooklyn's great era of horse racing was over.

After betting on horses was outlawed, the Sheepshead Bay Racetrack switched to auto racing for a few years. In 1919, it was demolished for housing. Today, pleasant homes stand where horses once sped down the track.

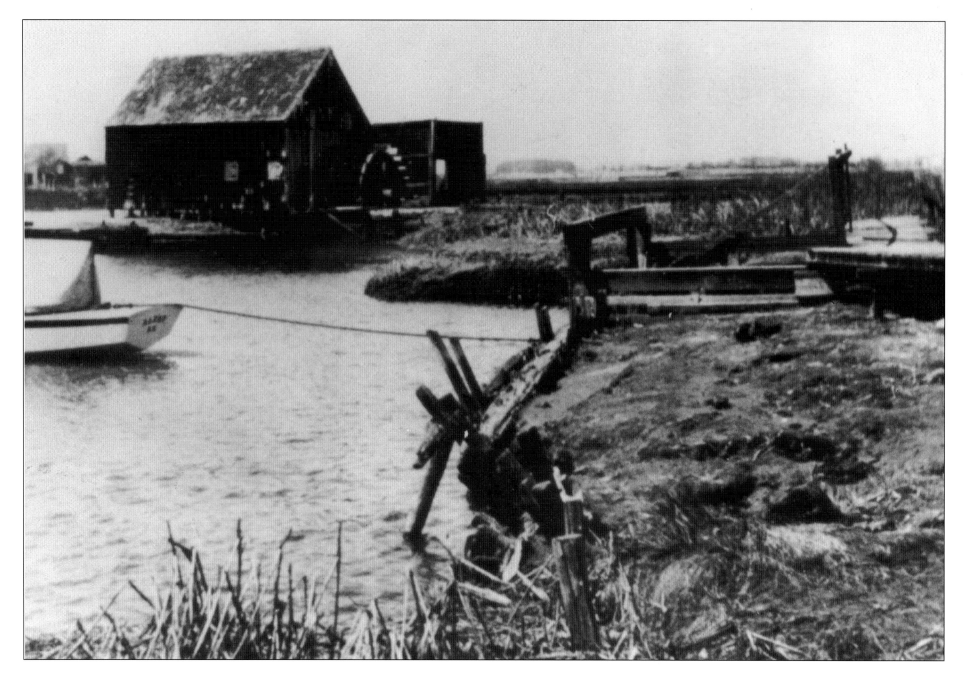

Fresh Creek, circa 1900. Generations of the Vanderveer family, descendants of the Dutch settlers who bought this land from the Canarsie tribe in the mid-seventeenth century, farmed here for two centuries. The land borders Fresh Creek, an offshoot of Jamaica Bay near Brooklyn's southeastern border. The mill, powered by the tides, dates from the 1750s. The farmhouse, built in the 1840s, was later moved to Flatlands Avenue in Canarsie, where it is still used as a church. In this early twentieth-century view, the area is still a rural backwater.

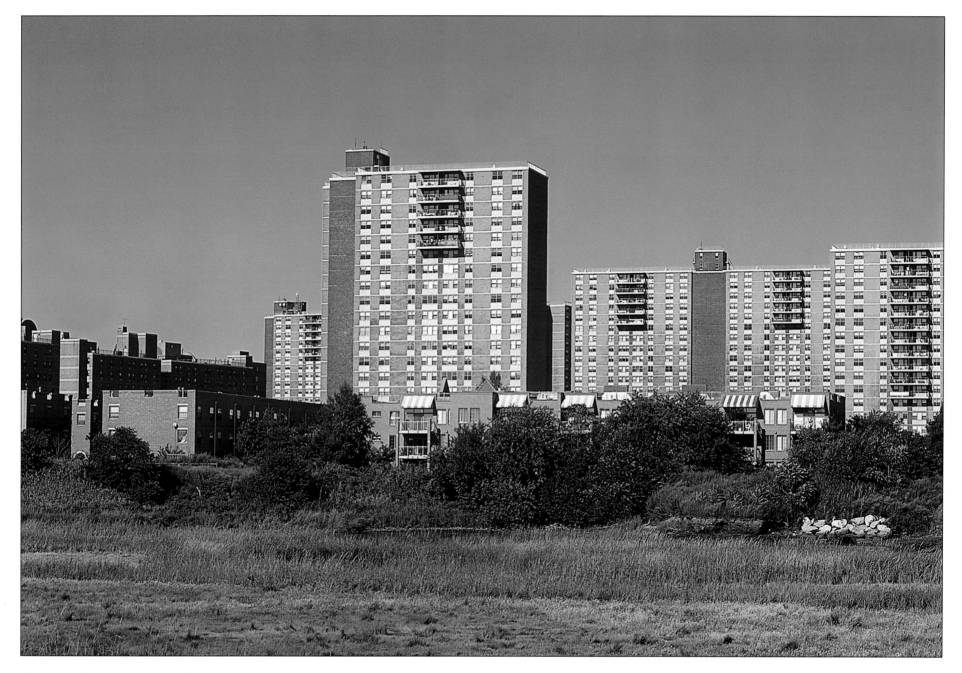

The area changed dramatically in the 1970s with the construction of forty-six
residential towers. Known as "Starrett City," the development includes six
thousand apartments and has its own power plant, parks, shopping areas,
medical centers, and public schools. This section along Fresh Creek was built
in the 1990s.

INDEX